John Constantine and Julia Wallis

The Thames and Hudson
Manual of Professional
Photography

with 108 illustrations in colour and black-and-white

Thames and Hudson

Frontispiece: With a 35mm outfit you can go anywhere! A system
camera, with its wide range of lenses and accessories; its
convenience and superb quality are features combining to
make it the most popular format for all serious photographers.

First published in Great Britain in 1983
First paperback edition 1983
Reprinted 1986

© 1983 Thames and Hudson Ltd, London

Printed and bound in Japan by Dai Nippon

Contents

Introduction

This book, as is explicit in the title, is intended primarily for the professional photographer. However, as there is no distinct division between professional and amateur photography, we feel that it will have a relevance to individuals other than those who earn their living by taking pictures. Photography is not a vocation where one begins to be a photographer at nine in the morning and stops at five in the afternoon; either you are a photographer or you are not. Whether you are paid for your work or whether it is done for your own pleasure is totally irrelevant.

We, the authors, are practising professional photographers and for some years have made our living entirely from the income of our own studio. Despite being engaged full time in the occupation, and having found a great sense of creative satisfaction in many images made to order in our capacity as professionals, we have taken many equally satisfying pictures in our spare time, strictly as amateurs. It is important for all professionals to retain the enthusiasm characteristic of the keen amateur: a loss of this will result in a loss of freshness and an eventual loss of all ideas and innovations.

Throughout the book we have assumed the reader has a basic knowledge of the techniques of photography: it is not for the absolute beginner who has just bought his first camera. We have also assumed that the reader will have at his disposal an enlarger for black-and-white work, and darkroom facilities, and is capable of producing a standard print of acceptable quality, correctly printed and processed.

Many of the techniques of photography are not in themselves particularly difficult, needing only care and practice to master. Focusing the camera, setting it competently and releasing the shutter should not be a problem: the tricky part is the consideration of the image in front of the lens. It is for this reason that we have paid particular attention to the aesthetics, to the ideas behind image-making and to the thought processes involved before the camera records the image.

The entire field of photography is subjective. Images are very personal, and although we have tried to remain dispassionate, the views expressed are nevertheless our own and may differ to a greater or lesser extent from those held by others. Similarly, the emphasis we have placed in some areas is based on what we have found in our own experience to be of importance. We have also hoped to cover certain aspects which are not so fully explored in other publications, particularly the sections relating to how we see pictures, business management and the examination – and revival – of the black-and-white photograph. You, the reader, may agree or disagree with our decisions, but if we give you the impetus to think, then we have succeeded in our aim.

This book has been written jointly by two authors. As the photographs taken and the events described have normally been so by either one or the other of us, rather than both working together, it seemed more reasonable to use the first person singular instead of the less direct 'we'. There are no references, however, to which of us the pronoun 'I' refers to in any specific case. And while we are well aware of the high proportion of women photographers, we have used the masculine 'he' simply as a matter of convenience.

Although we have mentioned particular manufacturers and makes of equipment, we have not intended to imply their superiority, unless specifically defined, over other comparable types.

Finally, we feel, as always but particularly in a teaching manual, that honesty is the best policy. Thus we have ensured that all information given regarding the production of photographs illustrated is absolutely correct.

Model: Do hurry up, Mister O'Brian—isn't the pose right yet?
Artist: Yes, yes, you look just right now. It's a beautiful picture. Come round and have a look at it.

1 Early days

We have all heard of Daguerre, we have seen the famous Fox Talbot negative of the latticed window, we know about calotypes, wet collodion, dry collodion, and have a passing acquaintance with other numerous and temporary patent methods of recording reality for posterity to a greater or lesser degree of permanence. Short histories of photography mention Niepce, Stieglitz and George Eastman, and are illustrated with the works of the inevitable Julia Margaret Cameron. A remarkable lady, Mrs Cameron, who, it is reckoned, must have been taking photographs twenty-four hours a day, seven days a week to achieve all the pictures attributed to her in the short space of time when she was active. But she, and many of the other pioneers of photography, were amateurs, un-doubtedly keen, and capable of capturing the most remarkable and superb images, but were essentially spare-time photographers earning their livings or receiving private incomes from elsewhere. So when did this novelty of the mid-nineteenth century first produce the professional photographer, relying on a camera for his livelihood?

The public was fascinated by photography, a miraculous invention producing likenesses out of a little box as though by magic. Inventions, technological advances and an awareness of a fundamental change in society as a whole pervaded the era. The Industrial Revolution had caused a major and relatively sudden alteration in the structure of the Western world, socially and economically, and machinery was generally more familiar to the inhabitants of the manufacturing nations than was agriculture. In the latter half of the twentieth century we have perhaps become blasé about novelty: pictures from space now cause only a passing comment, and men walking on the moon hardly merit a second look. These activities do not, after all, have any particular relevance to us in our day-to-day lives. A hundred years ago, however, technological change was far more personal: the telephone could be used, the railway engine was a means of transport, the machines in the mills were reality for millions of workers, and photography gave the public an opportunity to have its portrait taken in a way which painting never could, being quick, relatively cheap and undeniably life-like.

To quote the poet and art critic Charles Baudelaire, writing in 1859: '. . . our squalid society rushed, Narcissus to a man, to gaze at its trivial image on a scrap of metal.' He was not, however, above having his own picture taken, although it is doubtful whether he would have identified himself as a member of a 'squalid' society, nor considered his own image to be trivial.

This idea of the triviality of the photographic image was the basis of an argument which raged among intellectuals as to the exact status of

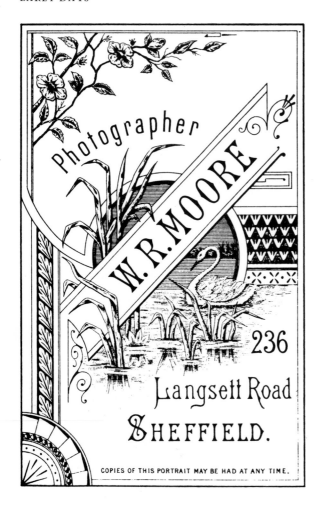

2, 3 Two examples of the decorative backs of nineteenth-century photographs. Often these are more interesting than the fronts

photography, and it persists to a certain extent today. The new phenomenon was of course a science, and could be put to great scientific use in the studies of astronomy, microscopic analysis and motion, leading to interesting and important discoveries. It could document and record facts with an impersonal eye, but was it an 'art form?' Many denied that it was an art, and said that it could not be because it had such an impersonal eye, and merely showed the world as it was, without the facility of interpretation open to the true artist. In those early days, when it was still an achievement to produce an image on a laboriously created piece of light-sensitive material, there was perhaps less general concern about the aesthetics than about the technicalities.

Some photographers, feeling the need to elevate their work to a higher plane in the face of the critics, set out to reproduce photographically the styles of painters, and we see interiors, heart-rending death scenes and tasteful still lifes; images conceived according to a sentimental concept of the Victorian age. These derivatives served only to compound the idea that photography was a mechanical means of recording and did not

help its status in any way. There has also been a reluctance in some circles to be associated with anything new, particularly if it has an obvious popular appeal, as though its very popularity has a cheapening effect, and there was the need to protect the status quo. If photography were an art form, then every individual with the means and motivation to purchase a camera could be considered an artist, untutored and untrained, with standing equal to the student who had spent many years being schooled in the technique of translating light and form on to canvas.

In 1857, Lady Elizabeth Eastlake wrote: '. . . photographers . . . are wanted everywhere, and found everywhere . . . the smallest town is not without them. Thus, where not half a generation ago the existence of such a vocation was not dreamt of, tens of thousands are now following a new business.'

Photography as a profession grew according to the laws of supply and demand. In the 1850's, public demand for photographers was evident, and the supply was provided by the new category of professional photographers, who opened their studios and conducted their portrait business in a manner not totally dissimilar to the general practitioner of today, although in many cases with a little more showmanship.

The majority of the portraits taken in these professional studios were not, as they are not today, what would be considered as great photographs. Straightforward, modern portraits have an appeal generally limited to friends and acquaintances, but those of a hundred years ago are interesting to us because of the nostalgia their age brings: we can look at the clothes, the props and the formal, set poses and expressions, and we can seek for family resemblances in the faces of our own ancestors, but few have any particular aesthetic importance. Socially, however, they had great impact.

4, 5 A Victorian portrait and
(opposite) a modern one. The
resemblance between the two is
a curious coincidence

The demand for portraiture led to fortunes being made by pho-
tographers, the establishment of huge chains of studios operating
nationally and internationally, and photography on a production line.
Once the wet, and later dry, collodion process had superseded the
initially very successful daguerreotype, the re-usable negative gave the
photographer the advantage of being able to make an unlimited number
of copies from the same negative. Obviously, there was little point in
making innumerable prints of an unknown individual who was of
interest only to his friends and family, but well-known figures were
likely to sell well to the public. Photographers were producing prints by
the thousand, for sale, of kings, queens and statesmen, and the patronage
of a royal or important personage was an obvious economic advantage.
Not only would money be made by selling prints of that person, but the
advertising of the studio was invaluable, and the 'by appointment'
designation carried great weight. Photography was extremely popular in
Great Britain at this time, probably helped by Queen Victoria's patronage
and interest.

Many of the most highly regarded photographers of that age were in
fact professionals, although their professional work is now far less well

known, if not forgotten, in comparison with the pictures taken simply for their own interest.

One such photographer is Frank M. Sutcliffe, who owned and worked in a portrait studio in Whitby on the Yorkshire coast for almost fifty years from 1876. He made his living entirely from his studio, which he was aware was a necessity, but which he felt was restrictive, particularly during the summer tourist season when his working hours were long. It was in his spare time that he produced the work for which he is famous today: his views of the town of Whitby, its inhabitants and its surrounding countryside. Yet restrictive though his professional work might have felt, he was also aware that in tying him down to one place, and limiting his spare time, it served to sharpen his vision of his home, and he was able to see pictures at every corner in every condition of weather where the cursory glance of the tourist might reveal nothing worthy of photography.

Mathew Brady, known for his reportage of the American Civil War, was established long before the outbreak of war in 1860 as a successful portrait photographer in New York. Sought after as a photographer of famous and society people, Brady was comfortably off, if not wealthy. His portrait of Abraham Lincoln in 1860 is an example of the very popular

carte-de-visite, and became widely known. Mr Lincoln was later to remark, when meeting the photographer again, that Brady had made him President. He recognized the power of communication that photography carried: the picture could put a face to a name and so familiarize the face to the public. Brady was also to take the portraits of Generals Grant and Lee, and was to say that thousands of prints of these men were sold 'at their greatest periods of rise or ruin'.

Despite his depictions of such figures as these, Brady is nevertheless most celebrated for his coverage of the Civil War, an amateur undertaking which broke him financially. 'My wife and my most conservative friends looked unfavorably upon the departure from commercial business to pictorial war correspondence. . . . A spirit in my feet said "Go" and I went. . . . I spent over $100,000 in my war enterprises.'

Brady in America and Roger Fenton in the Crimea brought images to the public of places and events they would otherwise have no means of knowing. War, to the average American or Englishman, was something which happened somewhere else and there was a general belief that the whole business was rather exciting and glorious. Verbal reports contrary to this view were considered treacherous and subversive. Fenton, unlike Brady, was despatched to the Crimea as a professional photographer, for the purpose of returning with pictures to allay the growing fears at home about the well-being of the troops in Russia, also with a view to recovering some of the costs of the exercise by selling prints to the public. It is not surprising that the pictures seem remarkably unwarlike by our standards: it was not politic to show reality, and gruesome images would be less likely to have popular appeal. Technical restrictions also precluded showing moving subjects. The dreadful realities had to wait for more than fifty years to be brought to the public's eyes: still inspired by 'death or glory', and unaware that there was anything particularly nasty in between the two, the British marched into the Great War. Pictures sent from the trenches were shocking: impressions were confirmed and reinforced by the returning soldiers.

It was not only war reportage which brought to the general public scenes which were to a greater or lesser extent distasteful. Poverty and the appalling conditions endured by some sectors of society was no longer a matter for idle speculation. Whereas the upper and ruling classes had previously to make a conscious effort to enter the world inhabited by a completely different economic and social group, this world was brought forcibly to them, and a conscious effort had to be made to ignore it if reality were not to be faced. Throughout the history of photography, it has become clear that the medium is capable of acting not only as a record, but as a conscience.

As a record of people and places, photography could not be equalled. No longer were the views of the Pyramids or the Parthenon coloured by the subjective impressions of an artist, but shown in unquestionable reality. Photographers, many of whom were amateurs of private means, travellers in the accepted sense of the word, journeyed to distant and inaccessible places, weighed down by equipment and aided by armies of

porters. Their pictures showed the average viewer sights he himself was never likely to see, thus broadening his field of knowledge and increasing his understanding of the world beyond his home town.

Having seen the value of this topographical coverage, governments commissioned photographers to conduct surveys of areas for a variety of purposes: it was found that the work of Nadar, the first aerial photographer from his vantage point of a balloon, was of definite strategic and military use during the siege of Paris in 1871. In the United States, 'Early in the summer of 1867 a surveying party of about forty persons left California to proceed eastward directly across the different ranges of the Rocky Mountains as far as the Great Salt Lake, and traveled most of the distance in the vicinity of the proposed route of the Central Pacific Railroad.' Accompanied by an escort of cavalry to protect them from Indian attack, the group set off into the interior. 'Two mules and an experienced packer were assigned to the photographing artist, and were by him duly accepted as a satisfactory outfit for the proposed expedition.' The photographer was Timothy O'Sullivan, already known for his pictures of the Civil War. Many such expeditions took place in the United States toward the end of the century. At the time, photographs were vital for planning purposes to the government of this vast, undeveloped land, most particularly relevant in the construction of the railway network needed to open lines of communication: today, we have a comprehensive pictorial record of the Old West.

We also have the opportunity to see the reality of such figures as Billy the Kid and General Custer, people we know to have existed, but whose actual likenesses have been clouded by countless movies. The public of the time was able to recognize the faces not only of their heroes, but also of their villains, thus providing the forces of law with a better means of identification.

Further to this, the viewer was given the chance to share in the immediacy of an event at which he was not present, the 'public relations' shot of today. The well-known picture of Isambard Brunel in front of hanging chains was taken in 1857 at the launching of the *Great Eastern*, an event felt to have sufficient general interest to warrant photographic coverage. The numerous exhibitions held during the Victorian era were also well covered by photographers, the organizers granting franchises to take pictures and sell prints in the exhibition halls, a practice which still operates in modern times.

Towards the end of the nineteenth century, enterprise and expansion had gathered momentum. 'Communication' was the key word: a widening of horizons due to a variety of factors, more widespread education, easier and cheaper travel, an organized postal and telegraph system throughout the world to reach all corners of the Empire, and the beginnings of a telephone network.

Photography gave the public visual images: newspapers and periodicals were read by almost all sectors of society, but there was still one major difficulty remaining: there was no mechanical means of fusing the two together. When photographs were first used as illustrative material

in the press, they were pasted onto the printed page. This method was restrictive because of its slowness and relative cost, so the more usual method of reproducing a photographic picture was to copy it by making a line engraving which could then be printed in the usual way.

The need for an alternative was obvious. The essence of a photograph was its impression of reality and sense of immediacy, qualities which were reduced in translation to an engraving, which, despite the fact the picture credit usually read something like 'Engraving by X from photograph by Y', still appeared to be a drawing, capable of adaptation and artistic licence, and could not help but lack photographic impact.

In 1880, the New York *Daily Graphic* published the first reproduction of a photograph from a halftone plate, using a single line screen. The quality was poor because of the coarseness of the screen, and it was not generally felt that much improvement could be made for newspaper reproduction because of the speed at which the presses printed the material and the quality of the newsprint itself. Books and periodicals, printed in less haste, and on better paper, were able to improve photo-mechanical reproduction with finer and more carefully prepared screens and more attention to inking. Essentially, the same situation applies today: a daily newspaper is not only prepared at speed, it travels through the gigantic presses at a lightning rate in comparison even with a monthly colour magazine, and a high-quality art book progresses even more slowly.

Some publishers resisted the halftone process in its initial stages because the results obtained were not exactly of the highest standard, but by the turn of the century, with improvements in technique, the halftone was beginning to supersede the engraving. Since then, the spread of photography, its familiarity and its usage have been closely linked with the history of printed matter.

For the professional photographer, this opened a huge new field. His portraits had been in demand for years: but his landscapes and views, his scientific studies, his social reportage, sometimes commissioned, sometimes speculative, had had a restricted audience. With the perfection of a direct method of reproducing his pictures in the press, the audience was restricted only by the distribution of the printed matter. Photographs became more than ever in demand.

During the twentieth century, all aspects of life have been changing, suddenly or gradually, radically or imperceptibly, but continuously. Photography has changed too, in sophistication of equipment and materials, and in style, both being linked together to a greater or lesser degree. We become aware that there is a tendency to use a certain viewpoint, camera angle or lighting technique: the fish-eye lens had a sudden burst of popularity in the 1970's; in the 1960's many images appeared hard-edged, angular and 'op-art'. The most *avant-garde* of those pictures now seem dated and we are amazed that once they were considered so modern, in the same way that we cannot understand why there was so much fuss about the Beatles' 'long' hair. It is impossible to tell how the accepted norm for today will be viewed in ten years,

although we have a sneaking suspicion that the style we may consider so wonderful now might seem embarrassingly bad after a passage of time. This reason alone should be enough to motivate the individual photographer to assess and re-assess his work continually, and take steps to ensure that he does not stagnate.

Photography today is a vast industry, the world's largest user of the resources of silver, one of the most popular leisure-time activities and the most powerful means of visual communication ever known. Life without it is unimaginable even to the individual who has never held a camera: everywhere we look we see the photographic image or the result of a photographic process.

Photography is now more than ever within the scope of the majority, and mass production and competition between manufacturers has led to improvements and refinements which would otherwise have not been made, so the professional must thank the amateur for his enthusiasm. But why do professional photographers survive, or even exist at all? We do not have secret information on how to take 'better' pictures, we do not use special equipment or materials denied to others. But it is staggering to learn how many of the millions of frames of film shot by amateurs do not come out at all! A newspaper report tells an amusing story of how a tourist managed to take a series of pictures of his ear by holding his pocket camera to his eye the wrong way around, and there are many, many more disappointments in films which are not completely blank: blurred, badly exposed, unrecognizable marks on bits of paper which can hardly be described as photography.

There are, of course, many amateur photographers whose work is on a completely different level, and whose achievements should be admired. There are also many competent picture-takers among amateurs: even my small son, armed with his automatic camera, does not make fundamental mistakes and has a good eye for composition. A good photographer transcends age, sex and social categories: professional or amateur status makes no difference. Interest and visual awareness are the vital factors and the professional must ensure that they are with him all the time. He must know the technical rules of his trade so well that he also knows how to break them successfully to achieve an effect which may not occur to others. He must be reliable and inventive, capable of working virtual miracles, proving that he is indeed at least a few steps ahead of the army of amateurs looking over his shoulder.

2 Job opportunities

It would be a mistake to imagine that a job in photography is easy to obtain. A college qualification and simple enthusiasm will not automatically guarantee employment, as competition is fierce and there are invariably more applicants than there are places to be filled. And it is only fair to point out that the majority of professional photographers do not lead the glamorous lives the media would sometimes have us believe they do; given the opportunity to travel to exotic locations, most photographers will tell you that they are expected to work extremely hard for the privilege. The shoot can hardly be seen as a glorified holiday with pay.

Yet despite the hard work, long hours and irritating restrictions, it is possible to be creative and enjoy photography within commercial confines; but if you feel that the pressures are likely to be too great, it is far better to continue as an amateur and keep your enthusiasm intact.

GENERAL PRACTICE

The majority of professional photographers are engaged in general practice, usually referred to as 'GP' studios. Most GPs rely primarily on social photography, and many have shop facilities offering a developing and printing service for amateurs' films, together with a retail outlet for cameras and other associated photographic equipment. If you work in general-practice social photography, you must be prepared to work outside normal business hours at weekends and in the evenings, have an ability to communicate with people of all kinds, and have the gift of putting sometimes nervous individuals at their ease, to take a relaxed and natural portrait.

COMMERCIAL PHOTOGRAPHY

Some photographers and studios specialise entirely in working for industry and advertising in all its forms, for magazines and other publications. In its widest sense, commercial photography covers a vast range of subject material, but photographers usually find themselves specializing to a greater or lesser degree, either through personal choice or because they live in an area with a predominance of a particular type of work.

3 The freelance photographer

To become a freelance is the dream of many employed photographers and amateurs, and a necessity for those unable to find a job, or made redundant. All prospective freelances should be aware that to be successful (which in simple terms means merely surviving over the first year or two) it is not sufficient simply to be able to take good pictures.

STARTING A BUSINESS

If you are already established in an employed capacity at an existing studio, you have an advantage over the amateur or college leaver in that you have had the opportunity to build a reputation and a list of contacts who may be helpful when you branch out on your own. You will also be aware of the difficulties involved in running a business, from the financial and organizational point of view. It should be understood by all, however, that the first few months, or even years, of being a self-employed person are likely to be financially difficult, and no schemes should be put into operation unless you are completely satisfied that any commitment can be met, and that you have enough capital to cover expenses and running costs before money is made by the new business. On a personal note, you should be sure that you have the full support of your family before starting on a freelance venture, as relationships may be subjected to severe emotional stress in a situation where you are working long hours for apparently little money.

Unless you are fortunate enough to have a private source of income or have been able to save sufficient to use as working capital, some kind of financial backing will be necessary. Any financial backer will expect to see a soundly considered and properly set out assessment of prospects and costings before considering your proposal. In order to make such proposals, you must study the market for your work, decide on the premises and equipment you will require to do your job competently, and find out how much they are likely to cost.

Some of the difficulties with starting a studio from scratch are overcome by buying into an existing business, either by joining as a partner, or taking over outright. An established studio will already have a client list, which is an advantage, but you should not overestimate goodwill, as the reputation of a photographic studio is built on the ability and personality of the photographer himself, and people are suspicious of change.

A partnership with a friend or colleague is one way round the loneliness and isolation of the freelance in his newly formed business, and with a partner, he does not have to shoulder the burden of decision-

making by himself. Nevertheless, many such businesses founder on the issues of personal relationships: some partnerships begin and remain stable, while others may disintegrate rapidly into arguments, the basis of which is usually money. If you do go into partnership, particularly with a friend or close relative, make sure that all financial considerations are worked out thoroughly beforehand with the help of legal advice, and try to ensure that no long-term personality clashes develop which will be harmful to the business as a whole.

RUNNING A BUSINESS

The freelance photographer has three valuable friends in his bank manager, his accountant and his legal adviser, all of whom can provide useful help in areas where the average individual has no real experience. Although my partner (and co-author) and I have been in business as freelance photographers now for several years, neither of us is any wiser about tax, and most financial matters are as a closed book. Our accountant devised a book-keeping system simple enough for us to manage, yet sufficiently comprehensive to meet requirements for tax returns and to use to prepare end-of-year accounts. Book-keeping is not difficult, but as a tedious, non-productive job it can often be overlooked. If you have a secretary, your task will be much easier, otherwise you may find it useful to employ a book-keeper on a part-time basis. Alternatively, there are now reasonably priced computers on the market which, once pro-grammed, will enable you to see the state of your accounts at a glance; these are particularly useful when handling large numbers of customers.

Costing

A conversation about a job between photographer and customer often opens with the question 'How much will it cost if. . .?' Your price will be based on the direct expenses of the job, the materials used and other services required, and on the time it is estimated the job will take. The hourly or daily rate charged must be calculated to cover, for example, the general running expenses of the studio, the rent, rates, interest on loans, telephones, and allow you to make a profit. A cost-profit ratio is difficult to determine, and on individual jobs it is more sensible to take only direct expenditure into account. Over a period of, say, a month, you should be able to see an emerging pattern: you will be able to add up your total turnover, subtract direct expenses from this, and assess whether this figure is enough to cover your running costs and allow you to live reasonably. If there is a deficit, either you need more work to do, or you are not charging sufficiently high fees. Only you know whether you have the capacity to do more work, and you should beware of increasing your charges as they may cease to be competitive with those of other photographers in the area.

Few people like giving quotations, particularly when the information provided is rather vague. I find it is wise to err on the high side rather than on the low, and prefer to tell the client the 'ceiling' price for the job,

which may even cost less. Whereas it is acceptable to present an invoice which is lower than the top limit of the quoted price, an invoice unjustifiably higher will invariably cause disaffection.

Before you can give even the roughest idea of price, you must make sure you have certain information about the job.

1 How long will it take? At first it is difficult to estimate the time you will need to complete a job, and only experience will guide you here. However, once you are able to calculate with a reasonable degree of accuracy how long a shot will take to do, you can use your hourly or daily rate as the basis of your costing.

2 How many and what sort of pictures? This will tell you how much and what sort of material you will use, and what your processing costs are likely to be. One photograph on a single sheet of black-and-white film will obviously involve less use of materials than a multiple exposure on $10'' \times 8''$ colour transparency, where you may have to use many sheets for the right effect. Remember to build apparent waste of film into your costings: I always shoot several sheets of transparency film, for example, bracketing exposures to be sure of having at least one correct, and where you are working with live models or moving subjects, wastage of material is far higher.

3 Will it be in the studio or on location? Extra charges may have to be made for location jobs to allow for travelling expenses, hotel bills and time spent waiting for favourable weather conditions.

4 Will other people be present at the shoot? Often a client expresses a wish to be there when the picture is taken, and you may find yourself waiting for him to arrive. Explain to him that you must charge for all waiting time, as though you were actually taking pictures.

5 How many extras? Models cost money to hire, and time has to be spent choosing them. 'Props' have to be bought or hired, and additional expenses can mount alarmingly.

6 Rush jobs. If you have planned your day, an unexpected rush job can severely disrupt your schedule. It is normal practice to surcharge under these circumstances. The actual percentage surcharge is up to you, although 50–100 per cent is normal for any kind of same-day service, and you should check with other photographers and laboratories in your area for an idea of the prevailing rate. Whatever rate you choose to surcharge, however, be consistent.

Invoices
Invoices should be presented to the client before the end of the month in which he received the completed job. Delay in the presentation of

invoices will inevitably result in delay in payment, which in turn disrupts cash flow.

Where reputable firms are concerned, it is not usually necessary to make checks on their financial reliability before allowing them credit facilities. As a shop dealing with customers on a one-off basis finds it preferable to allow no credit at all, so commercial studios with a new client would often be well advised to ask for cash on delivery of the job, perhaps with a discount for prompt payment.

Incoming bills should be checked and placed in order for payment, so that nothing is overlooked and discounts for prompt payment may be taken advantage of where possible. Slow payment of bills tends to reduce the creditability of the firm and, at the worst, the account may be stopped, which is not only embarrassing but disrupts the flow of supplies.

Working systems

1 *Numbers and indexing* Each job undertaken should be given its own number, which can then be used to identify it at all stages. Enter every commission into a day book, giving the date, details of the client, and the nature of the work undertaken. This is particularly important for reprint orders or transparency work, where there is no negative to keep as a record. Where there are negatives, identify them with the job number and client, and keep index books for easy reference: searching through hundreds of negatives for a particular one is inefficient, frustrating and a waste of time. Prints leaving the studio should be identified with the name of the photographer or studio, together with the number code to enable clients to re-order, by simply writing on the back of the print (remembering to use a pen which will not smear), or by having a rubber stamp made or self-adhesive labels printed. Having your name on the prints can also act as a promotion for yourself. In practice it is not always possible to identify every print, however: where large numbers of prints are required for press-release purposes it is not usually expected.

2 *Storage* Your negative file represents a considerable sum when calculated in terms of possible reprint orders, and the worth of a shot which can never be repeated is obviously incalculable. Negatives should therefore be stored carefully in special sleeves in a dry place, away from possible disasters such as a burst pipe or blocked sink, in a room which is not subject to extremes of temperature. Some photographers like to keep their negatives in ring binders, together with a contact sheet for reference, but after a while you may find that this sytem occupies rather too much space, which is usually at a premium. Filing cabinets are ideal, but there is no reason why initially you should not use the cheaper alternative of strong cardboard boxes.

Storage space will also be required for the paper work involved in running a business: records must be retained for several years, for legal reasons, and current files should be kept in order for instant reference. It is not easy to run an efficient office when you are more interested in taking photographs, but establishing an efficient system at the outset will save you time in the end.

3 *Stationery* A carefully designed business letter heading and co-ordinated range of stationery looks professional, attracts attention and inspires confidence. The temptation may be to cut costs and design the heading yourself, but it is well worth the expense to commission a graphic designer to produce some ideas, give advice on printing and the types of paper to choose, thus achieving a more personal and interesting result. You will need headed writing paper, business cards and compliment slips essentially; adhesive labels, invoice and order books are also useful.

The portfolio

A photographer's portfolio, or 'book', is essential, and must be assembled with care, and designed chiefly to impress. All prints and transparencies must be of the best technical quality, covering a range of subjects to show the extent of your abilities, and a selection of commissioned printed work should be included where possible, to indicate that you are capable of handling commercial jobs successfully.

There is always a temptation to include too much work in a book, thus increasing it to physically unmanageable proportions, and incidentally running the risk of boring your customer, so pare it down as much as possible. One way round the size problem is to mount several related subjects on one sheet, varying the shapes of the individual prints or transparencies to provide an interesting overall picture. This also gives you the opportunity to show how you can tackle a subject in a variety of ways, or examine a theme.

Portfolios of a high standard of work may be ruined by shoddy presentation, and most pictures will look incomparably more impressive and 'finished' by being mounted and shown properly. Don't keep your work untidily in an old cardboard box: it does not look professional nor is it easy to transport. A case with clear plastic folders to protect pictures from damage is the most usual method of presentation.

If you are making any progress at all, a book will need constant revision. This is not to say that old work is necessarily bad work, and some photographs are of course timeless. Others, however, may quickly appear to be out of date, particularly those of people, where fashions change very obviously. Despite the fact that you may be busy taking pictures to earn money, try to make time to take pictures for yourself and for your portfolio. You will find it a welcome relaxation.

An extension of your portfolio is a display board of your work in the studio or shop window. This gives your customers something to see when visiting you, and an attractive window display helps to catch the passing trade. Make sure your display is neat and up to date, and be careful not to allow colour prints to fade in sunlight. Change them regularly or use prints with light-resistant characteristics, such as Cibachrome.

Subcontracting

There is a temptation to reduce outgoing expenses by trying to do all aspects of a job yourself, particularly in the first few years when money

6, 7 Blocking out. In Fig. 6 the shape of the machine is confused by the background. Fig. 7 is a print from a blocked-out negative of the same machine, showing its outline clearly

is tight and you have time available. Several factors are involved in the decision whether or not to subcontract.

1 *Skill* Tackle a job only if you feel competent enough to complete it to the same standard as a professional. Making frames or blocking out negatives may not appear difficult, but are you sure you are able to do it as well as the man who earns a full-time living by doing these jobs? It is better to tell your customer that you yourself are not able to undertake a particular section of a job, thus giving him the option of subcontracting the work himself, or allowing you to handle it for him. Producing an inferior result damages the reputation you have as a photographer.

2 *Time* If your work commitment allows, it is economically sensible to spend time doing something yourself rather than spend money sub-contracting, if the work is within your scope. However, when pressed for time, it makes equal economic sense to subcontract, particularly when the choice is between a day's photography which you enjoy and pays a good daily rate and a day's slide duplicating which is not only more tedious but is less lucrative.

3 *Equipment* A trip around a modern colour laboratory will show why it is preferable to subcontract colour print work. The machinery is sophisticated, large and extremely expensive, and no matter how skilful a colour printer you might be, using vastly inferior equipment it is im-possible to compete in terms of speed and quality with a colour laboratory.

Suppliers
You should try to establish a circle of suppliers of the various services you need, and build a mutual trust so that you know you can seek advice and assistance, and, above all, find consistent quality and reliability. You are only as reliable as your supplier when you buy goods and services: you cannot be continually explaining that delivery dates have not been met because it is someone else's fault. Also, don't hold a job up yourself and then expect your supplier to make up the time you have wasted.

The type of supplies you will need obviously varies according to the sort of work you undertake, but the following list covers the main areas.

1 *Equipment* Cameras and associated equipment are the tools of your trade. When purchasing, price must be taken into account, but you should also look at the facilities your retailer offers for repairs and service. For a fully booked photographer, any equipment failure is a disaster, and you cannot afford to wait weeks to be operational again. Most retailers dealing with professional photographers are aware of this and will undertake to carry out repairs or supply replacements immediately in the event of breakdown, damage or loss.

2 *Materials* Film, paper and chemicals are also essentials no photo-grapher can be without; although your normal stock control should keep materials at a level capable of meeting average requirements, a

8 Copied by the enlarger method on Plus X Pan 5″ × 4″ from an old, damaged photograph mended with adhesive tape

sudden run on one particular item may necessitate a rapid delivery of extra supplies to complete the job. Check that your supplier has regular and frequent deliveries in your area and that he can bring you your order within days of receiving it. The price of materials is less important to a professional photographer than their quality and availability at short notice.

3 Processing laboratory The factors to be taken into consideration are quality, speed of service, price and ease of access. Many labs offer a collection and delivery service, thus ensuring the safe arrival of valuable materials without the need to send a member of the studio staff from door to door, or use a courier service. Sending parcels in the post or on the train is not entirely satisfactory under any circumstances, as delays or loss may occur. Laboratories vary in the type of work in which they specialize: some will concentrate on high-quality hand printing, while others will also cater for the amateur developing and printing packages.

9 A retouched version. The air-brushing was done by a highly skilled artist. The 'antique' appearance of the portrait could be re-created by sepia toning

Study the services of each lab in your area, compare the prices relative to the quality, and concentrate on the ones which seem to offer the best deal.

4 Artist and designer For retouching where the skilful handling of an airbrush is required, and for blocking out complex negatives, it is advisable to call in the services of a commercial artist for a professional result. A graphic designer may be needed when your photograph or series of photographs forms part of a whole, such as in the production of a brochure. If you can work closely with a designer, you and he together are in a much stronger position to get new work, being able to offer a photography and design package, than you would if you were each to seek work independently.

5 Model agencies They will supply you with information and photographs of models on their books, and you arrange photographic sessions with the models through them. Not all models are fashion mannequins:

some agencies specialize in character figures or children, and they will help you find the right person if your requirements are specific. If, for instance, you need someone with perfect teeth or fingernails, to save embarrassment and time they will advise you who is prepared to do glamour work.

6 Other specialist services Professional models are trained in the use of make-up, but on some occasions you will require the expert assistance of a skilled beautician and a hair-stylist, particularly where close-ups of the face are involved and every cosmetic inadequacy will show. If you have food to prepare and are not sure about the standard of your own presentation, use a home economist or enquire about the possibilities of help from a local restaurant or catering school. Where props are needed, as for background sets in portraiture, there are firms specializing in hire, either specifically for photographers or for general usage, as in amateur theatricals. Some shops and theatres are prepared to lend objects for use as props, and for clothes there are fancy dress stores. Even when you have to buy rather than hire props, it is useful to be on friendly terms with various shopkeepers who, when they know why you need the goods, are usually very helpful.

4 Bricks and mortar

PREMISES

City centre offices are more expensive than those out of town: a High Street shop will cost considerably more than one in the suburbs. If you feel that centrally located premises will be beneficial for business, the extra money is well spent; otherwise, the financial pressures of high rent, rates, service charges etc. may result in a failure to meet overheads.

A social and portrait studio will definitely benefit from a central location, and should ideally be sited in or near a well patronized shopping centre to attract the attention of the casual passer-by. Otherwise, find a shop on a main road where it will be seen by the maximum number of people. Freelances dealing principally with other traders, as in industry, advertising or publications, need a less public frontage.

Vehicle parking can present great problems in town centres and on main roads. Not only is there a difficulty over where to put your own car, but there are visitors to consider. Clients prefer to be able to be in the studio for extended periods without having to worry about parking tickets, and suppliers may be reluctant to deliver if they cannot easily do so. You should also be wary of studios up flights of stairs which may be difficult to negotiate with large, heavy items.

Determined by the type of work you intend to do and the depth of your pocket, size is a major consideration. It is obviously impractical to squeeze room sets into a 20ft by 15ft area, but if a room set will be a once-in-a-blue-moon occurrence, an unnecessarily large studio will eat up money in heating alone. If you acquire premises too small, however, you will rapidly feel constricted, so err on the larger side if possible.

Size in a studio does not simply mean floor area, but floor area related to ceiling height. For serious commercial work in a small studio, there should be an absolute minimum ceiling height of 12ft to allow you to shoot from a high angle and arrange the lighting satisfactorily. On the other hand, a larger floor area will probably mean larger sets, with higher shooting angles and lights raised higher for even illumination, so the ceiling must be correspondingly higher. This rules out modern-type offices, and knocking through two smaller rooms may not prove as useful as first thought.

Apart from the studio itself, other rooms will be required for darkrooms, an office and a storeroom as a bare minimum. Further to this, you may find you need workshop facilities, a changing room for models, a kitchen and a conference room separate from the work areas for meetings. It is common knowledge that you expand to fill the space available, but you should never underestimate the area you are likely to need, as inadequate space leads to clutter, confusion and frustration.

Where to look

A vacant photographic studio would seem to be ideal, being already converted for the purpose, but examine it carefully first to ascertain that inherent unsuitability was not the reason for the departure of its previous occupant. Occasionally there may be an opportunity to rent space in a photographers' co-operative or in an established studio where you will be entitled to use facilities, which may include equipment and materials, in return for an agreed fee, but the details of such schemes should be studied carefully beforehand. Disagreements may arise when everyone needs to be in the same place at the same time; moreover, the element of competition between photographers engaged in the same type of work can lead to accusations of client-poaching, and you must be sure of your security of tenure.

Premises particularly suitable for conversion to a photographic studio are small factory buildings, garages, ex-chapels and old schools, although you should be prepared to spend a considerable sum on a reconstruction of the interior. Some domestic houses will provide the space you need, although very old and very new buildings are usually unsuitable, with either enormous size or low ceilings and small rooms. The most suitable are the generously proportioned nineteenth-century town houses, with large reception rooms for studio areas and cellars to make ideal darkrooms. If you are converting domestic accommodation into business premises, you must check with the local authorities that you are allowed to do so, and you should examine the terms of any lease or mortgage agreements for clauses forbidding you to work from the house.

Working from home

When you start in business, saving money is an essential, and it may make good economic sense to work from home. If you need shop-front facilities, however, this may be less easy unless the shop has living accommodation above; if your house or flat is too small to cope separately with both yourself and your business, a great strain can be placed on your domestic arrangements. Using a bathroom as a temporary darkroom and turning the living room into a spare-time studio may be acceptable to the amateur and his family, but in the long term it will cause friction. It is of course an unimpressive professional approach and should not be considered.

If it is possible to work from home without compromising yourself through lack of space, you will find there are many advantages besides the obvious financial ones. There are no commuting delays so there is more time available to work, and overtime is less of a problem emotionally and as far as the family is concerned. Also, where there are children to be cared for, working from home gives an opportunity to work which might otherwise be denied. On the converse side, you may find that there is no real privacy in your home, as business visitors are inclined to call at any time, so you should make it clear to your clients that you have opening hours too, although you should be prepared to be flexible by special arrangement. It is useful to install a private telephone

line with an unlisted number given only to friends and family, while your business telephone has an answering service after working hours.

A certain strength of will to work is required when operating from home, and if you feel that you need the discipline of going out to work it is probably preferable to keep home and studio physically separate. It is wise to maintain a separation even when the two establishments are housed under one roof: do not allow business and domestic affairs to become inextricably entangled as it is essential to feel there is a retreat from the mechanical clutter of the studio in the civilized comfort of carpeted floors and soft furniture – or whatever your ideal domestic arrangement may be.

Decor

If the premises are rented, you will be averse to spending large sums of money on decoration, but you should nevertheless see that repairs are carried out and that the place does not become shabby. You should pay particular attention to external appearance if you have a shop: repaint the woodwork, replace the sign and give a few moments' thought about integration of the design of the façade as a whole, to produce a co-ordinated and aesthetically pleasing image, eye-catching and attractive to prospective customers. Carry the scheme through to the inside of the shop, where there should be a comfortable reception area for dealing with general enquiries and retailing. Behind this there will need to be a room suitable for use as a studio, of a minimum size of 15ft by 12ft, painted in neutral colours, and a darkroom. Any extra rooms can be used for storage, or converted into a conference room where bookings can be discussed over a cup of coffee.

It is equally important to maintain an image in a purely commercial studio. The reception area should be hospitable and in good decorative order, and preferably situated directly inside the door, acting as a buffer between the studio and the outside world to prevent disturbance while photography is taking place. In the office you will need the usual equipment: filing cabinets, typewriter and furniture, some of which is very expensive. However, today low-budget chic is perfectly acceptable, and relatively cheap second-hand furniture repainted in co-ordinated colours can be quite acceptable. The majority of clients will respect your investment in better photographic equipment rather than in designer furniture.

Whereas a portrait studio should be decorated in pastel but relaxing shades, so that there are no colour reflections and the sitter feels at ease, a still-life or fashion studio should have black walls and ceiling to prevent uncontrolled reflection back onto the subject. For the same reason windows should be fitted with blinds or curtains to exclude all daylight. The floor should be smooth and sound: an uneven floor will damage paper backgrounds and make castored stands difficult to move. The cheapest way to level a floor is to lay sheets of hardboard over floorboards, or a heavy-duty PVC-type covering over a solid surface.

Finally, on premises, it is well worth while installing a security system.

Equipment is valuable; most of it is portable and attractive to thieves, and there is also a duty to protect clients' property while it is on the premises. Apart from actual theft, there is a danger of vandalism, and the destruction of negative files, portfolio and other records can be both financially disastrous and emotionally distressing. Although you should have insurance policies to cover you in the event of theft or destruction, a burglar alarm and strong locks act as deterrents against break-ins. You and your insurance company will feel more secure.

As your business develops, your premises will be modified or enlarged accordingly. By now, your conception of the needs of accommodation will have matured, and you will formulate your own ideas and implement them accordingly.

THE DARKROOM

Ideally, there should be two darkrooms, one for processing and loading, and one for printing. Whereas one darkroom only may be adequate for a small studio with a single photographer and an assistant, delay and inconvenience may be caused in a larger studio when several photographers and assistants need simultaneously to use the one room to do different jobs which demand a variety of lighting conditions. The ideal situation for darkrooms is in dry cellars or basements, where light-proofing difficulties are minimized and temperatures are more even throughout the year and during the day than rooms in direct sunlight or under a roof. Extremes in ambient temperature cause havoc with processing and make standardization difficult: for example, print developer in a dish may need to be kept warm in a bath of hot water to prevent the rapid cooling and longer development time resulting from cold air and materials. Where the room is overheated, chemical reactions are speeded up, and adjustments will have to be made in exposure times and solution strengths to compensate. Very hot or cold rooms are also unpleasant to work in.

Most darkrooms are too small – afterthoughts crammed into awkward places under the stairs or squeezed into an area no bigger than a large cupboard. There may, of course, be no alternative to this, but whenever possible, darkrooms should be of a size to accommodate all the equipment installed, so that each item is ready for immediate use. It is more efficient to have enough floor and worktop space to allow the maximum number of people who will be using the room at any one time to work together in comfort. Small darkrooms, wherever they are situated, become intolerably hot very rapidly, and where employees are concerned, health and safety regulations must be implemented and current laws observed.

Lightproofing
The first requirement of a darkroom is that it should be light-tight. Windows must be blacked out with firm, well-fitted shutters made from a material such as hardboard, and if these are designed to be removed,

light leakage round the edges of the frame is prevented by fitting strips of black felt or black-painted foam plastic between it and the window. Doors must be sealed either by means of black draught excluders, or by a light trap in the form of a vestibule with a door or heavy curtain that will close securely. The light trap is an advantage when the darkroom is used by several people, as it allows them to come and go independently, provided they ensure that both darkroom doors are not opened at the same time. Without the light trap, the darkroom door needs an internal bolt, and an added precaution is an external warning light which can be switched on to indicate that the darkroom is in use. Having your unrepeatable *pièce de résistance* accidentally fogged by the door being opened is, to say the least, annoying.

A light-tight room is also often an airtight room, and the atmosphere, particularly of a small darkroom, very quickly becomes hot, and poisonous with carbon dioxide and chemical fumes. Besides being unhealthy, such conditions can lead to the operator being so keen to get back into the fresh air that quality control is relaxed and substandard work is passed because he simply cannot stand being in the room any longer.

Ventilation can be improved by installing a motorized fan designed to circulate the air. If the fan is not a light-tight version made specially for darkrooms, a simple light buffer is easy to construct from hardboard, with all internal surfaces painted black to prevent reflected light coming through. To allow a flow of air without an increase or drop in pressure in the room, holes can be made in a wall or door, preferably diametrically opposite the fan, and these vents can also be light-proofed with a buffer. Air pulled into the room from outside the building will be relatively dust-free, but in winter may be too cold, while air from within the building, although having a higher dust content, is warmer in winter. A fan with a reversible action is ideal to suit all conditions, and where the problems with dust are severe, it is wise to fit some kind of air filter, even if this simply consists of a screen made out of fine muslin.

Safelighting

All panchromatic black-and-white, and all colour materials must be handled in total darkness, as light leakage of any colour will fog the emulsion. Orthochromatic emulsions are blue- and green-sensitive and may be handled in red safelighting, while normal black-and-white print paper is used under yellow or amber safelights. However, the manufacturer's recommendations on safelighting should always be followed, as specifications do vary.

Safelights, although of the correct colour for the material being used, may cause fogging if either placed too close or fitted with a bulb of too high a wattage. A test can be made for safety by laying a sheet of paper or film on the bench where it is intended to be used, and leaving it under the safelighting for at least five minutes with a solid object such as a coin on it. Process the material in the normal way and check for an image: if one appears, the safelighting will need adjustment.

Power

Safety is essential where a combination of electricity and water is concerned. If converting an ordinary room into a darkroom, check that the existing wiring is capable of standing any extra load placed upon it, particularly where machinery is to be used. Sufficient power points should be positioned around the room and located conveniently close to equipment to reduce trailing leads and cables, which are hazardous in darkness; and all sockets and switches should be kept as far away from the water supply as possible. Cord-pull light switches are safer in darkrooms than the conventional wall-mounted variety, and for convenience should be placed within easy reach. A cord running the length of the room which can be pulled at any point to operate the light, rather like a communication cord on a train, may be useful in helping to prevent unnecessary blundering about in the dark. It is easy to become disorientated in total darkness, even in a familiar darkroom, so all equipment should be allocated a place and kept in it at all times, for safe and easy use in complete blackout. In a printing darkroom using safe-lights of two colours, all lights of the same colour should be linked, so that it is impossible to leave an incorrect colour light on accidentally, and an additional switch between yellow and red safelighting is helpful. All darkroom lighting should be connected to a main on/off switch near the door so that individual lights are not forgotten and left burning. The actual positioning of safelighting around the room depends on personal requirements, but the obvious places to illuminate are the enlarger baseboard and the developing dish, which will be used most heavily.

Water

Hot and cold running water are not essential, but as most processes require washes in running water, it is convenient to have it: carrying buckets of water is both exhausting and messy, and it is not professional. Also, automatic processors must have a supply of running water and usually this must be at a specific temperature. If the premises are centrally heated, a large hot water tank as part of the heating system may be used to feed the darkroom, but where this is not possible, two other methods may be used:

1 Install a cold water tank and heat it with an immersion heater. The temperature of the water used in the darkroom can be regulated by means of a thermostatically controlled valve to mix the heated water with the necessary quantity of cold.
2 A continuous water heater fed from the mains will produce hot water on demand.

All heating units consume a great deal of power, and should therefore not be left on when not in use. They can also be expensive to buy, especially when manufactured specially for photographic purposes, but it is possible to find non-photographic alternatives which are generally less costly. I have installed electric domestic shower heater units on both black-and-white print and colour transparency processing systems, and

after years of heavy use, I have found them to be entirely satisfactory, at less than one-third of the price of equivalent units supplied specially for photographic use. Similarly, the temperature-control unit for the colour transparency line was a general laboratory unit, rated at twice the accuracy of the photographic version, and at half the price.

Water used in processing should be clean, with filters fitted as necessary. Although distilled water is best for mixing chemicals, ordinary mains water is usually adequate, except where the water is particularly hard and contains a concentration of calcium salts, which precipitate in the developer and form calcium sludge. This causes a scum to form on negatives which has to be removed by immersing in a 2 per cent solution of acetic acid after washing, followed by a short rinse. Alternatively, a calcium sequestering agent can be added to the developer to prevent scum forming by turning the insoluble chemical into a soluble one.

Safety
As a place of work, a photographic unit must conform to regulations and legislation on safety. A darkroom can be a particularly hazardous area, not only because absence of light can lead to accidents, but also because of the nature of normal darkroom stock. Care should be taken when handling chemicals: some contain poisons, most will damage eyes. As a general rule, avoid getting chemicals on your hands. Potentially lethal materials are usually marked as such on the packaging.

You should keep an emergency telephone number you can call if there is an accident – a nearby doctor or hospital, for example. Kodak, at the time of writing, offer a 24-hour advisory service, with trained medical staff who will specify treatment for any mishap involving their products.

While you may be careful with chemicals in storage and in use, do not forget about disposal. Simply throwing them down the drain may not be enough, so be sure to sluice them down with plenty of water. If the volume of chemicals used is high, you should check with local authorities that your dumping is not breaking any pollution laws.

5 Equipment

CAMERAS

Camera formats generally used by professionals range from 35mm to 10″ × 8″, each having its place in the spectrum of work, with its special advantages and disadvantages in a given situation. A reasonable yardstick to work to is to use the largest format possible for a commission, but the definition of 'possible' is not a simple choice of, say, 5″ × 4″ or $2\frac{1}{4}$″ square. Choice can be dictated by such photographically irrelevant factors as how much the job is worth financially: 5″ × 4″ format will be more expensive because it takes more time and the material costs more, and the charges may be more than the client wishes to pay. Ease of access is another factor: it may be impossible to climb scaffolding or move in restricted spaces with a view camera and its associated paraphernalia, and you may also find that your creative ability is fettered by the increased technical aspects of sheet-film format.

Thus, with a mixed client list and a variety of jobs, you should own or have easy access to 35mm, 120 roll-film and 5″ × 4″ monorail cameras, to be able to choose correctly when the details of the job are known. If you are more specialized, as with press photography, your needs will be more limited, and you can afford to buy fewer pieces of quality gear, while the general practitioner, with the same funds at his disposal, will have to spread them more thinly over a wider range of equipment.

35mm

The 35mm-format cameras are easily the most widely known as it is the most popular amateur format, and the vast sums of money spent by the amateur on his hobby have led to numerous manufacturers producing an extremely wide range of cameras, updating their models almost annually. Consequently, the intending professional has to consider, when making a purchase decision, as the equipment will have to last for some years, whether he can be reasonably certain that the manufacturer is unlikely to change the range so radically that the equipment he owns becomes obsolete. Other criteria are: range of lenses and ancillary gear; the possibility of interlinking with other formats; availability of compatible equipment from hire firms; reliability.

Most professionals use one of the 'system' SLR cameras, so called because the camera body is central to a system of lenses and extras, all of which are interchangeable. Nikon, Olympus, Pentax and Canon are popular cameras of this type, all equally reliable, each with their faithful professional followers. Once you have made your choice of system, you can add lenses and change bodies as you choose, to build a comprehensive selection.

Basic 35mm equipment list:
Body
Lenses: standard, 28mm, 135mm, with extension tubes for close-up

Additions
Extra bodies with various focusing screens
Motor drive (not a basic autowind)

Lenses: 24mm, 35mm, macro, 80–200mm zoom, or 80mm, 105mm, 150mm, 200mm.

This list is subject to personal requirements, and should not be regarded as complete for all situations. You may have an occasional need for a fish-eye or a 1000mm lens, but remember that the infrequent picture will not justify the capital cost. In these circumstances it is preferable to hire, and here it is an advantage to own a camera in popular use. The facility would be of little use if you own a 'Kamikaze XAY' when the hiring company stocks only Nikon, Olympus etc. However, other cameras should not be dismissed out of hand. The Leica, for example, has a reputation almost second to none, and on the other hand the Olympus Trip, a fixed-lens, zone-focusing, fully automatic 35mm pocket camera, is handy to carry around to capture the odd shot which would otherwise be missed.

Roll-film cameras
Whereas the 35mm market is dominated by single-lens reflex cameras, the 120 roll-film camera range is more varied, with SLR waist- and eye-level, and various twin-lens reflex. At one time the TLRs dominated the photojournalist field with the Rolleiflex, but although these are fast to use, they have a restricted range of lenses, and significant arallax problems evident in close-up work. Consequently, recent developments have been of the SLR type, current major models being Hasselblad, Bronica, Mamiya and Pentax. Hasselblad and Bronica are both 6 × 6cm (2¼″ square), while Mamiya and Pentax are 6 × 7cm, the manufacturers deeming that this format gives a greater usable area of negative than the square. Each model has its advantages and drawbacks, and you must decide which suits you best. For instance, I prefer between-the-lens shutters, which allow a combination of daylight and flash at any shutter speed, but this increases the cost of lenses significantly.

This is one of the features available on the Hasselblad, which is an excellent camera with good reliability. Its range of lenses and ancillary equipment is extensive, and the motor-drive body is useful when working with models as the photographer suffers less distraction by not having to wind on. Unfortunately, the motor drive is not an add-on unit but integral to the body, so it would be safer to possess either a second motor drive or a manual version, in case of failure. Because of the film size, the motor drive is not as fast as those available for 35mm cameras, and the manual body may be used as quickly as the motorized, if need be. For scientific work, the motor drive can be equipped with a timer which will operate the camera at regular intervals automatically.

For roll-film photography where movements or close-up facilities are required, I attach the Hasselblad body and back to the Sinar. This also gives the advantage of view-camera lenses with smaller apertures, and a simple multiple-exposure technique of locking open the Hasselblad shutter and using the shutter of the Sinar.

View cameras

The availability of sheet-film cameras is fairly limited because of the specialized nature of the market. Essentially, these cameras are not dissimilar to those of the nineteenth century, and older models were of the baseboard type, in which the lens panel and bellows pulled out along a flat baseboard. The limitation of this type is that the characteristic swing and tilt movements of the lens panel and film plane are restricted, and may not be able to fulfil the demands required by the still-life or architectural photographer. Extreme movements are often necessary to achieve the required depth of field, corrections of perspective, or distortion for creative reasons. The monorail camera was developed to fulfil this need, and the range of movements was vastly increased.

The factors to consider when purchasing a view camera are:

1　The range of formats currently available for sheet film are 6 × 9cm, 5″ × 4″, 7″ × 5″ and 10″ × 8″. Some cameras may be adapted to take all formats by changing the back and bellows and using the appropriate lens.

2　The standards should be capable of closing sufficiently to allow you to use extreme wide-angle lenses with movements. For example, the 75mm Super Angulon on a 5″ × 4″ format will require special bellows, called bag bellows, to allow you to focus and use the swing and tilt facilities. Remember that distortion is more severe with wide-angle lenses.

3　For a long-focus lens or for extreme close-up, you will need to extend the monorail. Several sets of bellows may need to be joined together.

4　The camera should be able to accept a roll-film back, and should have adaptors for 35mm or roll film, to allow you to use the movement facilities with these formats.

Having carefully considered these points. I chose a Sinar P. This camera is a sophisticated piece of engineering, in which the angles of swing and tilt are fully calibrated, and the micrometer drive for the movements allows precise control. Depth of field is easy to calculate by means of a dial, and built-in spirit levels check horizontals and verticals. Although the Sinar P, by itself, does not take better pictures than the old view camera the studio possessed before, its refinements and precision take away the technical chores to allow more freedom of creativity for the photographer.

Shortly after purchasing the Sinar, we were commissioned to produce a major cutlery catalogue to be shot on 10″ × 8″ transparencies. This was a job which would run continuously for about six weeks, so it was

worth while to invest further capital in a 10″ × 8″ back and bellows, the cost of which was more than recovered on the job. Had this conversion facility not been available to us, it is unlikely that the commission would have been ours. Thus it is now possible to do the occasional 10″ × 8″ shot where the job cost does not justify the hiring charges that would otherwise have been necessary.

For location work, we have the less complex, less expensive and more portable Sinar F. As part of the same system, the elements may be combined or interchanged.

CAMERA LENSES

The lens is arguably the most important part of the camera, and consequently of the whole range of equipment owned by the photographer. A poor-quality lens makes it impossible to produce top-quality images. Although there is no doubt that your visual ability is of prime importance, you cannot but be limited by poor equipment.

A lens is simply a piece of glass with two curved surfaces which refract light passing through, to focus at a single point. The distance of the object in front of the lens determines the distance of the image behind the lens. Objects at varying distances will therefore focus at varying distances from the lens: that is, if you focus on one object, the nearer or further ones are blurred. This is overcome by varying the aperture. A fully open lens will have a shallow depth of field, while by stopping down, depth of field is extended to bring more of the subject into focus. (See 'shutter/aperture', p. 40.)

The greater the image size relative to the object, the less depth of field you have. Thus, the closer you are, the longer the lens and the larger the film format, the greater are your focusing problems. On small-format, 'rigid' cameras, only a smaller aperture will give you greater depth of field, but a monorail with swing and tilt on the lens panel will give greater flexibility when the subject is essentially on one plane.

Another characteristic of the simple glass lens is that it will refract differently the various colours of the spectrum. This is overcome by using multiple elements made up of different types of glass, to bring all the colours of the visible spectrum to a single focal point. Better-quality miniature cameras are marked with a separate focusing point for use with infra-red film, as the refraction effect of a normal lens is significantly different for this end of the spectrum.

All modern lenses are coated to reduce flare, which would otherwise appear as a glow around bright points and, in an extreme, would lower the whole contrast of the negative. Other problems are 'barrel' and 'pincushion' distortion, and astigmatism, but it is assumed that a professional will be using lenses of sufficient quality to be effectively free of these problems.

At one time, when the fashion was for soft-focus portraits, particularly of women, as with early cinema close-ups of female stars, special lenses were used which varied the degree of softening by moving the lens

elements relative to each other. However, it is now more usual to achieve these effects with filters, and it is preferable to aim for the best quality and to add 'defects' artificially afterwards.

Lenses are manufactured to relate to a specific format, which is represented by the focal length of the 'standard' lens. This standard is the diagonal of the film area, thus the standard lens for 35mm format is about 50mm focal length, and so on. The design of the lens is computed to avoid leaving an excessive amount of picture area beyond the limits of the format in the case of miniature and roll-film cameras, although the lenses of view cameras have a greater covering power to cope with the swing and shift movements. It is possible, and fairly common, to use lenses designed for a larger format than the one actually being used, but the reverse would result in cut-off at the corners of the film.

The range of 35mm lenses is extensive, from very long focus to fish-eye. All extreme lenses tend to be costly, and more restricted in their range of apertures, and you should consider their cost-effectiveness before any purchase. Zoom lenses are also expensive, but very useful: within the limits of 80–200mm, say, you have an infinite variation of focal lengths, so the cost of the one lens may be less than that of the several you would need to cover the same range. These lenses are complex mechanisms in which the elements move relatively to each other for the continuous variation, and are prone to poor definition, so you should not be tempted to make do with a cheap alternative even if it is compatible with your chosen system. The 40–80mm zoom is ideal for portraits, while the 80–200mm is useful for sporting events. Another feature is the possibility of achieving dramatic effects with the zoom during a time exposure.

As an alternative to the standard lens, the macro lens, which is available for many types of camera, has the advantage of focusing down to 2:1 without extension tubes, and 1:1 with one extension.

Medium-format SLR cameras also have a wide range of lenses available although, being larger, they tend to be considerably more expensive than those for the smaller format. Because of the price, you may at first be restricted to the standard 80mm, but you should try to add at least one wide-angle and one telephoto when funds permit, for greater flexibility.

More expensive still are the lenses for the view cameras. The standard for the 5″ × 4″ is 150 or 180mm, and for the 10″ × 8″, the 300 or 360mm. The usual wide-angle lens for the 5″ × 4″ is 90mm, originally available as an 'Angulon' suitable for baseboard cameras because of its restricted field, but now the 'Super Angulon' allows greater off-axis movement, essential for extreme movements. Wider-angle lenses are usually set in a recessed mount so as to be sufficiently close to the film plane. All wide-angle lenses need to be used with bag bellows as the concertina type standard bellows do not allow for the compression required.

SHUTTER/APERTURE

The shutter/aperture combination controls the quantity of light reaching the film. Given an emulsion of the same speed, a bright subject will

1 *Egrets*, by W. Marynowicz. A gift from the photographer to the author, this colour posterization is an excellent example of the technique in which Marynowicz specialized

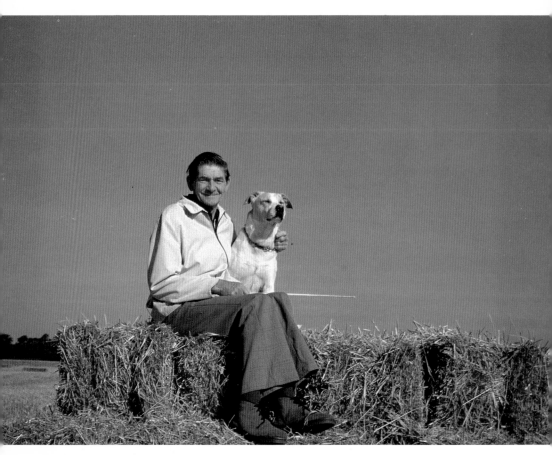

II Olympus Trip, Ektachrome 64. The dramatic low angle outlines the man and dog against the sky. Photo by Michael Constantine

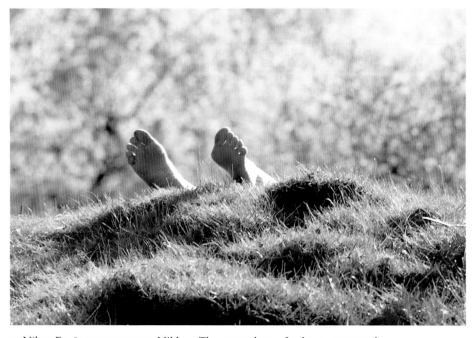

III Nikon F2, 80–200mm zoom Nikkor. The atmosphere of a sleepy summer day

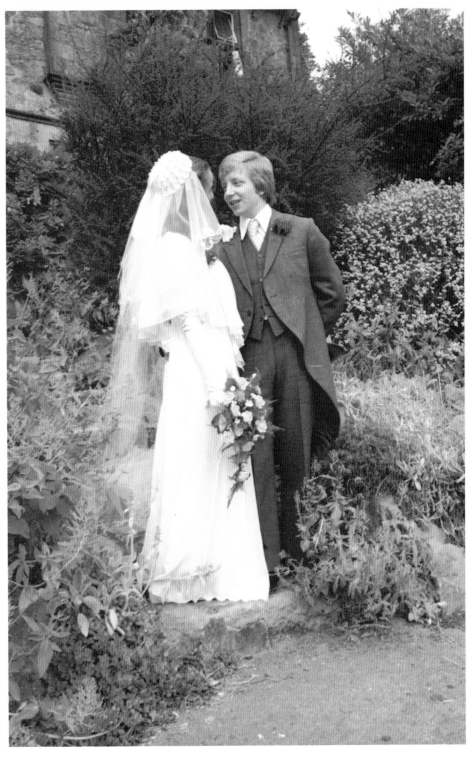

IV Nikkormat, 50mm Nikkor, Kodacolor II. A romantic, informal shot of the bride and groom

v Hasselblad, 100mm Planar, Ektachrome 200. Two Softars for soft focus. Three Broncolor lights: *1* Hazylight $\frac{3}{4}$ front left, *2* Standard head with diffuser $\frac{3}{4}$ front right, *3* Standard head with snoot for hair

VII *(Opposite)* Hasselblad, Ektachrome 200. Broncolor Hazylight with honeycomb screen fitted at top. Single flash head with barn doors below camera. Background flames on front projection screen. The expressions and poses on this publicity shot of the rock band Saracen were critically important. Their manager required them to 'look tough' but not like 'thugs on a street corner'. Obviously, smiles were out of the question for this image. Positioning the hands was particularly difficult and needed careful attention

VI Front projection. Hasselblad, and Broncolor front projection system. The slide for the background was made by photographing several strips of coloured celluloid through a split-prism filter. Normally, when using front projection, the black shadow line outlining the subject is removed. In this case it was retained to emphasize the figure

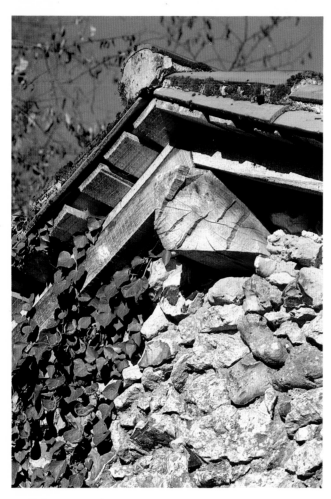

VIII Nikon F2, 80–200mm zoom Nikkor. A rustic barn, with strong directional evening light showing up textural qualities, and good colour saturation

IX Nikon FM, Micro Nikkor, Ektachrome 200. $\frac{1}{4}$ second, hand-held but resting on companion's shoulder. The flames form an interesting composition with the neon light bulb

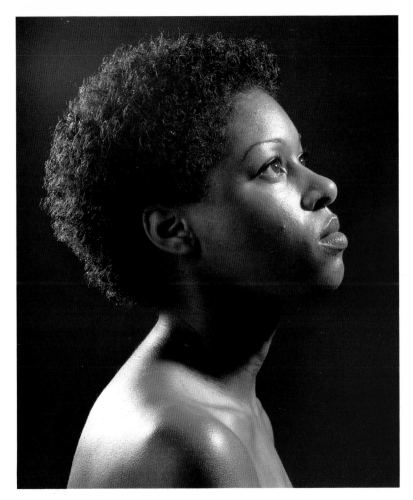

x Hasselblad, 150mm Sonnar, Ektachrome 64. Three Broncolor lights: *1* Hazylight front, *2* Standard head with barn doors, top right, *3* Standard head with diffuser, back left. Baby oil was used on the skin

xi Sinar P 5″× 4″, Ektachrome 64. Broncolor Hazylight overhead with front card reflector. This long shot, to fit page layout, was livened up by persuading the studio cat to eat a dish of mince on the set. A less phlegmatic animal, unused to the environment, might have been less co-operative

XII Sinar P 5″×4″, Ektachrome. A device to hold screws to a screwdriver: an inexpensive product, insignificant in isolation, needed dramatic treatment. The screwdriver bar was sprayed black and a brass screw was used to emphasize the steel of the main subject, which was shown in use also, to explain how it works

require a smaller aperture or a faster shutter speed than a dull one. If you need a greater depth of field, you will use a small aperture, which may necessitate a slow shutter speed; if, on the other hand, you want a shallow depth of field – for differential focus, say – you must use a fast shutter speed for a correct exposure. The combinations, technically and creatively, are endless.

Shutters are generally of three types: focal-plane, between-lens and behind-lens. Modern SLR 35mm cameras have focal-plane shutters, consisting of blinds immediately in front of the film plane. The lens is open for viewing, and the image is reflected onto the viewing screen by a mirror. When the shutter release is pressed, the lens automatically stops down to the preset aperture, the mirror springs out of the way, and the shutter moves either horizontally or vertically across the film. A focal-plane shutter may cause distortion in occasional circumstances involving moving subjects, and flash synchronization is restricted to the slower speeds. This latter can cause serious problems when using a combination of daylight and flash, where the ambient lighting calls for a fast shutter speed.

A between-lens shutter is situated as its name suggests, and consists of a set of leaves which open and close to make the exposure. This allows flash synchronization at any of the shutter speeds, but the speeds are generally restricted by mechanical limitations. The fastest speed of the Hasselblad is 1/500th of a second, and as the physical size of the lens increases, so the possible shutter speeds decrease.

A between-lens shutter on a single-lens reflex camera needs other modifications to avoid the fogging of the film which, obviously, would otherwise result. Hasselblad employ a secondary shutter immediately in front of the film plane, which remains closed except during exposure. The exposure is made by the following sequence of operations:

1. Lens shutter closes
2. Diaphragm stops down to preset aperture
3. Mirror lifts
4. Back shutter opens
5. Lens shutter makes exposure
6. Back shutter closes when shutter button is released
7. Mirror is brought down and lens shutter and diaphragm are re-opened when the film is wound on.

Hasselblad have introduced a camera with a focal-plane shutter, but the only advantage to be seen is that lenses are available for it of a larger maximum aperture than for the 500cm/ELM.

The behind-lens shutter is principally championed by Sinar, who manufacture this type as part of their highly sophisticated and extensive large-format camera systems, as it gives standardization of shutter speeds when used with any lens. It should be understood, however, that shutters, like any mechanical device, can deteriorate with age, thus leading to a significant difference between the nominal and actual speed. Consequently a change in lenses during a job could lead to a change in

exposure through a different shutter speed. Although this may be noticeable with long exposures, there is little difference to be heard between 1/125th and 1/90th, but the result would show a 50 per cent variation.

TRIPODS AND STANDS

35mm and roll-film cameras are frequently hand-held if the light level is sufficient, and if it is not, only a light tripod is necessary. Alternatively, you can use a monopod, which is simply a single column with a camera platform at the top. For a view camera, however, you will need a more stable structure, capable of supporting the heaviest camera you possess, without vibration, during prolonged exposures.

For studio work, a single-column camera stand is an ideal solution, being extremely steady, and without the inconvenience of tripod legs. A stand comprises a heavy base on castors, simpler versions having a geared extending column, while other models are fitted with a crossbar on which the camera is mounted. The crossbar type have floor-to-ceiling movement with more stability, together with greater flexibility and range of camera positioning. All castors should have a locking mechanism to prevent movement of the stand before or during exposure.

The stand or tripod should be fitted with a ball and socket or a pan-tilt head to allow for universal movement, strong enough to cope with the stresses placed upon it by the weight of the camera. In use, all locking devices should be tightened firmly.

Finally, a clamp to fix the camera to a convenient rail or similar fixture is useful when you are on location and it is impossible to use a tripod – on scaffolding, for instance, or an overhead crane track, or simply when space does not permit.

LIGHTING

Continuous lighting

Otherwise known as tungsten lighting, this is simply a filament bulb fitted into a reflector and supplied with electricity, usually from the mains. Many established photographers use tungsten lighting, as do the film and television industries, but its lack of flexibility and other disadvantages in comparison with flash lighting have led to a tendency away from it for studio work. The 5000 watts or so that you will need to achieve a reasonable level of light for your film will generate heat and this can be uncomfortable for models, while sensitive still-life subjects, such as ice cream, will quickly disintegrate.

Tungsten or quartz halogen lamps manufactured for photographic use have a colour temperature of about $3200°K$, while daylight and electronic flash have a temperature of about $5500°K$. As colour films are balanced for a specific temperature, tungsten and daylight materials cannot be interchanged without showing colour casts unless filters are used for correction. Thus you cannot mix the two types of light, and tungsten lighting may not be used to fill in when daylight is the main source.

Tungsten lamps do not give an illumination which is absolutely constant. Variations in voltage, the age of the lamp and how long the lamp has been burning will have an effect on the brightness and therefore the colour temperature, and this may be noticeable with a critical subject. However, for industrial work, a set of efficient and portable quartz halogen lamps are useful and generally easier to control than the equivalent in electronic flash.

Flash lighting – expendable bulbs
The advantages of flash lighting have been known almost since photographic emulsion was first exposed. To avoid the long exposure needed to record the subject on film a short, bright light was found to be ideal, and we have the nineteenth-century cameo of the portrait photographer holding aloft a tray filled with magnesium powder, crying 'Watch the birdie' as it is ignited by a spark from a flint wheel. This method was obviously a little hazardous and totally impossible to synchronize with the camera shutter.

The next development was the flash bulb filled with magnesium wire, ignited by an electric current activated by the camera shutter. Small flash bulbs and cubes for the amateur market fire instantaneously, but the larger, high-output versions for the professional are slightly more complex. When the flash bulb is fired, its peak light is not emitted immediately, but rather builds up, then falls away. Thus we have two positions for flash synchronization on shutters. At X synch., shutter and flash are activated simultaneously. At M synch., the flash is activated fractionally ahead of the shutter, to allow it time to build up. If you use electronic flash, which should have the instantaneous X synch., at M, your film is likely to be severely underexposed, as the flash will have come and gone long before the shutter opens.

For lighting large areas, an array of flash bulbs is useful. A set of holders and control equipment is relatively cheap, portable, and can be used anywhere as no mains supply is necessary. However, lack of modelling light facilities (see p. 53) makes assessment of the illumination difficult, and the cost of the bulbs is high.

Flash lighting – electronic
Electronic flash consists of a discharge tube which emits a bright flash of light for a fraction of a second when a high voltage is applied. This voltage is stored in electronic capacitors. When the flash is fired, a small extra voltage is applied to the tube, which arcs, and releases the stored power instantaneously. The more powerful the flash, the greater the physical size of the capacitors.

The small units designed for the amateur market are very feeble compared to the heavy-duty alternatives in the professional's studio. Given the use of 100 ASA film throughout, a typical miniature flash will give you an aperture of $f11$, a professional battery flash will give $f32$, and a 1500-joule studio unit will give $f64$ with a standard reflector, all at a distance of two metres. With large-format photography, where you will

need a high output of light to enable you to stop down your lens sufficiently for the required depth of field, you will need a powerful flash.

As power output tends to be directly related to cost, beware of cheap units. Claims made may be somewhat optimistic, and one suspects that the stated apertures were achieved by photographing in a small room with white walls.

The surroundings in which you are using the flash do have a significant influence on the aperture you require at any given distance. Remember that light walls and ceiling will reflect, while dark colours will absorb, and you must alter the aperture to compensate.

Choice of studio flash equipment
A wide range is available at various prices and degrees of sophistication, and you should make your choice bearing several factors in mind.

Power output If you plan to light large sets in a large studio, you will need more powerful equipment than if you confine yourself to small groups in a small room. Tend to err on the side of having more power than you need, so that you are not always working to the limits of your equipment, but it is a waste of money to buy too powerful a unit, which may give you problems in *reducing* the light to a usable level.

Extent of usage Our first flash equipment, excellent as it was, was simply not designed for the heavy usage to which it became subjected. The power packs protested at being on all day, every day, by smouldering at regular intervals, requiring frequent repair and consequent disruption in scheduling.

Reliability Flash equipment is a complex electronic package, and it would be unrealistic to suppose that even the more expensive types will never go wrong. Make sure that your dealer can provide an efficient after-sales service, and, in the event of equipment failure, will effect repairs on the spot or provide you with a replacement to allow you to continue working. It is, on the whole, preferable to buy from a reputable dealer, even if buying second-hand from a private individual may save a few pounds in capital outlay.

Flash heads
You will need at least two or three general-purpose flash heads, which are used with a variety of different reflectors and 'umbrellas' for controlling lighting effects. Direct lighting with a standard flash head will give a hard, even harsh, quality of light, casting strong shadows. The light may be pooled by using a conical reflector called a 'snoot', or a 'barn door' attachment consisting of hinging flaps which are moved to shade the light. For a softer effect, bounce the light back from a reflector or an umbrella. Umbrellas are made in various materials and colours for different effects: for instance, a white cloth version will provide a softer illumination than one with a silver reflective surface; a gold umbrella will serve to 'warm' the light, and so on.

For a diffused effect, you can shine the light through cloth or tracing paper, but more easy to manage is the large flash head colloquially known as a 'fish frier'. At 2m × 1m, or 1m square, it consists of one or more flash tubes behind a diffusing screen set in a large reflector. Broncolor make a version called the 'Hazylight', which we use extensively in the studio. Although it is essentially designed to give a soft, shadowless illumination, its uses are not confined merely to this. A simple removal of the diffusing screen will provide a slightly harder light, but not unacceptably harsh, and it can be angled from any direction at a touch. If you are intending to work in the studio at all, this versatile piece of equipment is to be highly recommended.

Other specialized heads are strip lights for even illumination on a full-length figure, and spot lights capable of focusing the pool of light to a more precise degree than that which would be achieved by snoots or barn doors, with which a certain amount of light spillage is inevitable. A focusing spot projector can be used to add colours, images or patterns into your subject.

Modelling lights

All studio flash equipment is fitted with modelling lights close to the flash tubes, low-powered bulbs kept on continuously to allow you to assess your lighting. These should be proportional to the power emitted by the flash tubes, so that you can see the effect of any change in lighting balance. Modelling lights are not normally used for taking pictures with, but this is possible if you use tungsten-balanced film, although the lighting is rather low.

Ultra-Violet

Flash tubes emit quantities of ultra-violet light, which will register as a blue cast on colour film. More sophisticated equipment has flash tubes coated to filter out the UV, but if the tubes are not corrected, you must use filtration to avoid colour distortion.

EXPOSURE METERS

Many small-format cameras are now fully automatic. The Olympus Trip, for example, adjusts its exposure according to the light level, and will not operate when this is too low. Such cameras are manufactured to react to the average illumination, and where the subject is abnormally lit or when you are aiming for a special effect, they are inadequate.

Most other 35mm cameras have through-the-lens metering, introduced by Pentax, where exposure is indicated by means of a digital read-out or a movable needle. This allows you to combine aperture and shutter speeds for the correct exposure, and you can under- or overexpose as you choose. Through-the-lens metering means that you do not have to make compensations for extension tubes, telephoto lenses or bellows, and allows you to work quickly in changing light.

Light meters not integral with the camera are of two basic types,

selenium cell and cadmium sulphide (CdS). The former generates a small quantity of electricity to activate the meter, while the latter is operated by a battery which passes electricity through the CdS cell, the amount of light varying its resistance and moving the meter accordingly. Both are equally accurate at normal light levels, but the CdS has the advantage of operating at lower light levels, although the battery must not be allowed to go flat.

Light meters designed for continuous light and flash meters are not normally interchangeable, as flash meters require special electronics in order to register the flash.

Two methods are used for exposure reading.

1 Reflected light. The meter is pointed towards the subject from the camera position. As the level of light reflected will vary from shadow to highlight, an average is taken, or compensations are made to retain detail in any given area.
2 Incident light. The meter is used close to the subject and pointed at the camera, the photoelectric cell being covered with a special translucent material to give an average reading.

Whichever method is used, it is important to remember to use your own judgment to assess exposure, not to rely blindly on the readings you are given, for peculiarities of light are likely to give false results.

Flash meters
Most modern portable flash units have a photoelectric cell and a computer which measures the light reflected from the subject during the flash, automatically altering its duration to give a correct exposure. If the flash gun does not have this facility, you must alter your aperture according to subject distance, with compensations for surroundings, using the tables supplied with the unit.

In the studio, flash meters are used to read incident light. The flash is fired, and the correct aperture is given on the meter. For multiple flash, it is useful to have a cumulative flash meter, which automatically gives a reading for the number of flashes given. However, here is a rough guide for multiple flash. If we assume that one flash will give an aperture of $f11$, two flashes will give $f16$, four flashes will give $f22$, etc. In practice, this system is not entirely accurate, and for an aperture of $f96$, say, when a great number of flashes are required, your estimations may be wildly out.

The Sinarsix
The most accurate method of exposure assessment is to measure the light value at the film plane, using a probe in a special cassette, manu-factured by Sinar and called a Sinarsix. The light cell on the end of the probe is positioned by the operator in order to measure the light from the subject at the point it reaches the film plane. The probe is connected to a Gossen Profisix meter able to read in continuous or flash lighting. This is an advantage when you are balancing daylight and flash.

6 The image

There is no universal and permanent definition of an aesthetic right and wrong in a photograph. Reactions to photographs are, and should be, subjective. However, a subjective approach is not the criterion for judging a shot which has been taken for professional purposes; it is successful when it fulfils the purpose for which it was taken. A commissioned shot may only be considered absolutely 'wrong' if it is technically inadequate or if the brief given by the client has not been followed.

Although it is impossible to state categorically that a photograph is 'wrong', there remains throughout an indefinable quality of what is acceptable and what is not, within any given culture at any particular time. The factors determining this sense of 'rightness' are infinite and extremely subtle, relying on how the human eye relates to the arrangement of shades and forms it sees before it. Within this very broad sense of acceptability are the reactions and the personal preferences of the individual: the photographer has a choice of decisions which may be considered aesthetic within the confines of his specification.

THE SUBJECT

Nevertheless, amateur photographic societies tend to have occasional criticisms of the work of the members, given by experts who appear to have positive and immutable 'rules' on what is good and bad in a photograph. Invariably, these tend to be conventional derivations from misunderstood principles of pictorial composition. As they belong to the rather enclosed world of 'amateur experts', they do not fall within the purview of this book.

Most people, when viewing a photograph, will react first to the subject material, the strongest reactions being towards images of other people. The initial response will generally depend on how the viewer relates to the *subject*, or how he feels about that particular human being, rather than how he sees the picture as a whole and its quality as a photographic image. Emotions are particularly strong when one is viewing an image of oneself, and it will be noticed how many people profess to be disenchanted with the result, expressing a dislike of having their picture taken at all. Portraits in general are normally more interesting if the subject is known to us, either personally or by reputation, and the familiar sense of boredom we experience when being shown other people's holiday snaps featuring relatives we are unlikely to meet is to a large extent due to the fact that such snaps have no other purpose than simply to be a record of who was there at a given time and what they

happened to be doing. It is difficult for us to react to these strangers and their activities unless there is any reason for us to do so.

The subject in reportage
Reportage may equally well be described as a record of who was doing what and where they were doing it, but the difference is that the activities are newsworthy. The old adage 'one picture is worth a thousand words' is, of course, true in the context of reportage, and the comment made in the early days of photography that 'from this day painting is dead' might quite justifiably be transposed to 'from this day words are dead'. An account of a newsworthy event will be made more vivid for the reader if accompanied by a picture, and human curiosity makes us wish to put a face to a name. It is in this field that allowances may be made for inadequacies in technical quality – if, for instance, the pictures are taken in extreme circumstances – for it is the subject which is all-important. The average viewer will not be concerned with a slight degree of 'out of focus' in shots taken at night, perhaps, in the thick of a riot, nor will he be worried by a lack of harmony in composition if he is able to see with a reasonable degree of clarity what is going on within the frame of the picture. Indeed, provided it is not carelessly overdone, news film taken on a camera being joggled on the shoulder of a running cameraman, and an

10 Two intrepid gas men, stopping for a moment in the freezing snow to pose for the camera. Nikon F2, Micro Nikkor, Plus X Pan. Taken at night using Braun F901 flash

abrupt ending to the film because the camera has been jumped on by an unco-operative rioter, almost always adds a sense of immediacy.

The subject, animate and inanimate

Where an image contains both human and other elements of equal visual importance, the tendency is for the human, however apparently insignificant, to take priority in the eye of the beholder. We may look at a photograph of a large room, full of interesting items, yet we will be drawn to the tiny child playing in the corner, or, failing the presence of a person, the dog on the hearthrug will attract our attention. Thus the introduction of a human or an animal provides an undoubted focal point to the picture, which in some cases serves a practical purpose in that it will give an ambiguous subject a sense of scale.

This reaction on the part of the viewer has been recognized and used heavily in advertising and promotions: photographs of mechanical objects in isolation can be devastatingly uninteresting and are not therefore likely to draw much in the way of attention. Items made to be used become more relevant in some situations when shown actually in use, and those with unphotographable characteristics such as 'sound' from a basic transistor radio or a quality 'hi-fi' may require a visual equivalent, a person whom the viewer may identify with or be attracted to. There is, after all, no practical reasons why scantily-clad young ladies should be draped on the bonnets of new cars at motor shows, but it is a device which apparently appeals to the gentlemen of the press. It has, however, less appeal for the female sector of the market, whose purchasing power has increased with growing financial independence and an awareness of equality in general. As the purpose of an advertising shot is to make the subject attractive to an audience, it is unwise to antagonize a large section of that audience by approaching it in a way which may be considered sexist.

The aim is to inspire the response 'That looks nice, I think I'll have one of those', whether it be a car or a bar of soap, so the subject should always be shown to the best advantage. If to that end it is necessary to include a human being, remember that it will be the human being rather than the product which the viewer relates to first, so a careful consideration should be given to his or her suitability under the circumstances. If the photograph as a whole fails to complement the main subject, with the inclusion of other material, animate or inanimate, as props, or with the use of 'clever' lighting, surrealistic arrangement etc., it is a wasted shot. The average viewer is not necessarily a photographer himself, nor even visually aware, and need not be able to define what effects were actually used: he simply knows whether he likes it or not, and therefore whether or not he likes the product.

The ambiguous subject

In the same way that we expect an apple to fall down rather than up, the sun to rise in the east and set in the west, we are governed by physical laws which we use to establish our relationship with our environment.

11 Sinar P 5″× 4″, Plus X Pan. Broncolor Hazylight on the right with a white card reflector on the left

We are also guided by an infinite number of lesser expectations based on experience: for instance, we know how heavy this book is likely to be before we pick it up because we have felt the weight of similar books before. We know the size of a loaf of bread, a bottle of wine or a glass because we have seen them before. Thus, at first glance, this photograph appears strange. We feel uneasy as we become aware that we have been tricked by an arrangement of curiously under-and over-sized objects to disorientate us.

Taking any subject from its familiar context, which is a fundamental premise in surrealism, often has this startling 'shock' effect. The object, whether it be a car or a bar of soap, floating like an asteroid against a background of stars, could have more impact than if the setting were more common, on a road or by the kitchen sink. The professional photographer is of course confined within the limits of his brief, but it is worth while to try a few 'odd' shots for inclusion in a portfolio of work which is intended to provoke interest and give the photographer an opportunity to demonstrate skills both imaginative and technical which he may rarely be asked to do during the normal course of business.

It is not always essential to show the subject in its entirety for it to be clearly recognizable. This silhouette, for instance, is quite self-explanatory without further information, as we are able to identify the total shape.

12, 13 Two silhouettes. Hasselblad, 80mm, Plus X Pan. Two Bowens Quad standard heads were diffused behind a large sheet of Perspex

If, however, we isolate a small section from the image, we are left with an ambiguous abstract in which the subject is subordinate to pattern. Many common objects seen from an unusual angle or in extreme close-up will not be immediately identifiable as the subject itself is suppressed by its component parts of shape, texture or colour. In other words, we are given insufficient visual information.

A normal reaction from the average person to abstract art is 'I don't understand it'. He feels he understands representational art simply because he can see what it is, but probably he has no more understanding

of the motives behind it or the symbolism it may contain than he has of an 'unrecognizable' abstract. The photographer must decide how many clues, if any, he should provide to the identity of the subject, bearing in mind the circumstances in which the shot is required.

Finally, remember that the subject is of primary importance in all professional photography. Photography is essentially representational: although the subject may be altered by various means, almost out of all recognition, there has of necessity to be something in front of the lens to use as a starting point. Treat the subject imaginatively, but be sensitive, remembering that clients, whether they be a bride and groom or a managing director, may not share your artistic views.

STARTING POINTS

Cartier-Bresson maintains that composing a photograph must begin and end in camera, without recourse to cropping away unwanted areas in the darkroom. In some instances this is obviously true: working with small-format transparencies for projection purposes does not allow you to crop the picture without severely reducing the size of the image on the screen. However, on other occasions it will be necessary to bear in mind that the picture may be cropped, particularly when the lens you are using is not exactly right for the job, and for technical or practical reasons you cannot have the camera too close to the subject. In professional photography it is common for the photograph to be required to

14 Nikon F2, 80–200mm zoom Nikkor, Plus X Pan; 5″× 4″ copy taken from 35mm Ektachrome 64. Cropping at the bottom of the frame exaggerated the sky and emphasized the loneliness of the human figure

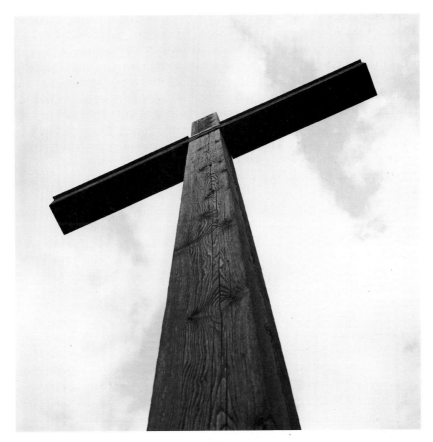

15 Hasselblad, 60mm Planar, FP4. The extreme low angle emphasizes the dramatic lines of this cross, a memorial at Bergen Belsen. The composition can be altered significantly by cropping in various ways. Cut two L-shaped pieces of black paper and move them around over the photograph to see the effect

fit fairly precise proportions. Frames and albums tend to be made in stock sizes, and where the picture is intended to fit the format of a page or within a specific area of a layout, the photographer must comply with these restrictions or the photograph will be useless. Having ascertained the proportions of the photograph to be taken, it is helpful to scale them down to fit the camera viewfinder and make a mask, using black paper or tape, or marking with a chinagraph pencil. This clarification will help you frame the image in camera, and guard against the possibility of misjudging proportions so that some essential part of the composition falls off the edge of the eventual frame.

The Golden Section
Also called the Golden Mean, this is the division of a line or rectangle reckoned by artists and philosophers to be ideal, and is a fragment of a complex belief in the mathematical basis of a harmony in the universe.★

★Rudolf Wittkower, *Architectural Principles in the Age of Humanism*, Vol. 19, Studies of the Warburg Institute, 1949, will give an interesting analysis of the spiritual and mathematical relationships in Italian art of the fifteenth and sixteenth centuries.

To us, however, there is no logical reason why this particular division or any other should have special mystic powers, let alone be given the grandiose status of being somehow in tune with the cosmos. Although theories about the music of the spheres and other fantastic notions have, in general, passed, the fact remains that the Golden Section proportions, not of course observed with absolute mathematical rigidity, are in some way usually more pleasing to the eye. An image of roughly $10'' \times 8''$ proportions is generally easier to view than one of, say, $10'' \times 3''$, where the eye has difficulty in assimilating the information of the image without being confused by what is happening around it outside the edge of the frame. Panoramic views may be interesting, but not particularly popular, except in school photographs, where there is more interest in examining the subject than in looking for aesthetic appeal, and in prints and drawings of landscapes and cities, which intend to be informative.

For effect, and where there are no practical restrictions in format, you need not regard the Golden Section as though it were a golden calf; there is nothing to stop you using whatever proportions you choose: long and narrow, or square; or try printing your image in the darkroom into round or hexagonal shapes, or split it into a series of images, perhaps in a line or a mosaic pattern so that the total picture progresses in stages.

Filling the frame
When we view a photograph, we are confined by its borders; we concentrate on the area within the frame, and our reactions to the subject depend to a great extent on the relationship that subject has to its confines.

In very simple terms, a subject filling the frame appears more powerful than one which does not. The actual dimensions of the print are less important: although the subject itself may be larger on a 10″ × 8″ than on a 6″ × 4″, if it does not fill the frame it may not have the same emphasis, and the viewer will not have the feeling of almost being surrounded by it. Often, poor cropping spoils an otherwise excellent image, as there is sometimes a reluctance to commit oneself to enlarging the image fully in the frame, leaving a margin of dead space around which tends to detract from the sense of immediacy. Obviously in some circumstances 'breathing space' must be allowed, for 'bleed' for reproduction purposes, or if the print is to be framed, but if there is no practical reason for a margin, and if you think your print would benefit, don't be afraid to fill your frame to capacity.

Framing the subject
In camera, one element of a composition may provide a convenient and ready-made frame: a tree with overhanging branches, an arch or a window are all devices giving a natural border to an image and defining an area of interest. Without a frame, you must take care that the composition does not falter at the edges or come to an arbitrary halt at the edge of the picture. Using differential focus may helf bring out a main subject more strongly, or spot filters may be used (see p. 101).

In the darkroom, by cropping an image carefully, you can exclude elements at the edges of the picture which do little or nothing to help the composition as a whole. When presenting transparencies, it is often

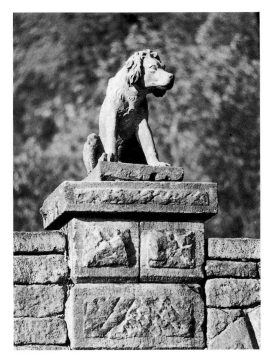

16–18 Three photographs of a stone dog on the gate post of an arch. All were taken on a Hasselblad with 150mm Sonnar lens. From an extreme low angle, the dog is outlined against the sky. At a less extreme angle, with the lens stopped down to *f*22, the dog tends to merge into the background of trees. At the same angle, but with the lens opened up to *f*5.6, differential focus allows the dog to stand out from the background

19 A straight print from a 35mm black-and-white negative

20 A print with a texture screen sandwiched with the negative in the enlarger

sensible to mask them with black paper to hide extraneous items outside the agreed picture area, so that the client will have a better idea of the result he will see finally on the printed page.

Vignetting

To make a black vignette surround for a print, cut the shape required for your image area out of black card, and fix it to a thin but rigid wire. Expose the print as usual, then expose without the negative, giving sufficient exposure to ensure a solid black, meanwhile holding the vignette mask over the area of the print you wish to keep from fogging. Make sure that it is far enough away from the paper so that the edges of the mask do not appear sharp, and move it slightly and continuously so that the wire will not show.

Making a white vignette is essentially a reverse of the above, with one exposure being made through a cut-out in black card.

21 A black vignette. A normal print was made, then the negative was removed from the enlarger and the paper fogged with white light to make the black surround while the central oval was shaded with a dodger held by wire

22 A print made by the same method as Fig. 21, with the texture screen

When vignetting, be careful that the edges of the mask are even, and that they appear neither too sharp nor too ragged on the print. If you find the correct balance difficult to achieve, ready-made vignette screens are available, or you could even try making your own. Using a screen has the advantage of giving a consistent result when several matching examples are required.

Mounting and framing

A wide range of mounts and frames is available in sizes suitable for standard paper formats, and if members of the general public buy your prints with a view to displaying them in frames in their homes, it is wise to stock as wide a choice as possible to enable the purchaser to select a style and colour to suit his or her taste and decor. If you cut your own mounts, make sure that all cuts are made cleanly, using a sharp knife and a metal straight edge, preferably bevelling the cut for a neater finish. The

print being mounted should be firmly fixed to a backing to prevent distortion: dry mounting will hold the print flat, although this method is permanent. Great care should be taken when dry mounting photographic prints done on resin-coated paper, as too hot a press will melt the surface, destroying the print and leaving a burnt-on deposit, difficult to clean, on the press itself. When using glass or Perspex in the frame, this must be held closely to the backing in order to keep the print and mount flat, and all materials must be as dry as possible to help prevent mildew.

Making frames is a skilled job, and it may be worth while sub-contracting to a professional picture framer or mount-cutter to do the job for you. Most photographers supplying pictures in frames find it more convenient to do this rather than stock a workshop with all the craftsman's tools required to fit together lengths of wood and pieces of glass. If you do decide to provide a framing service, make sure you can rely on your subcontractor, and keep up to date with the types of frame he can supply, so that you are always able to show the correct stock.

7 Colour photography

Colour is now the normal medium for the amateur market. It is no longer an expensive alternative to black-and-white, and is often more readily available and even quicker to have processed and printed. In this colour explosion black-and-white is often regarded as a poor relation: 'It's only black-and-white' is the apologetic phrase frequently heard by the professional photographer from his client, often accompanied by the belief that a high-quality black-and-white shot is inferior to a colour version because it is likely to be easier and cheaper to produce. In some respects the client may be correct: black-and-white materials are generally less expensive to buy and the photographer is likely to be able to process and print in-house, but the time taken to set up a black-and-white photograph is identical to the time taken to produce a colour alternative up to the moment the film is exposed in camera.

In some cases, it may be more difficult to make a satisfactory rendition of a subject in black-and-white than in colour. However we may train our eyes, the fact remains that we see in colour rather than in shades of grey. The actual world is three-dimensional, with constantly changing light and full of movement, sounds and smells, and we must use our judgment to decide exactly how our sense of reality will be satisfied when translated through the camera lens into two-dimensional, static monochrome. Obviously, a colour print is also far removed from reality, but the viewer is provided with more visual clues on which to base his impressions.

CHOICE OF MATERIAL

Although it is true to say that colour film reproduces the tones exposed to it more or less accurately, different types of film will show different characteristics, varying according to the film speed, and from one manufacturer to another. Although a picture may appear quite accurate in isolation, a comparison with the original subject or with the result gained from using another brand of film will often show some extraordinary differences.

The professional photographer, for reasons of convenience of supply, is likely to use mainly one brand of materials. This also helps to provide continuity in the standard of results achieved and allows the photographer to become familiar with his materials, so that he is able to make a reasonably educated guess at exposure, for example, should the conditions be particularly adverse or in the event of equipment failure.

A basic stock of colour film for the professional should comprise both negative and transparency, in a range of speeds, in formats to suit the

cameras used, and balanced for use in tungsten artificial light for photo-floods, or in daylight, which includes flash lighting. It will soon become clear whether there is likely to be a bias in any specific direction, and stock carried may be adjusted accordingly. Thus if you find that the majority of your work is 35mm negative taken on location, you are unlikely to stock your darkroom with the same materials as you would if you plan to stay in the studio with a 10″ × 8″ camera using transparency and tungsten lighting.

There are a few specialized types of colour film, such as that for use in infra-red light, although the professional in general practice will find little call for their use.

COLOUR BALANCE

This is more critical in transparency materials where there is no opportunity to make corrections at the printing stage. It is, of course, possible to alter colour balance on transparencies which are used for mechanical printing at plate-making, but the photographer should ensure that all transparencies supplied to printers are as perfect as possible, to guard against the risk of being blamed by the plate-maker or printer for an inferior result.

Colour balance may be affected for several reasons.

1 As already stated, the films of different manufacturers vary, so it is a mistake to use a mixture of materials on the same job. It is also advisable to try to ensure that that the film is of the same batch. Many photographers buy film in bulk to ensure continuity, as colour and film speed may vary significantly from one batch to another. Using the same batch allows you to test a few sheets or a roll first to check that the film is behaving normally, before shooting and possibly wasting a lot of expensive material. You can then use the test to assess whether any filtration is necessary to correct imbalance.

2 The film should be kept in suitable storage, preferably refrigerated, and never left in a hot environment such as the back parcel shelf of a car, either before or after use. Film should be processed as soon as possible after use. Material supplied to the professional user is in fact more sensitive to ill-treatment than that supplied to the amateur, because it is assumed by the manufacturer that professional stock is likely to be handled with greater care and will not be subjected to a possibly lengthy stay not only in a camera but also on the shelf of a shop. The compensation is that the more sensitive professional film is slightly superior in all-round quality.

3 It is recommended that film should be used before the expiry date shown on the pack. Using out-of-date film on a professional job is not worth the risk.

4 Using tungsten film in daylight, and vice versa, will upset colour balance, but sometimes using incorrect film will produce interesting

results, and it is worth experimenting to discover what effects may be achieved. If it is unavoidably necessary to use incorrectly balanced film, filters are available to negate the effect. (see p. 97).

5 Incorrect processing and printing (see p. 179).

6 Particular problems of colour rendition may occur with dark greens and browns, and although this difficulty may go unnoticed on most occasions, the professional photographer may find a client annoyed that a colour has failed to reproduce accurately. It is not easy to explain to a sceptic that colour film is not perfect, and in some instances is simply incapable of registering a colour properly. He may be disinclined to believe that pigments in paints may react unfavourably with the dyes in the film, so you may have to call in an independent technical adviser. The common seamless background paper is also susceptible to peculiarities: the several varieties of white available are not made simply for fun, but each is specially designed for a particular type of lighting. If you use flash, for instance, check with your supplier which type of white you need for the best results.

7 All film must be protected from X-rays, a point to watch when going through security controls at airports.

The primary colours of painting are red, blue and yellow, which when mixed together give a dirty brown. The primary colours of light are red, blue and green, which, when merged in a subtractive process of overlapping colour filters, produce black. Rays of light, however, when travelling together, produce what is said to be white. We have all seen the colours comprising the visible spectrum in a rainbow, where water droplets in the sky act as a giant prism, refracting the different light wavelengths at their various angles. Beyond these wavelengths, the human eye is not sensitive: we cannot see ultra-violet, and we find it difficult to comprehend the idea of 'seeing' radio waves. The eye, however, is considerably more sensitive within its limitations than film, in that we are able to make adjustments for niceties of colour temperature and the imbalance between daylight and tungsten, for we have the power of selection and may see what we want or expect to see.

USING COLOUR

Here we are not concerned with the technicalities of the construction of colour film, nor the problems associated with accurate rendition in colour printing, but with colour as seen by the camera in front of its lens.

In practical terms, using colour means, to a photographer, knowing how the colours of his subject will be reproduced by his film, in terms of the sensitivity of the emulsion. Beyond this scientific fact, we are very much in the realms of emotive response, where it is not possible to state categorically what is and what is not 'right'. Very broadly, it can be said that some colours 'go with' other colours without creating discord,

although this cannot be stated in words, in the same way that one cannot explain to one who has never seen it what blue is, still less how that blue looks good with that red. Within these wide limits we all have our personal preferences, based on general human reactions, cultural and fashionable standpoints and our own responses and tastes.

Colours are said to have meanings: blue, say, means cold. It is of course nonsense to take such a simplistic view, leading to speculation on what exactly the meaning of 'blue' is anyway. Is it Prussian, cobalt or aquamarine? A generic 'blue' may indeed be the colour of ice, but it is also the colour of a tropical sea, an obvious conflict of interests. The 'meanings' of colours are not absolute, but usually born of association with something else, although green is the colour of verdant growth. Others have their roots in practicalities, such as purple, which was accepted as a regal colour, not because there is anything special about purple in isolation, but possibly because purple was once a difficult and expensive dye to produce, and was therefore used only for the clothes of the rich, who then used the colour as a badge of their status.

So, given this alarming array of complications, preferences, associations and so-called meanings, how do we attempt to use colour? First of all, we cannot help being influenced by our own tastes, and our photographs will tend to reflect our likes and dislikes. We must remember, however, that what appeals to us need not necessarily appeal to others, and professional photographers are sometimes given specifications which may include colours or combinations of colours which they would perhaps not use through choice.

Colours may not be taken in isolation, as each has an effect on its neighbour, an interaction often seen in optical illusions in which the same colour patch appears variously larger or smaller, colder or warmer, lighter or darker, depending on its surroundings. Such effects should be remembered when choosing a background for the main subject, and one's own preferences may need to be suppressed in the circumstances. For instance, subjectively one may like a particular shade of red for a variety of emotional reasons, but as a backdrop it may prove to be too strong for the main subject of the photograph.

Aesthetic use of colour is generally based on observation and perfected through trial and error. To some people a sense of colour awareness comes more easily than to others, some may never really 'see' colour at all, and others may develop the faculty. Because we are unable to transmit our impressions of colour to anyone else, we can never be certain that our idea of a shade is just the same as another individual's.

Finally, do not be afraid of colour. Try different combinations, patterns and mixtures, and do not abide rigidly by any set of rules you may come across. The only real rules are your own.

INSTANT PRINT

On many occasions it is useful to have an immediate photographic reference to the subject in front of the lens. It is easy to miss details

23 'Normal' negative/positive
system

through the camera, particularly when you are using a small aperture
to give you the required depth of field. With small-format cameras, the
lens is always fully open for viewing, but with 5″ × 4″ or larger format,
stopping down the lens will darken the image on the ground-glass
screen, making it difficult to assess accurately. Consequently, a medium
which will give a positive print similar to the final result, but within a
few minutes, is a valuable tool for the professional photographer. It will
allow you to judge composition, to see that supposedly hidden supports
(or clips, sticky tape etc.) are not visible, or whether the full colour subject
will translate into black and white. As the materials for any kind of
instant print tend to have the unforgiving characteristics of reversal
films, it will also give an indication of exposure and lighting balance.

Polaroid manufacture a wide range of both colour and black-and-white
materials, to fit both their own cameras and special holders for use with
120 roll-film and view cameras. The material is used either as a single sheet,
or in a pack of several exposures to be used one at a time. After exposure,
the envelope containing the negative sheet, the positive (print) sheet and
the processing chemicals is pulled out of the holder through a pair of
pinch rollers which breaks the pod containing the chemicals and spreads
them between the negative and positive sheets. As the material is
effectively of a reversal type, where there is no control between negative

24 Polaroid print

25 Bromide print from Polaroid negative

and print stage, the processing time and temperature are critical, and you should take careful note of the instructions for the type of material you are using. As a general rule, at a temperature of 20°C (68°F) the processing time for black-and-white is about 30 seconds, for colour about 1 minute.

When the specified time has elapsed, the envelope is opened and the negative and positive peeled apart. Some types give a re-usable negative which is washed and dried before use, but otherwise, all but the print is discarded. You should remember that the chemicals are caustic, and the waste should therefore be disposed of carefully, and any contamination on hands or clothes should be washed off immediately or neutralized with a weak acid. The print itself usually should be coated with a special fixative solution if it is black-and-white: a colour print needs no further treatment.

10″ × 8″ Polaroid colour and black-and-white materials are loaded into a specially designed holder as with the types mentioned above, but after exposure the holder is attached to a processor which pulls the material out of the holder for processing. Although the equipment is designed to

26 Agfa Copyproof print 27 Bromide print from bromide paper negative

be used in normal lighting it is electrically powered, so cannot be used without a source of power.

There is also the type which develops 'in front of your eyes' in normal lighting. This is also the only kind of instant-print film manufactured by Kodak. It is available only in colour, and must be used with specially designed cameras. A pack of the film is loaded into the camera, an exposure made, and the camera immediately ejects a rectangular sheet which begins to develop an image while you watch, taking about five minutes to appear fully. As the picture is made directly on a paper positive, the optical system of the camera must be designed to reverse it, or the result would be a mirror image of the subject, as were the old daguerreotypes, which were also direct prints onto positives.

Agfa-Gevaert have extended their excellent range of copyproof materials to include a tone material capable of being loaded into a normal dark slide. A sheet of panchromatic negative paper is loaded into the slide and exposed according to the rated speed of the material. This is then fed through a processor containing an activator, face to face with a positive sheet. After about thirty seconds of emerging from the processor

the two are peeled apart, to give a paper print and a negative which cannot be re-used. This is the type of material also used for continuous-tone copies with a process camera. Copytone is intended for studio use only, as the processor requires electrical power.

A quick but crude method of producing an instant print is to load a dark slide with an ordinary sheet of bromide paper and exposing it as usual, although it is rather slow at about 6 ASA. Process the paper and contact-print it with another sheet of paper. This may not be so rapid if you do not have an automatic processor, and the results produced are somewhat high in contrast, even if you use soft-grade paper throughout. However, although it will not give correct rendition of tonal values, it can provide a check for composition, and gives an immediate black-and-white reference, useful for a designer to work from.

Although producing an instant print has many advantages, you should not rely on it to show up errors which should be spotted through the camera. Remember that the materials are generally expensive and excessive use can add significantly to your job cost, so tend to use the instant print as a final check before you release the shutter.

8 Black-and-white photography

There are undoubtedly areas where colour may be superfluous, detracting from the essential strength of an image by adding irrelevant and confusing detail.

Texture and shape, for instance (the illusions of form and solidity) are emphasized in black-and-white. Even in the area of food, an apple, a loaf of bread, a wine bottle can be given a sense of weight and richness without the use of colour. The photographs illustrated demonstrate how strong lines and patterns may be used to produce an abstract arrangement. Using a strong, directional light creates greater differentiation between areas of shadow and highlight, minimizing the overall grey effect resulting from a more diffused source.

Black-and-white is an alternative. We are now so used to colour in published material, on television and at the cinema that it is in some instances possible to create impact with the increasing unfamiliarity of black-and-white. One example of an award-winning film-maker working in black-and-white through choice is Woody Allen, who feels his view of 'Manhattan' is better expressed in the starkness of the medium. Of course, black-and-white in competition with colour must be particularly strong and powerful to guard against the risk of being passed by, unnoticed by the audience.

Black-and-white is an ideal medium to convey a sense of drama, and is the medium of choice in photojournalism where the intention is to show desolation or poverty. The use of colour in such circumstances is often too warm and comforting, thus reducing the impact of the image. Most press work is executed in black-and-white, although the reasons for this are more practical than aesthetic: the fact remains that newspapers are not printed in colour.

Because colour is the normal medium of today, using black-and-white gives an old-fashioned feel. We know that old films were made in black-and-white, we remember our early days of watching TV without colour, and we recognize the first photographs not only by content but by their monochrome. Thus there is a tendency to assume that monochrome equates with age, even though the work might have been done yesterday. A sense of antiquity is reinforced when the print is sepia-toned, softening the blacks and greys into warm browns and reducing the contrast between the light and dark areas of the picture.

Given that black-and-white is the chosen medium and you are free from problems relating to colour rendition, your main concern is with contrast. As a rule, subjects which are high in contrast are most successful for black-and-white work, where areas of light and dark are clearly defined and the picture will retain a bright, crisp appearance after the

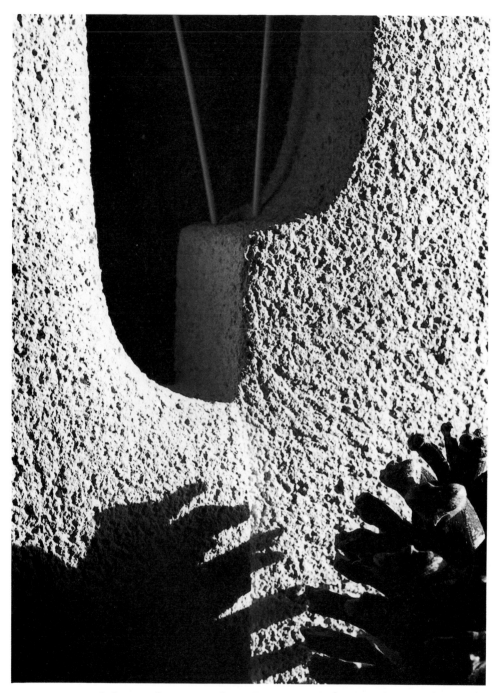

28 A close-up of a ceramic sculpture, lit by strong, directional sunlight, showing texture and deep shadow of the pine cone at bottom right. The contrast was retained by printing on hard-grade paper (Kodabrome II Grade 4). Nikon FM, Micro Nikkor, Plus X Pan

29 *(opposite)* Night shot of trees in snow. Nikon F2, Micro Nikkor, Plus X Pan, lit by Braun F901 flash

elimination of colour. Some subjects are intrinsicly more contrasty than others, and will display 'black-and-white' characteristics under most conditions, while others may need a little help.

Contrast may be increased in several ways. A strong, angled light, as we have seen, will emphasize contours and textures. A hillside at noon may lack interest, while the long shadows of evening disclose a profusion of rocks, bushes and gullies. For high-contrast lighting in the studio, use a directional source such as a spotlight as the only illumination, without reflectors or secondary lights for particularly deep shadows. When using this type of lighting, you should ensure that you capture the essence of the subject you wish to show. Some subjects are instantly recognizable with very few visual clues, while others are less obvious; and remember

that it is not always appropriate to show a strongly textured surface. In portraiture, for instance, a severely angled light reveals pores and blemishes, causing an otherwise ordinary skin to appear like orange peel, a point unacceptable to the average sitter, unsympathetic to the 'warts and all' concept.

Having established the contrast existing in the subject itself and the way it is lit, it is then necessary to decide whether that contrast should be reproduced faithfully, increased or suppressed. The critical factors here are the choice of film and development, and the choice of paper and its processing, all of which are closely inter-related. If an increased contrast is required, use a high-contrast film, under-expose it, over-develop and print on hard paper. To suppress contrast, the reverse is roughly true, but these are obviously extreme situations and may in practice result respectively in a virtual reduction to line, or a confusing image of large grain and poor resolution.

CHOICE OF MATERIAL

Although black-and-white film displays inherent characteristics according to type, the extent to which these characteristics develop (literally) is closely related to the chemical solution used in processing (p. 165).

Film
Black-and-white general-purpose film is categorized broadly as being fast, medium or slow, with reference to its degree of sensitivity to light, and speed is expressed in terms of ASA (American Standards Association) or DIN (Deutsche Industrie Norm) ratings.

Fast film invariably displays a coarser grain structure than a slower one, owing to the size of the grains of silver halide in the emulsion. This texture will show considerably if the negative is to be greatly enlarged.

Slow films are generally higher in contrast than fast ones, although development of the material has an effect on the final result.

Most professional photographers will tend to use one or two different types of film which suit the majority of their requirements. Our studio uses the medium-speed Plus X Pan rated at 125 ASA for most indoor work under controlled conditions of lighting, for location large-format jobs, and for exterior small-format work when the light is good. The 400 ASA Tri-X Pan is particularly useful for outdoor small-format assignments, where hand-holding the camera in typically dull English weather conditions necessitates the smaller aperture and faster shutter speed to eliminate problems of depth of field and camera shake, while allowing the film to give a reasonably fine quality.

To summarize, the factors to be considered in choice of film are:
1 *The subject* If it is necessary to show fine details clearly, maximum resolution is required, which means using a slow, fine-grain film.
2 *Lighting conditions* If light levels are low, use a film with a speed to suit reasonable aperture and shutter speed. When shooting a moving subject, fast films are almost essential to allow short shutter speeds

30 Bas-relief effect made by combining a 5″ × 4″ Ektachrome and a black-and-white negative taken at the same time in camera

for freezing action. *3 Enlargement* Grain will become more apparent with enlarging, so unless grain is required for reasons of effect, use a slow film.

There are, as always, occasions when the circumstances do not suit the requirement, and a compromise must be made. If, for instance, light levels are low, it is better to have a sharp image with grain than a smooth, blurred one. Black-and-white film is remarkably tolerant in that it allows itself to be 'pushed', that is, rated faster than it actually is and developed for a correspondingly longer time to cope with low light,

and there is greater latitude for rectifying errors or difficulties encountered in camera at both processing and printing stages than there is with colour. However, film and developers cannot work miracles, and can only give of their best when used under conditions recommended by the manufacturer.

CREATIVE BLACK-AND-WHITE PRINTING

Correct printing of an ordinary continuous-tone negative is a basic skill of most photographers. Given a correctly exposed, evenly lit negative, it is not difficult to produce a correctly exposed, evenly lit print, and be able to choose a grade of paper to suit the subject. Beyond this we find a vast range of methods by which the image may be altered, many of them rarely being required for professional purposes, but useful to bear in mind for the odd occasion when a client is looking for fresh ideas.

Texture and reticulation
Reticulation, in its true sense, means the distortion of the emulsion of the film caused by processing at too high a temperature. Modern films are so constructed to resist unwanted faults that reticulation is extremely difficult to obtain by hot developer alone, but a normally developed film may be treated with acetic acid, then rinsed alternately in hot water ($150°C$) and in cold water before being fixed, washed and dried without the use of a wetting agent. However, this renders it useless for anything other than special effects, so a less drastic method is to use a reticulation screen with a normal negative. Various special screens are commercially available to be sandwiched together with negatives during printing, and a range of textures from canvas to mezzotint can be obtained in this way. When using these screens in conjunction with a small negative, remember that the pattern on the screen as well as the image on the film will be enlarged, and may appear too coarse on the final print. An alternative when making, say, a 16″ × 12″ print from a 35mm negative is to place a suitable screen over the printing paper, so that the size of the elements of the texture may be assessed accurately. Any translucent material is suitable as a screen, such as a sheet of ground glass or a piece of fabric, but it must be firmly in contact with the paper, or the texture will not be sharp and the print will simply appear to be dirty.

Reduction to line
Essentially, this means eliminating grey from the print to leave an image made up entirely of black and white with no intermediate tones. A 'bleach-out' effect, as line reduction is commonly called, may be achieved very simply by increasing contrast at all stages, beginning with a contrasty subject, and ending with printing on hard-grade paper, although the end result is likely to show at least some degree of grey tone.

Using line film, also called lith film (see p. 82) will remove all greys to create a true bleach-out.

31 Nikkormat FT3, Tri-X Pan. Reticulation effect obtained by printing the negative together with a Patterson texture screen

32 Bleach-out. The original photograph was taken on a Hasselblad using Plus X Pan film. Then a bleach-out was made on lith film, with slight retouching on the negative to emphasize the eye. This dramatic image gives the impression that the studio dog is a fierce, formidable creature, when in reality the reverse is true

Making a bleach-out
1 Choose an image with a strongly graphic quality, in which the subject will remain recognizable with mid-tones removed.
2 Print the original continuous-tone negative onto lith film to give a film positive and process in lith developer according to the manufacturer's instructions.
3 Print this film positive onto another piece of lith film to reconvert to a negative, and process as before.
4 Print the lith negative onto paper.

Varying the exposure of the initial positive will give a greater or lesser area of black, and it may be necessary to experiment with exposure length to discover the most successful result. After this stage, any variation in exposure will not affect the amount of black obtained, only its density, as the original image is translated into terms of pure black and white with the first print onto lith film. Although high-contrast paper is available specially manufactured to take line images, this is principally designed for use in copywork and preparation of artwork; for the purpose discussed here, normal photographic paper is suitable, but preferably choose a hard grade to give density in the black while retaining a crisp white.

Bleach-outs from positive original prints may be made by copying the print onto lith film to make a negative, and printing directly from this.

When working with bleach-outs, remember that the final image will be considerably removed from reality, and that what you are looking for is design. There is of course nothing to stop you from using the film positive to print from, resulting in a reversal print. Your intention is not to reproduce actuality faithfully, but rather to create an interpretation of actuality, and you will use a completely different set of criteria to assess the effect from those you would use if you were setting out to show reality with a 'straight' print.

Posterization
This is based on a reduction to line, but with the addition of two or three distinct areas of flat tone intermediate to the black-and-white. This effect may be achieved in two ways.

1 Using the original continuous-tone negative, make film positives as though you were making an ordinary bleach-out by printing onto separate sheets of lith film. To produce a black and two intermediate tones, make three positives at different exposures, say, at 4 seconds, 8 seconds and 12 seconds to give a variation in areas of black. Then contact-print each sheet separately onto one sheet of continuous-tone film, having tested for exposure, and making sure that the contacts are completely in register. Expose each for the same time, then process and print the negative as usual.
2 From an original continuous-tone print, make three lith copy negatives, varying the exposures as outlined. Then make three separate exposures with the negatives onto one sheet of paper, ensuring each is in register, and process the print normally.

Registration is essential for a successful posterized effect. To help with this, *1* use sheet film, 5″ × 4″ or larger; *2* ensure that the enlarger and baseboard are firmly fixed; *3* contact-print, using a register board, having punched holes in negative materials before making exposures; *4* copy originals, having made registration or 'tick' marks out of the image area. These then appear on the negatives and are used as constants to line up when making the different exposures onto paper.

33

33–37 Black-and-white posterization. Nikon FM, Micro Nikkor, Plus X Pan. Lit by daylight on an overcast day

33 *(above)* A straight print from the negative

Then three prints were made onto line film from the continuous-tone negative, at 5 seconds, 10 seconds and 15 seconds, all at an enlarger aperture of $f11$. As these were line *positives*, they had to be reversed to be line *negatives* for printing. I elected to use this method rather than that outlined in the text because of problems of registration.

Opposite
34 A print from the line negative showing the least black

35 A print from the middle line negative

36 A print from the line negative with the most black

37 The posterized print. At an enlarger aperture of $f16$, on Kodabrome II Grade 3 paper, machine-processed, each negative was exposed for 2 seconds. The negative with the most black provides the lightest grey, and the accumulated exposure gives the solid black

34

35

36

37

38 The original photograph was taken on 35mm transparency, and a 5″ × 4″ black-and-white copy negative was made for this print

Solarization or Sabattier effect

True solarization is where exceptional long exposure in camera has caused a reversal in the image, so that both positive and negative appear. As camera exposures would need to be in the region of one thousand times that recommended, the more commonly encountered Sabattier effect, achieved in the darkroom, has superseded the true process.

For *print solarization*, a sharp, strongly graphic subject should be chosen. Expose the negative as usual through the enlarger, selecting a harder grade of paper than if you were making a straight print. Develop the paper for half the tested time, then switch on the light for a few seconds before completing the development without agitation. Several attempts may be required before a satisfactory result is obtained, and even then there is a tendency for prints to appear curiously dirty and muddy.

For *film solarization*, make a film positive by contact-printing the original negative onto contrasty continuous-tone film, and, with agitation, process in a dish using print-strength developer. Halfway through processing, fog the film with white light for the same length of time as the exposure given to the film through the enlarger, then continue development without agitation. Contact-print this film positive

39 A copy negative was made from the black-and-white print opposite. This copy was made on Kodak Gravure Positive sheet film, which, being blue-sensitive, may be processed under safe-lighting conditions, making it possible to monitor the development of the negative while the procedure for the pseudo-solarization or Sabattier effect is carried out. Note the reversal in tones and the characteristic black pin stripe separating adjoining light and dark areas

onto another sheet of continuous-tone film and process normally to provide a negative to use for printing onto ordinary paper.

Colour toning
Colour may be added to a black-and-white print by several methods.

Hand colouring Before it was technically possible to make photographic prints in colour, the only way to introduce colour was by painting the image by hand. Some movie films of the pre-Technicolor era have been so treated, a phenomenally long operation when one considers the numbers of individual frames to be painted. Nowadays, hand-colouring is not seen as a substitute for 'the real thing', but rather as a charming alternative, where the essentially muted shades and generally subdued appearance are ideal to evoke a nostalgic 'old postcard' atmosphere. Hand-colouring may also be used to emphasize a particular area with 'spot' rather than all-over colour. However, an artistic skill with a brush is required for this, and it is unlikely that expert results will be achieved at the first attempt, but if you do want to have a go, use a paper with a matt or semi-matt finish which will 'take' the dyes better than a glossy surface, fine brushes of artists' quality, and special

dyes manufactured for the purpose rather than ordinary paints or pens.

Colour dyeing To tone the whole image one colour, immerse the print in a solution of ordinary cold-water fabric dye. The black areas are unaffected and the white is changed to the chosen colour. Care must be taken to avoid a streaky effect.

Colour toning This changes the areas of the print containing silver halide, i.e. anything which is not white, into a colour. Commercially made toners are available for colouring prints, and there are four major systems used. The familiar sepia-tone is an example of two-bath toning, where a print is bleached, then redeveloped so that the areas originally black reappear in the chosen colour. Single-bath toning has a gradual replacement of the silver, and three-bath toning has bleach, colour develop and then removal of the silver. Further to this are multi-coloured toning kits, complete with colour couplers and dyes for results in 'glorious Technicolor'.

XIII Peaches. Sinar P 5″× 4″, 180mm, Ektachrome 64. Broncolor spot projector side right, small white reflector side left. Black Perspex background

XIV Catalogue shot for Pearsons of Chesterfield. Sinar P 5″×4″, 180mm, Ektachrome 64. Bron-color Hazylight side right, large white reflector side left. A brown, country atmosphere to suit the nature of the pottery

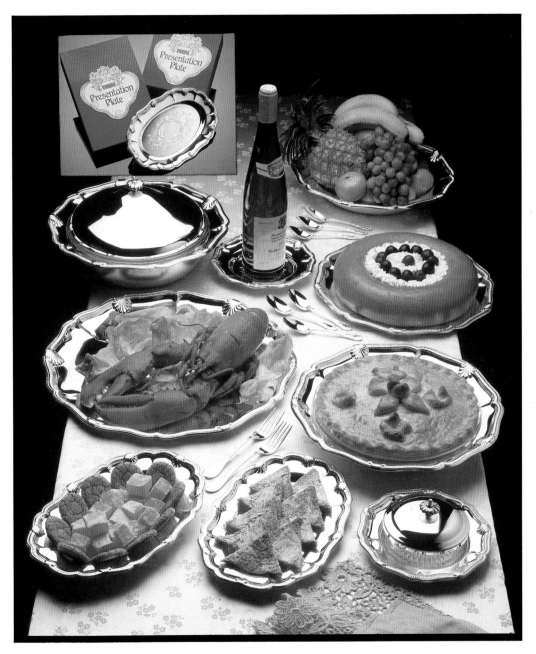

xv A page from a catalogue for Viners of Sheffield. Both shots Sinar P 5″×4″, 180mm, Ektachrome 64. Main shot Broncolor Hazylight top back, allowing rear fall-off of light; note the change of texture in the fabric. Insert: back-lit black Perspex; indirect lighting on salver to retain the engraving. A cool, sophisticated approach for silver plate, in contrast with the terracotta

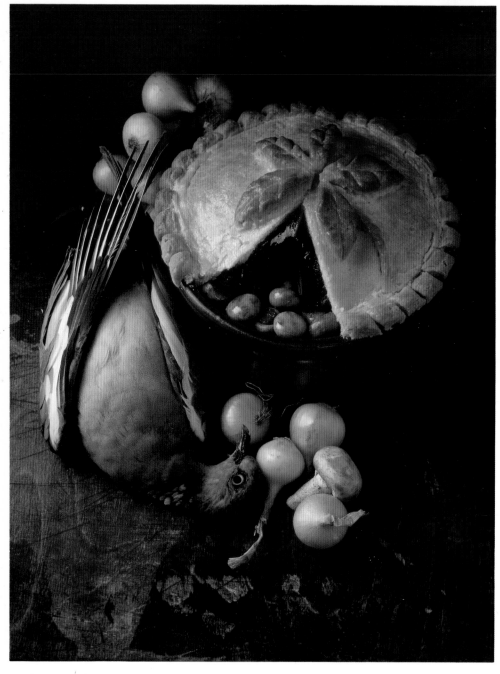

xvi Pigeon Pie, by Michael English. Gandolfi 10″× 8″, Agfachrome. A classic 'nature morte'

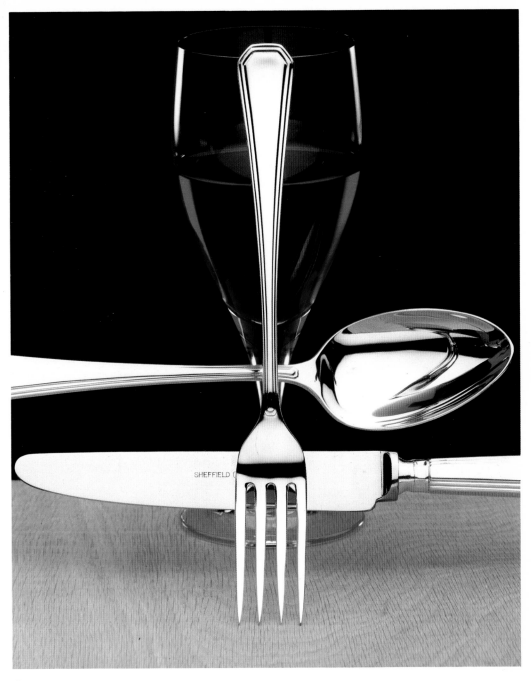

xvii Sinar P 5″× 4″, Ektachrome 64. Broncolor Hazylight top, with front card reflector. Two flash heads back right and left to light the wine in the glass.

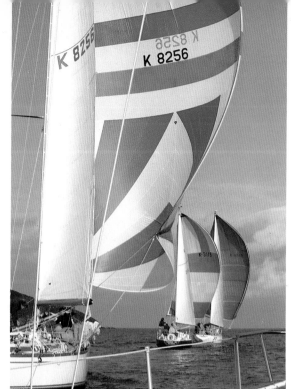

XVIII, XIX Two pictures at the start of a yacht race. Nikon F2 with motor drive, 80–200mm zoom Nikkor. Fast working is essential for sports photography, so the motor drive is invaluable. Although these shots show very different lighting effects, they were in fact taken within ten minutes of each other, in opposite directions

Opposite

XX Nikon F2, 28mm Nikkor. Vario Rainbow diffraction filter. A dramatic impression of machinery from the Industrial Revolution. Photo by Andy Barber

XXI A night shot of the Crucible Theatre, Sheffield, taken on a Hasselblad on VPS material at dusk. The sky was actually darker than it appears in the picture. The exposure balances the exterior and interior lighting

XXII A 35mm rostrum camera slide

9 Filters

Filters are used for colour correction, for balancing black and white tonal values, for polarizing, and for special effects. The photographer is principally concerned with filtration at camera stage, though filters are also used to alter lighting and in printing.

There are three types of filters, gelatin, glass, and optical resin; all must be handled with care, as blemished surfaces will cause a loss of definition in the image. Gelatin filters cannot be cleaned, and are liable to scratching, damage by dust, and fingermarks, and may also fade in prolonged exposure to light, so they should be kept in their packaging at all times. Geltain and resin filters are normally fitted into a special filter holder which is then attached to the lens. Some glass filters are circular, and made to screw into the lens itself. Resin filters are less prone to breakage than glass and do not easily scratch, as gelatin does.

COLOUR CORRECTION

As we have seen, colour film is balanced for use with a specific type of light, according to its colour temperature. This is measured in degrees Kelvin (°K). A light source with a high colour temperature is bluish, while a lower colour temperature tends towards red. This is why the result will appear to be yellow if you use daylight film in artificial conditions.

Kelvin scale

Daylight/electronic flash	5500°
Blue flash bulbs/flash cubes	5400°/5500°
500-watt tungsten lamp	3200°
100-watt domestic light bulb	2900°
40-watt domestic light bulb	2650°

The colour temperature of daylight is, of necessity, an average, and will vary according to weather conditions and time of day: dawn and dusk have a low temperature in comparison with noon, hence the characteristic golden light.

For normal studio work, either with electronic flash or with tungsten lighting, you will choose the correct balance of film. In an emergency you may need to use, say, daylight film in artificial light, in which case you will use colour-conversion filters to compensate:

to convert	use filter no.	exposure increase/decrease
5500° to 3200°	85B	$-\frac{2}{3}$ stop
3200° to 5500°	80A	-2 stops
2900° to 3200°	82B	$-\frac{2}{3}$ stop
2650° to 3200°	82C + 82A	$+1$ stop

(Filter numbers given are common to all manufacturers)

Neutral density filters (No. 96) reduce the intensity of the light by a specific degree, without affecting the colour balance, and are used in both colour and black-and-white photography to allow longer exposures or maximum apertures in light which is otherwise too bright. Filters range from ND 0.1, with an 80 per cent transmission of light and an exposure increase of $\frac{1}{3}$ stop, to ND 4.0, with a transmission of 0.01 per cent and an exposure increase of $13\frac{1}{3}$ stops.

BLACK-AND-WHITE PHOTOGRAPHY

Although on occasions some of the paler filters can be used in colour photography to shift the colour balance for aesthetic as well as technical reasons, the majority of coloured filters are for black-and-white work. Black-and-white films are panchromatic, sensitive to all colours of the spectrum. Reproduction of colours into grey is technically fairly accurate, but visually the emphasis may be altered. A blue sky often appears lighter on a photograph than we remember reality, while grass may seem to be darker.

When you use a colour filter in black-and-white work to shift emphasis, remember that the parts of the subject which have the same colour as the filter will appear to be lighter, while the complementary or opposite colours will appear darker. Thus, in the illustrations here, the tomatoes appear almost white with the red filter and almost black with the green.

Yellow, orange and red filters are used in landscape photography to affect the blues and greens. No. 8 (yellow) and the slightly darker No. 9 (deep yellow) are often used for sky effects; for a more dramatic rendition try No. 15 (deep yellow) or No. 16 (yellow-orange). For extreme contrast, No. 25 (red) will turn a blue sky almost black. Yellow filters 2A,

Opposite

40–42 Filtration for black-and-white. 5″ × 4″ black-and-white photographs of a group of fruit and vegetables on an underlit Perspex background with diffused top lighting

40 With no filter

41 With red filter. The effect on the tomatoes is striking: the red has bleached, while the green has darkened

42 With green filter. The tomatoes appear very dark, but the flecks in the skin of the green apples have shown little change. The yellow filter we tried gave only a very slight difference from the unfiltered version

40

41

42

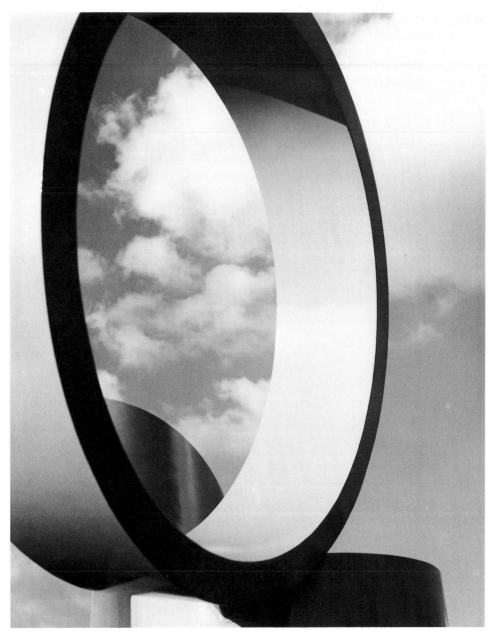

43 Large sculpture by Bernard Schottlander, Park Royal, London. Mamiya C33, 80mm Sekor, HP4, with red filter

2B and 2E are useful at high altitudes when there is ultra-violet radiation present, and to help reduce atmospheric haze, which can be a particular nuisance in aerial photography. Blue and blue-green filters will also reduce ultra-violet, darken reds and correct the 'bluish' effect in some atmospheric conditions.

POLARIZERS

Polarizing filters affect the wave pattern of rays of direct, reflected or polarized light travelling from a surface such as glass. The filters are colourless, so may be used in either black-and-white or colour photography. For photography of a shop-window display or of a picture in a glass frame, a polarizing filter will eliminate to a great extent the reflections confusing the main subject of the shot. By eliminating reflections on other non-metallic surfaces, such as china, polished wood or gloss paint, you can prevent colour desaturation if it is not possible to angle your lighting as you would like (see p. 133), and you can photograph through the bright surface of water.

Polarizing light will also cause manufacturing stress patterns to appear in plastics and Perspex: it gives fascinatingly colourful special effects, and is very useful scientifically as an indication of structural weak points.

SPECIAL EFFECTS

The possibilities of filters for a variety of special effects are endless, particularly for colour photography.

The *coloured gelatins* previously mentioned for black-and-white photography can of course be put to work for colour.

Graduated filters are half coloured or neutrally fogged, and half clear, in a range of shades and densities to allow an alteration of a portion of the picture – to give, say, a stormy or misty sky over a bright, clear landscape. These work best when there is a clearly defined divide in the image, such as the horizon.

Spot filters are clear in the centre, surrounded by a neutral or coloured diffuser, similar to the graduated filters, to provide a vignette effect. This is easier to control than the traditional method of using petroleum jelly on the lens. (N.B. Neither petroleum jelly nor anything else should ever be put onto the lens directly.)

Soft focus filters are diffusers covering the whole image, and are often used in portraiture to minimize skin blemishes or to give a generally more aesthetically pleasing image.

Star filters. Some of these are fixed, giving a variety of rays with a set angle between each ray, while others may be rotated to change the angle. Either way, they work best with very bright points of light: an overall bright area will merely degrade.

Diffraction filters produce prism effects on bright points of light, splitting the light into the colours of the spectrum but without distorting the image.

Prism filters. A large prism in front of the lens will both split the light into the colours of the spectrum and distort the image for special effect, on occasions giving a result similar to a coloured posterization. Where the filter is a multiple rather than a single prism, there will be no distortion of shape or colour, but a split image, circular or linear. Here, you should take care not to have the multiple images confusing with each other: the linear split prism is particularly useful to give an impression of forward movement.

There is no reason why more than one filter should not be used at one time, but remember that the more filters you use, the greater the degradation of the image, and the more exposure compensation you must give. Where the camera has through-the-lens metering, the compensation for filtration is given automatically, but where the metering is separate, the filter factor must be taken into account and the appropriate adjustment made. Most filters will indicate on the packaging the required filter factor, or the exposure increase measured in terms of extra stops. A filter factor of 1 means no exposure increase is necessary; a filter factor of 2, increase by 1 stop; a filter factor of 4, increase by 2 stops; a filter factor of 8, increase by 3 stops, and so on, with appropriate calculations for a filter factor of, say, 3 or 5 ($1\frac{2}{3}$ stops and $2\frac{1}{3}$ stops respectively).

10 Multiple images

Apart from the various prism filters, you can make multiple images in camera or in the darkroom. For professional purposes, this type of work is useful not only for special effects, but also when more than one aspect of a subject must be shown, yet there is only one of a subject available to photograph.

IN CAMERA

Stroboscopic light

A typical stroboscopic lamp will fire as many as 20 flashes per second, and depending on its brightness, you may need more than one, synchronized to provide enough illumination to register on film. With so many flashes in a very short space of time, you can capture a moving

44 Sinar P 5″× 4″, Plus X Pan, 1 Broncolor flash head. The first exposure *(left)* used the flash head with barn doors on the right side, with a white card reflector on the left. The camera was moved forward for the second exposure, and the white card removed. The camera was moved further forward for the third exposure, and a conical snoot reflector replaced the barn doors, to concentrate the light and allow the side of the face to go completely black. The aperture for each exposure was the same, and there has been no dodging on the print

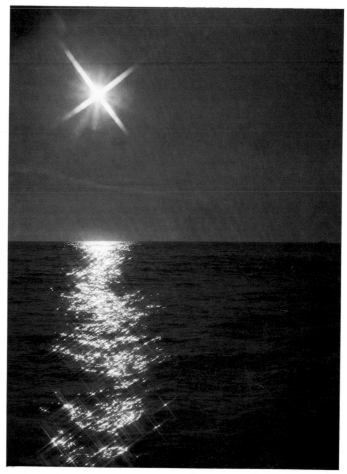

45 A print from a 35mm black-and-white negative. A star filter was fitted on the camera and the film under-exposed for detailing in the bright reflection

subject in different positions during one exposure, each position frozen by the rapidity of the individual flash. A subject moving quickly with the light firing slowly, for instance, will produce fewer and more separate images than a slow-moving subject with less interval between the flashes.

The sequence of movement resulting is useful to show exactly how the movement takes place, interesting from the point of view of the patterns produced, and of scientific importance in the study of the mechanics of motion. It could be considered a direct descendant of the early work of Eadweard Muybridge, who, without the advantage of electronic flash lighting, made his studies of motion by taking a series of pictures in quick succession. For his sequence of horses, for instance, he rigged a series of trip wires, each leading to a separate camera. As the horse passed each wire, the camera shutter was triggered and the exposure made. Thus it

46 A print from a $2\frac{1}{4}''$ square colour negative, sandwiched together with a texture screen in the enlarger. The white vignette was made by printing through an oval hole cut in a piece of black card

was proved that the 'rocking horse' gallop, familiar on countless sporting prints, was not the true motion of the animal at full gallop.

Conventional multiple exposure
Whereas with the stroboscopic light you make only one, prolonged, exposure, other multiple images are made by exposing the same sheet of film more than once. It is an advantage to use a large-format camera with a viewing screen, or at least a medium $2\frac{1}{4}''$ square format, as 35mm is likely to be too small for accurate positioning.

A simple black backdrop is the easiest to work with for all multiple exposure. The background will not interfere with the subject, whereas a lighter background will cause colour casts and less substantial images. A strong, directional light is most effective, the dramatic aspect being emphasized; and be careful not to allow light to spill over onto the

47 A double print made by combining elements from the two preceding pictures

background. Expose the film according to the reading obtained, then shift the camera or the subject, and make another exposure as before. This may be repeated as many times as practical, if you wish. Images which do not overlap will not affect each other.

If images do overlap, remember you are doubling the exposure given, since you are effectively exposing twice. To avoid the resulting burning out, you should ensure that the overlapping areas are less brightly lit. When superimposing over any colour other than black, compensation must be made for exposure.

It is helpful to make a sketch of the results you hope to achieve before starting photography; use a chinagraph pencil to mark the position of the subject on the camera viewing screen for each exposure, and be prepared to experiment. Although it is possible to produce many enigmatic images with double exposure, beware of being trite and too obvious. The subtle approach tends to be more eye-catching than one which is obviously a trick. The actual trick is to fool the viewer without his being immediately aware that he is in fact being fooled.

IN THE DARKROOM

The opportunities for manipulation of ordinary negatives into strange images are unlimited. The simple technique of sandwiching two negatives together for printing can be effective; or two negatives, in whole or in part, may be printed independently onto the same sheet of paper. Shade with your hands the areas you do not wish to appear, or if the break is at a hard edge – the horizon, for instance – you can cut a mask out of black paper to the appropriate size.

To make a montage in the enlarger:

1 Choose two or more negatives with a matching contrast range.
2 Make a sketch of the idea you hope to achieve.
3 Enlarge the negative as required. If you have two enlargers, you can set both negatives to size, otherwise you will have to effect the change after the first exposure.
4 Make the masks and dodgers you may need.
5 Test for each exposure individually.
6 Make the first exposure, shading away the areas you don't want.
7 Using the sketch, position the paper for the second exposure and expose, with appropriate shading.

You can also make a montage using prints, cut out and patched together, then re-copied. Remember to cut carefully and accurately, as the cuts will show on continuous-tone film.

48 Hasselblad, 100mm Planar, Plus X Pan. Two flash heads, one direct, diffused, from the left, the other bounced off the ceiling on the right. Informal, 'at home' shot

11 People

FORMAL PORTRAITS

Although amateur photography is a popular pastime, there is still a desire to have a portrait taken by a professional photographer, because it is felt that only a professional will be able to produce a sufficiently good result to grace the family album or the mantelpiece. As a general practitioner, you will have many different people to contend with, average people who may not be handsome or beautiful, but all have an idea of how they look, and how they would like to look.

The first step is to talk to the subject, become familiar with him, and find out something about him. This gives you time to study his face and appearance, and assess what kind of picture he would like, and builds a rapport between photographer and subject, so that when the picture is finally being taken, neither feels he is being faced by a total stranger.

Many portraits are taken for a specific reason, often to commemorate a special event such as a degree ceremony or a birthday, or for a gift. Pictures of children are popular as presents for grandparents and other relatives, perhaps living overseas. Social events within a family are often recorded; as well as weddings, there are engagements and christenings, with portraits of individuals or of the family as a group.

Surroundings

The environment in which you place your sitter should complement him: his face and personality should fit the background, which should never be unintentionally allowed to shout against him. If you want to build an environment in the studio rather than use a plain backdrop, there are many suppliers who can provide props, from stairs and chairs to curtains, rugs and stuffed animals, and you need not worry about using the same props over and over.

Otherwise, you may photograph the sitter in his own home, with his own possessions to suggest personality. Sometimes photography at home is preferable to that in the studio. The sitter feels more at ease on home territory, and children are usually less difficult when at home. Very busy people often do not have time to come to a studio, and it is more convenient for them to be photographed at home or at their place of work. Royalty, prime ministers and the like are not only busy, but more suited to their own impressive environments than to even the best of studios, and are conditioned to expect the photographer to travel to them, rather than vice versa. However, we have taken the portrait of a cabinet minister who had no pretensions to grandeur and very kindly came to the studio for his picture.

Whether at home or in the studio, you should beware of clutter, if it is disorganized. As a rule, you will only confuse the issue by cramming artefacts into the picture with the subject, and even simple props may appear trite. Suppose we have a subject who likes to play the guitar. If he happens to be playing in a real situation, such as on the stage or at a recording session, the picture may seem authentic, but posing him artificially holding his guitar may lack spontaneity. An alternative would be to suggest the presence of the guitar rather than emphasizing it in an obvious way.

Sometimes, a deliberately cluttered approach is suitable. If your sitter's home is a riot of objects, that is his personality, and he may seem out of place in anything other than apparent chaos. You should organize this chaos, and choose an angle where the sitter is happily surrounded, and not overwhelmed, by his possessions.

A plain backdrop will give more prominence to the sitter, supplying no distractions and no suggestions as to environment. The background is anonymous, and used extensively in fashion work, and also for publicity portraits where the intention is simply to put a face to a name. If you use a plain background for a standard portrait, remember that the sitter must be 'perfect' enough in terms of appearance to stand by himself, or be of a personality suited to this simple approach. The plain nature of the background may be used as a contrast and to offset an extravagant appearance, or it may be used to complement a simplicity or even severity of aspect. Plain backdrops are also more suited to portraits based on lighting: where the sitter is haloed by a spotlight, for instance, or when soft focus is being used to concentrate on the face. In such cases, obvious backgrounds will cause confusion and a distraction away from the main subject.

Posing the subject
Should he sit formally, or should he relax? Should he smile, or look solemn? These are points you can resolve only after you have spoken with your subject and ascertained the purpose of the shot. If he is a business executive, it is probably preferable to pose him in a way that indicates a business-like attitude. He will probably not, in any case, be likely to loll about and grin.

Where the portrait is more than a head and shoulders, there is the difficulty of posing the rest of the body. Many people are awkward and self-conscious about their appearance, so they should always be provided with a comfortable chair in which to relax but not slouch, or, for a standing shot, some convenient prop to lean against. At the very least, the sitter should be given something to do with his hands, even if it is only holding a hat, for standing in isolation is an impossible task for most of us.

Eyes are the focal point of the face, and as such, should always appear sharp on the image. When you are working in extreme close-up with a shallow depth of field, or using differential focus, the eye nearer to the camera should be in focus. Lack of focus on the eyes invariably leads to

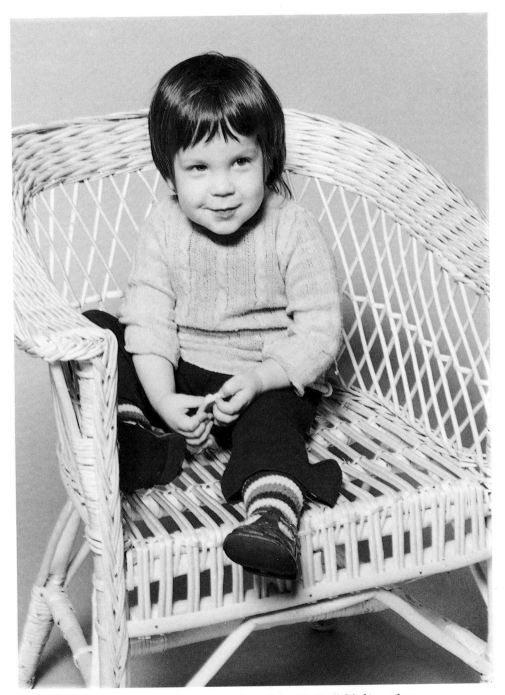

49 Hasselblad, 80mm, Plus X Pan. One Bowens Quad light, 'Big Top' fish frier at front top. A quick, informal 'snap'

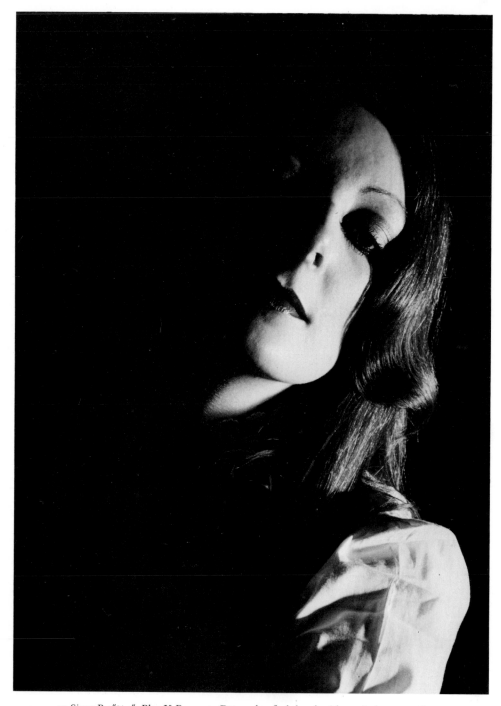

50 Sinar P 5″× 4″, Plus X Pan, one Broncolor flash head with conical snoot reflector

51 High-key portrait. Hasselblad, 150mm Sonnar, Plus X Pan. Softar for soft focus. Broncolor Hazylight front right, with a white card reflector from the model's knee to the camera position. Two standard flash heads on a white Colorama background, set at half a stop brighter than the foreground lighting

an unacceptable result, giving a dead, vacant appearance to the whole face or figure.

If the sitter wears glasses, and the glasses, being an integral part of his appearance, cannot be removed, you will have to pay particular attention to the positioning of the head relative to camera and lights to avoid reflections. Also, you should be careful that the frames do not obscure or detract from the eyes. Eyes, as well as glasses, are reflective, so you should always ensure that the light source does not create unacceptable and distracting highlights, particularly when you are working close up and

the highlights become more obvious. Soft focus and polarizing filters may help to minimize the effects of high spots.

The arrangement of the features of a face is how we recognize and identify an individual by sight. In reality, we can adjust to the fact that a face may have a over-large nose, a slight double chin or a poor complexion, but photography can exaggerate these features out of all proportion. Unless you are after caricature, it is not wise to depict your large-nosed, double-chinned sitter, whose skin suffers from open pores and wrinkles, using a wide-angle lens close to and from low down, lit by a strongly directional light. The result is likely to border on the grotesque for this sitter, while for another, with a completely different set of features, the same treatment may prove to be compelling and dramatic.

Conversely, photography also has the capacity to flatter. For the sitter mentioned above, a frontal light will minimize blemishes, a higher shooting angle and the consequent upward tilt of the sitter's head will slim down the chin, and the prominence of the nose may be reduced by the frontal lighting. A three-quarter view of the head will show neither a profile nor a full face, and a more standard lens could be used.

Assess the subject critically, and aim to suppress any defects and accentuate good features by careful choice of camera angle, lens and lighting. Choose the direction and quality of the main light to suit the subject and the kind of mood you are trying to create. As a general rule, use one main light for the face, filling in as necessary with reflectors, and a secondary light may be used to highlight the subject's hair from behind. However, you should not be afraid to experiment: as every individual is different, so every portrait may be different, according to the subject.

Check list

1 Examine the subject for good and bad points. Try various camera positions and poses for the best result.

2 Make sure that the subject's hair is tidy and the face is not shiny. Women, on the whole, will pay more attention to this than men, and although some masculine types may be averse to having face powder applied, sometimes it is essential, to avoid a glowing nose.

3 Discuss choice of clothes with the subject before the session. Some styles and colours will not suit photographic treatment of a particular sitter, and this should be pointed out tactfully, emphasizing those which will suit rather than those which will not. High collars or polo necks are not flattering for anyone, for they leave the face perching in an almost disembodied way; clothes with a slimming effect are generally more suitable, as photography is often supposed to add about five pounds to the apparent weight of the subject.

It is no longer common to retouch photographs for the purpose of flattering the sitter, although in advertising, where perfection of image is the aim, retouching is often used. We are now so familiar with the

snapshot picture of ourselves that we perhaps feel too uncomfortable when faced with a completely bland representation of ourselves to accept it. Styles have relaxed considerably since 1970: previous to this it was expected that everyone should appear perfect and fashionable, everyone wore similar clothes and hair styles, and any variation from the norm was more or less frowned upon. During recent years, a change in attitude has led society away from this structured outlook. However, although we are now attuned to a 'warts-and-all' approach, we nevertheless expect that a formal portrait by a professional photographer should perhaps show us in a more ideal light.

GROUP PORTRAITS

Weddings
A wedding is a major social event in a family, and a professional photographer is normally required to record a selection of key moments in the festivities, together with group shots of the principal participants and the guests.

The photographer is booked well in advance, which gives you time to make your arrangements and plan the pictures to a precise degree. Before the event, you should make sure you have all the facts at your disposal, including, first and foremost, the place, date and time.

Some photographs will be required at the ceremony. Assess the location for its suitability as a setting for wedding photographs, which should, after all, be a little less prosaic than normal. A pleasant garden is rather more romantic than a car park. If the place is a church, find out from the vicar or priest where photographs may be taken.

The reception venue is often more suitable for photographs than the church or register office, where there is often no time available because of other weddings; the setting, too, may be less pleasant, and guests are often keen to get away to the reception.

Lastly, find out where photographs may be taken in bad weather.

The number of photographs you take varies according to the charges made. If many pictures are wanted, and you have to be present through the whole proceedings, make it clear that you must charge accordingly. Often, you will simply be expected to cover the ceremony and take one or two shots at the reception.

The shots required as standard are:

> bridegroom and best man;
> bride arriving with father;
> signing the register;
> bride and groom;
> bride and bridesmaids;
> bride and groom with close relatives;
> full group of all the guests;
> in the car after the ceremony;
> cutting the cake.

To this can be added the procession down the aisle and other shots of the ceremony, as allowed by the priest; speeches and toasts at the reception; and any other specified individuals or groups. It is also tactful to be *au fait* with any points which may cause embarrassments or distress, such as in the case of family divorces or deaths.

When you are taking photographs at a wedding, you may find yourself hindered by guests who have brought their own cameras. Not only are you bound to feel a certain degree of resentment in that they are effectively robbing you of sales of prints, but you may feel that you are not in a position, as an outsider in a family celebration, to be giving orders. However, you must remember that you have a responsibility to your clients, the bride and groom, to produce a record to act as a happy memory for many years, and you must not be distracted or overwhelmed by other guests.

The next stage after the wedding is to produce a set of proofs for inspection. If you are able, you can boost your sales by returning to the reception with proofs, so that the guests, who may have travelled some distance from home to be present, can order at the time, with the event still fresh in their minds. As time often precludes this, the more normal procedure is to arrange an appointment subsequently. How you choose to conduct your business is up to you: you may decide to supply a set of finished prints in an album as a package deal, or alternatively you may prefer to allow clients more freedom of choice with shots and albums.

For special effects in vignetting, many laboratories are able to make prints with flowered borders etc., and there is a wide range of mounts, frames and decorative display material to appeal to all tastes. Make sure you know what is on the market by reading the relevant professional magazines and visiting exhibitions, and keep examples to show to clients.

One word of warning applying to all dealings with the general public: although you should not suspect your customers of being dishonest, you would be well advised to have at least some payment in advance, and beware of allowing customers to take away any material not paid for.

Remember that much of your wedding business is a result of personal recommendation. You are also carrying a great responsibility: a wedding is not repeatable.

FASHION

Whereas portraiture means a representation of an individual, showing features to allow the viewer to recognize the identity of the subject, together with an indication, however slight, of character, other aspects of photography of people are completely the reverse. The model as an individual is not the point of the picture: the model is a means to an end, to show off clothes and make-up, to set a scene, to be a graphic image, or just to be attractive. The fashion shot suppresses the identity of the model beneath an intentionally created façade, and it is generally not required that the shot of the model be accepted, even if it is seen, by the model herself (or himself).

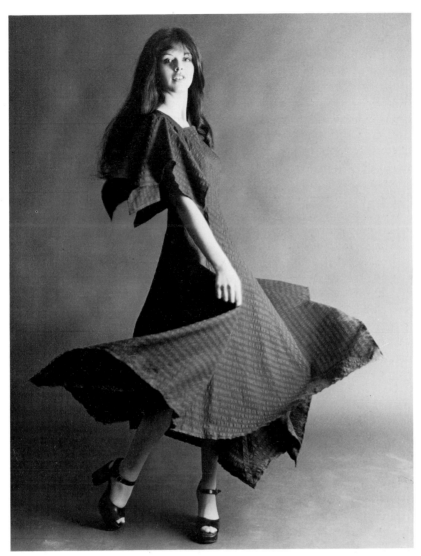

52 Hasselblad, 80mm. One Bowens Monolight with silver umbrella on the right-hand side

There are two fairly distinct types of fashion photography: mail order, and editorial and advertising.

Mail order
Mail order catalogues are big business and a source of regular work for a professional photographer. Many catalogue publishers employ full-time studio staff to handle their requirements, but other companies and shops also place mail order advertisements in magazines. Because the purchaser of the garment is buying 'unseen', the photograph must furnish a comprehensive description of the clothes for sale. The overall look and cut of the clothes must be shown, and details such as stitching, buttons,

53 A stylized fifties look. Hasselblad, 60mm Distagon, Plus X Pan. Broncolor Hazylight front left, standard head and barn doors side right

collars and cuffs must be made clear. Photography has limitations, in that it cannot convey the 'feel' of the fabric, but texture should be suggested.

Thus, much mail order photography is on a plain backdrop, or in a setting where the scene is unobtrusive or suggested rather than emphasized. The models may be posed on the deck of a ship, but the sunshine will be bright, the background defocused and the clothes described down to the last buttonhole. The models themselves are generally attractive but 'normally' proportioned people, and it is in this area that there is a call for models other than women, for men and children are also in demand.

Equipment used must be of the highest technical quality to achieve the required degree of detail, and $2\frac{1}{4}''$ square or similar size is the most suitable format. Lighting will generally be of the overall, shadowless variety in the studio, or, outside, there should be plenty of daylight for maximum clarity.

Fashion editorial and advertising

This area is generally considered to be the more exciting and creative of the two aspects of fashion work. Fashion editorial work for such magazines as *Vogue* and *Cosmopolitan* is highly prized by photographers. The direct financial rewards are not considered to be particularly great in comparison with equivalent advertising material, but the prestige is enormous.

The intention in editorial and advertising, as opposed to mail order, is not to show off a garment down to the last stitch, but to depict a collection of clothes or a single item within a mood to reflect the current style. In an extreme, it may not be possible to see very much of the clothes at all, but this does not matter if the pictures capture atmosphere. It is expected that the reader will take this as a starting point to create her own look.

The scene to be set depends entirely on the clothes themselves and the ideas of the client, and the scope is unlimited. Not restricted by the confining of attention to detail in the product, any location may be considered, and any approach or lighting technique may be used.

Models

For professional work, it is preferable to use a professional model, booked through a reputable agency. A client may often suggest cutting costs by using someone he knows who may be suitable, but this is rarely successful, and may lead to embarrassing situations when the photographer has the unenviable task of informing his client that his daughter, say, is too fat or too thin, or, although visually attractive, is simply not photogenic. Remember that a pretty girl will not necessarily make a good model: the only way to assess how she will appear in a photograph is to make some test shots. A quick snap under very simple conditions will do: it will show you not only how her face and figure will appear on film, but also how comfortable she is in front of the camera and how

quickly she is able to follow your instructions. A relaxed and 'natural' amateur model, or a professional, makes working considerably easier for the photographer as he is not continually having to explain to her exactly what he wants to achieve. It is assumed that a professional model will have been trained in the use of make-up, and will be able to adopt expressions and poses to order.

An agency will supply photographs and information about the models they have on their books, and transactions are made through them rather than with the model personally.

When you are booking a model, there are several points you must remember when considering her suitability for the job.

If you are working on a commissioned assignment, the 'look' of the model is usually of vital importance. Her face and general appearance must be totally in keeping with the ambience to be created, and a homely, soft girl may be completely out of character where the intention is to show a futuristic, dynamic approach, and vice versa. Therefore the client must be consulted before the booking, although in instances where the mood is particularly critical, he will often choose the model himself.

Although the agency supplies photographs, you should ensure that the model looks the same as she did when the picture was taken. She may have dyed her hair, changed its style, or put on weight. Check that if the hair is dyed, the natural colour is not showing at the roots, that she has no recent scars which cannot be disguised or has not returned from holiday with an uneven sun-tan.

You should ascertain the area of modelling in which she specializes. Many models on agencies' books concentrate on publicity, demonstration or mannequin work rather than on still photography, and many are involved particularly with TV commercials. Some have good hands, feet or teeth, for instance, and consequently specialize in this way. You should also find out whether she has any objections to nude work, to save embarrassment and a waste of everyone's time when she arrives at the studio to be told to disrobe and refuses.

It should not be the job of the professional photographer to prepare his model for the shoot. At the very highest level of editorial and advertising photography he will have the assistance not only of an experienced model, but also of a beautician, a hair-stylist and a fashion expert, all of whom will have considerably more knowledge of clothes and cosmetics than he himself. When this professional advice is not available, although you may express a preference for colour – bright red lipstick and green eye-shadow, say – it is usually wise to leave the final selection to the girl. She knows the type of make-up most suited to her skin and colouring, to create the effect you want to achieve. As a rule, it is not important to keep a comprehensive stock of cosmetics, apart from powder, blusher and body make-up in various shades, as women generally do not care to use items known to have been used by someone else. They are also more familiar with their own make-up, and consequently more skilful in applying it, than with strange products.

Clothes for fashion photography will be supplied by the client, but it is useful to keep a stock of clothes and accessories for glamour work, and a robe to wear between sessions will be appreciated by the nude model. Space to hang clothes, a comfortable and warm changing room and well-lit mirrors are essentials, and privacy in the studio during photography is desirable.

Once the session is over, you must ask the model to sign a form, called a model release form. These are available ready printed from some professional or amateur photographic associations. Alternatively, you can write to the effect, 'I, , in consideration of the fee paid to me for photographic modelling, understand that the photographs taken do not represent me personally, and I relinquish all rights to the pictures taken at the photographic session on the above date.' Without this documentation, if you publish the photographs or use them in any other way, the model retains rights to the pictures and you are liable to prosecution for their use.

For subjective fashion work you should have an extrovert personality and manner which will allow your models to give of their best. You will need to work quickly because the shots are often full of movement, so it is helpful to have a motor drive on your camera, which should be of medium format or 35mm. You should be prepared to shoot a large quantity of material to capture the right combination of expression and pose, and it helps the flow if you have an assistant to change film for you. Keep spare backs for your medium-format camera so that the film may be loaded in advance and the back changed quickly, and it is useful to have two 35mm bodies, so that one may be loaded by your assistant while you are still working. This way, you can take your breaks when the time is right rather than when the film runs out, which it will do frequently. Constant halts are disruptive to concentration of both models and photographer.

Encourage your model at all times: tell her she looks wonderful and do not destroy her confidence by constant criticism or silence. Even if you do not keep up a flowing stream of chat, the odd 'Good' or 'Marvellous' or some such indication of admiration is helpful among the instructions such as 'Look up' or 'Move to the left'.

Unless you are on location using natural daylight alone, flash lighting is now most commonly used for fashion photography. Flash is not only more comfortable for all concerned, it allows you to capture movement more easily.

Try different techniques, experiment with alters and effects, and don't forget that you can allow freedom to your imagination.

Posing the nude
This will obviously vary according to the effect you wish to achieve, but there are some basic points to watch in the arrangement of the figure.

Foreshortening. Be careful that arms and legs do not come too directly forwards towards the camera. This causes them to appear short and

54 High-key figure. Hasselblad, 100mm Planar, Plus X Pan. Softar for soft focus. The lighting plan was the same as for the high-key portrait in Fig. 51

stumpy on the photograph, so try to position the model at a less acute angle to avoid this. Conversely, you can effect exaggeration of limbs by allowing them to approach the camera, increasing elongation with the use of a wide-angled lens. This is useful to achieve a long-legged look.

Body shape. Most people have a tendency to slouch slightly, and a straight back on almost military lines will usually produce a more pleasing image than a slight hunch, which will also cause sagging of the breasts and spare tyres of flesh around the waist, even on the slimmest of models.

When shooting in profile, the breasts cease to be separated, and the illusion of one breast with two nipples can easily be created. Make sure

that the camera angle overcomes this, or use lighting to outline the curves of the body clearly.

If the model is seated, crouching or kneeling, watch the position of the feet. It is easy to overlook the fact that although most of the foot is obscured, a few toes are showing behind the legs, giving a curious effect.

Although the model should be encouraged to relax, total relaxation will cause the muscles to become formless and the body to become slack. Remember that a normal pose in real life may need to be exaggerated to reproduce correctly on film, and whereas tension of the muscles is not usually maintained in reality, for photography it is essential.

Certain areas in bodies are inevitably unaesthetic; although this will vary from one model to another, the soles of the feet, under the arm, elbows and knees may be unattractive or show rough skin and scars.

Eyes. Looking directly at the camera, the model in the photograph will appear to be looking directly at the viewer, and her expression, linked with her pose and appearance, will set the mood of the shot. A direct gaze may appear inviting or as an accusation of intrusion, while lowered lids may be an indication of eroticism or demureness. Where the model is not facing the camera, the shot may appear as a relatively impersonal figure study, or may have voyeuristic overtones suggesting an unnoticed insight into the woman's private world.

Skin. The texture and colour of the skin can be altered considerably by the angle and the quality of the light used. Black, brown and sun-tanned white skins are easier to work with generally, although a very black skin may present some lighting difficulties with its reluctance to show detail. Darker skins will tend to produce a more attractive image than a pale complexion, which may appear unhealthy in colour and cause flare in black and white. In colour, a white skin will show a more glowing, darker shade on location if the evening light is used, with its lower colour temperature; in the studio, filtration can alter the effect. An alternative for transparencies is to underexpose by a stop or so for a darker picture.

The texture is emphasized or suppressed by the angle of the light, and you should use a raking light only if the skin is virtually flawless. However, again, filtration may be used to diminish the effect: a soft focus is particularly useful in figure work to disguise blemishes as well as to soften the image as a whole. It may be necessary to apply body make-up to the figure to minimize the difference in colour between the face and hands, and the rest of the body which is normally clothed and therefore often paler in colour. A light application of oil to the body can also add depth to tone, and increases the sensuality.

12 Projection

A simple method of projecting an image into the subject of the photograph you are taking is to use an ordinary slide projector, suitable when working with natural daylight or tungsten. For working with flash, the focusing spot projector is used, synchronized with the lighting system. In both cases, the lighting must be carefully balanced so that the projected image does not appear dim in comparison with the main sources.

BACK PROJECTION

The transparency is projected by an ordinary slide projector from behind onto a translucent screen, and viewed from the front. Plenty of room is needed at the back of the screen. Because of the difficulty in achieving a correct balance of light between the screen and the subject in front of it, it is often necessary to double-expose. Expose for the foreground, covering the screen with black cloth, then expose for the screen image, with no foreground lighting, varying the aperture according to the readings taken.

FRONT PROJECTION

This has tended to supersede back projection for the purpose of professional photography. It occupies less space, lighting is easier to control, and the general quality of the projected image is superior. If you are going to use front projection professionally, there is no substitute for a fully integrated, flash-synchronized system compatible with your other studio lighting.

The projection unit and the camera are mounted at right angles to each other on a stand. The projector is connected to the flash pack and the slide placed in front of its lamp to be focused by a lens.

A half-silvered mirror is fitted on the stand at an angle of 45° in front of the camera lens. The camera is able to see through the mirror, while the beam from the projector is deflected to run parallel with the angle of view through the camera lens.

A front projection screen is made of a special material which intensifies the image. This is obviously necessary, otherwise the projected image would appear on the subject, in the same way that the picture appears on you if you walk in front of a conventional slide projector. The screen is fragile and extremely expensive, so should be kept carefully behind rigid shutters to protect it from damage when not in use.

Do not allow the lighting for your subject to spill onto the screen, for this will desaturate the projected image. Remember that the beam from

the projector is low-powered and intensified by the screen, so any interference from main lighting will spoil the effect.

Make sure that the camera lens and the projected beam are properly aligned. If they do not run absolutely in parallel, the subject will cast a shadow on the screen, showing as a black line.

Ensure that the balance of lighting between the subject in the studio and the projected image is correct. Also ensure that the quality, colour and angle of light between the two are consistent.

Although 35mm slides are adequate for projection, larger formats are recommended, giving a clarity more similar to the subject in the studio.

You cannot use the system for high- or low-angled shots unless you have a screen which may be moved to be square to the camera.

Front projection may seem to give you the opportunity to shoot your subject anywhere you choose, but this happy solution may tend not to work in practice, with results appearing disappointly false, for several reasons: incorrect lighting; incorrect alignment; difference in clarity between subject and projected image; an awkward meeting point between studio set and screen; peculiarities of depth of field.

However, when used wisely, spectacular and very realistic effects can be achieved. The atmospheric approach tends to be generally more successful than the factual: a hazy sunset, for instance, or a stormy sky, often gives a more acceptable picture than a pin-sharp building or city street. Also, non-representational images are very effective – colours, shapes and patterns of all kinds.

13 Still life

A still life is a deliberate or chance arrangement of objects, usually inanimate, in which you have total control over your subject. It is exacting and challenging work, depending entirely on lighting and composition to describe the essence of the subject and to convey atmosphere and message, and demands absolute attention to detail.

Still-life images are to be found everywhere in ordinary situations, and the practised eye will note the possibilities of a picture in familiar things. Often the essence of a place can be captured better by a still life than by a general view: produce on a market stall or souvenirs in a shop window, say, may give a personal comment lacking in a wider shot which simply states where it was taken. It is important to cultivate the ability to isolate areas of particular interest, to see an object not for what it actually is, but in terms of its shape and colour, and how it relates to its environment.

A peach, for example, is not simply something to eat. For the photographer, light and shade emphasize the roundness and tactile quality of the solitary peach, and a pattern of form and tone is created when the fruit is juxtaposed with similar or different shapes and textures. When cut, the glossy flesh contrasts with the velvet skin and the hard irregular stone, and the sense of taste is stimulated. The theme of peppers has been examined by photographers, notably Edward Weston, where the pepper appears to be less a vegetable than a pattern of form and tone, reminiscent of a piece of sculpture or a curiously distorted human figure. The possibilities of describing a simple object are endless, and it is the photographer's aim to enable the viewer to share his impressions through the image he has made.

The standard equipment for still-life work in the studio is the large-format view camera, usually 5″ × 4″ or 10″ × 8″. The majority of professionally commissioned still-life work is product photography, which is likely to be reproduced by mechanical printing, so the highest technical quality and the best possible definition are essential. The monorail camera has the advantage of swing and tilt movements which enable you to bring the whole of the shot into sharp focus more easily, and to make corrections for perspective and distortion, invaluable when you are working in close-up.

LIGHTING

Lighting is of vital importance in all branches of photography. On location, there is little you can do to influence the light, but in the studio you have complete control. Although this chapter is essentially concerned

with still life, the observations on lighting relate equally to other studio work. Still-life photography has the advantage, however, that it is still: that you have the time to alter lighting angles to a minute degree without your model growing restless, and you do not feel pressed by the presence of another human being.

Whereas the composition of the shot cannot change the lighting, the lighting can change the composition, in subtle ways or dramatically, emphasizing or suppressing various aspects with bright areas or shadows, to the extent of totally altering the apparent shape of the subject. One has only to consider numerous horror movies to understand how influential lighting can be on the way the audience reacts. Would the werewolf be quite so alarming if he were not lit by an upturned spotlight under his chin? This kind of grotesque light can quite easily so distort its subject, creating unfamiliar emphasis and shadows, that even a normal face appears to be frightening. A strong directional light has the effect of dramatizing the subject by increasing the contrast. Clearly defined shadows add an extra element to the composition and should be positioned with as much care as a solid object.

Experimental work with lighting is important because it enables you to familiarize yourself with the equipment and explore its possibilities fully. A tight deadline on a job restricts the time available to try something new, and this, together with a certain amount of natural laziness, may tempt you to use the same old formula because you have used it before and know it works. A new approach may not be a better one, but you cannot prove this until you have tried.

Lighting a subject is not simply a matter of providing sufficient illumination for it to be reproduced onto a sheet of film. Controlling the light also means controlling the shade, as too much light removes contours and flattens the subject. When lighting a still life or any other subject in the studio for a natural effect, it is necessary to use one key light. Two or more equally strong lights will cast confusing shadows and the result will be theatrical. Psychologically, two main lights are disturbing, because we naturally expect only one main source, the sun. Presumably, if there were two suns in the sky we would expect two lights and consider two shadows to be normal. We also expect the sun to shine from an angle above the horizon, but if it were to shine upwards from beneath our feet, underlighting would be nothing extraordinary.

Most subjects are not, however, lit by one single light source in the studio, although the impression may be given that only one has been used. Instead, the subject is lit by a subtle combination of key light, secondary or fill-in light, and reflectors, which may be silvered, white, grey or even black. A black reflector may seem a contradiction in terms, but the art of lighting is not only to add light, but also to subtract it to achieve the required image.

Quality of light
Light sources vary in strength and concentration, the most diffused of all being daylight on a bright but overcast day, right through to the

intensity of a laser beam. Whether you are using tungsten or flash, you should have a range of lighting heads and reflectors able to give you a variety in quality of light.

Bearing in mind the atmosphere you want to convey in your shot, choose a key light as a starting point. It may be necessary to try several different lights, or light and reflector combinations, before you reach the solution you want. If you start with a large, diffused fish frier, you may feel that the shot lacks contrast, but a standard lighting head with an ordinary reflector adds too much, and there is insufficient distribution of light. For extra contrast with a fish frier, you could remove the opal diffuser totally, or try a honeycomb screen. This has a mesh shaped like a honeycomb, about $\frac{1}{4}''$ thick, fitting in the lamp head in place of the diffuser; it concentrates the illumination and gives greater contrast and a sharp cut-off for a light-pool effect, while still allowing the light to come from a large source. Standard lighting heads shining directly onto the subject will increase contrast considerably, and there are associated problems of heavy shadows, uncomfortable glaring lights for human sitters, and flare on any object with reflective qualities. The area of light cast by a direct lighting head can be controlled with various attachments, such as conical snoots which concentrate the beam in a small area, or barn doors, a fitment with hinged flaps which are moved to shade the light.

Often, standard lighting heads are not used to light the subject directly but turned away from it, the light being bounced back from a reflector, usually an umbrella attached to the head itself. This indirect lighting gives less contrast, shadows are reduced and problems of glare and burning out are decreased. Varying the type of umbrella used will control contrast: for a soft lighting effect, use a white umbrella, while a silvered version will give a harder light. If the studio has white walls and ceiling, the light may be bounced back from these surfaces onto the subject, providing a diffused, even illumination, although for difficult subjects this method is less easy to control than a fish frier.

Directional light
Although there are infinite numbers of possible main light positions, and endless variations with fill-in lights, reflectors etc., there are six broad areas from which the light can fall, corresponding to the six sides of a cube. Point 3 below is additional to these, but has sufficient importance in its own right to warrant a special mention.

In all the illustrations of the ship, the main light source is a 1 metre square fish frier (specifically, the Broncolor Hazylight), with no secondary lights or reflectors, although the backdrop was white paper and the wooden surface used for all except – for obvious reasons – point 6, light in colour.

Pages 129–132

55–60 Photographs of wooden ship model to show the effects of lighting direction

55

1 Top light Shadows are evenly distributed under the ship, and there is little differentiation between the tones of the backdrop and the wooden surface. The sails are given shape by light falling on the upward-turned curved surfaces, the spars, deck and bar of the stand are lit directly, and light reflected from the pale surface on which it stands picks out the portholes. No particular emphasis is given to any part of the ship, although all the details are recorded clearly. This type of light is ideal for a record shot of a purely descriptive nature.

56

2 Side light Shadows under the ship show the light to be falling from the right-hand side of the picture. The foresails are bright, the metal of the portholes stands out strongly in the direct light, the roundness of the

masts is clearly defined, and the ship is given depth by the shadows cast by the rigging on the sails. The overall impression is one of movement from left to right.

It would not be correct to light this particular subject from the left-hand side, as this would create a tension in the sense of movement, causing it to appear to travel backwards. Although side left light is technically a mirror image of side right, the Western eye is conditioned to travel from left to right across a page, and an image is also more comfortable psychologically if read from left to right. Side right lighting tends to pull the eye in the correct direction.

57

3 Top back light This is one of the most commonly used key light positions, normally in conjunction with reflectors (of the white card or paper variety rather than those used on lighting heads) to provide a soft frontal lighting. Without this fill-in, as illustrated here, the front of the subject tends to become rather dark, but considerable detail is shown on the deck, and the weave of the sail fabric can be seen. The brightly lit spars, their undersides in shadow, emerge strongly from the image.

4 Front light The weight of the hull is considerably diminished by the flare on its polished surface and by the lack of contrast between it and the surface it stands on. The frontal light gives little contouring to the sails and has the effect of flattening the subject completely. Although

58

useful to illuminate some flat surfaces, and to minimize blemishes, such as wrinkles on a face, this lighting direction is not used where it is essential to retain a sense of depth.

59

5 *Back light* This also has the effect of flattening the subject but the image is much stronger than with frontal light, with a pattern being created, as illustrated by the effect of the sails here. Without the addition of frontal reflectors, solid objects will appear as silhouettes, and care should be taken that fine lines do not disappear. The rigging and the tops of the masts are slightly weak in this shot as the flare from the light has turned them rather grey.

60

6 Underlight Generally considered to be a grotesque light, this is obviously not suitable for all subjects, although it works well for the ship. Good contouring is given to the hull and the sails, and the purity of the white surface leaves the overall impression of sharp, clean lines. Diffused underlighting is used mainly to provide a shadowless background and is normally a secondary rather than a key light.

When you light a subject, your lighting plan begins with the quality and direction of the key light. Then assess where, if any, secondary light is required. For a dramatic effect, or when the light is large and from an approximately overhead direction, no other direct light source may be needed, and you may only serve to confuse the issue by using extra lights. A spotlight is often useful to isolate a specific area of the shot for particular emphasis, or retain its importance when it is tending to become suppressed by other elements of the composition, but be careful about shadows, which are sometimes more obvious on the finished picture than on the set itself.

The next stage is to add reflectors, and at this point you should take care not to overlight the shot. You can use white card or paper as reflectors, but I have found polystyrene and foam-core board very useful, as they are light and rigid even when in large sheets, where card is heavy and liable to bow, and paper will crease and tear.

Difficult lighting situations
All objects are reflective to a greater or lesser degree, the extent to which light is thrown back at the eye depending on the nature of the object's surface and its colour. Look at the cover of this book and hold it at various angles to the light. When the light shines directly on it, it will show as a general area of flare in which the colour is desaturated and the image disappears. The eye, constantly moving and seeing in three-

dimensional terms, will accept this: it can easily alter its viewpoint to clarify the image. The camera, freezing the moment of time and space in two dimensions, is unforgiving, and will reproduce the cover so ambiguously that the viewer will not even be able to read the title. This effect is found on many surfaces not normally considered to be particularly reflective, such as ceramic pots, gloss paint, plastic and polished wood. The problems of flare necessitate a different approach to lighting.

Direct lighting with an ordinary lamp head is clearly incorrect, as you can see when you hold the book to the light. Direct lighting with a diffused source is preferable, and acceptable in some instances, while in others flare is still a problem. If it does not show as a high spot, the general intensity of colour is reduced and the surface may appear milky. Thus it may be necessary to ensure that no direct lighting falls on the surface at all, by angling your light carefully and using an equally carefully placed reflector to give you enough light to take the shot.

61 Direct *(left)* and indirect lighting – the effect on a reflective object, such as a silver tray

Chased or engraved metal, trays or items such as sports trophies, presentation tankards etc., are usually photographed for the purpose of showing the design or inscription. If you use direct lighting of any kind or incorrectly positioned reflected light, the engraving will disappear owing to flare, which rather negates the point of the exercise. When you are photographing a tray, try to arrange the reflector so that the surface is neither too bright (to avoid burning out), nor too dark, when the image will appear excessively harsh. An overall grey, although the engraving will show clearly, may appear dull, so to retain the reflective character of the object, allow a degree of gradation, perhaps to the extent of introducing a small patch of flare or solid black. A three-dimensional engraved object, such as a tankard, often benefits by placing it on opal Perspex lit from beneath, and using a combination of underlighting and top lighting to show detail.

'Pack shot' advertising photography is beset with problems of flare on packaging, with the widespread use of cellophane as a protective cover, and 'blister' packs, where the product is encased with its card in a less than smooth wrap of thick transparent material. The cellophane wrapper on a pack of cigarettes, for instance, can either be removed completely, as can the 'windows' in display boxes, or you can light in directly as outlined above. Cellophane bags, containing such items as sweets and other foodstuffs, and blister packs are more difficult to deal with as they

62 This solid silver bowl, the Davis Cup, presents the classic problems of reflection. Sinar P 5″× 4″, Plus X Pan, Broncolor Hazylight

are made up of a series of facets, one of which is bound to reflect direct light and cause flare. If this is not acceptable, it will be necessary to retouch the transparency or print at a later stage.

All polished metal objects are composed of a series of three-dimensional curves which have, for the photographer, the irritating property of reflecting all their surroundings. Odd reflections appearing on surfaces can confuse the shape of the object, and your client will rarely be happy to see a clear picture of you, your camera, your lights and a general view of your studio mirrored in the subject of the shot.

The standard method of lighting shiny objects has been to put them in a light tent, completely surrounding them with a thin, white fabric, leaving a small hole for the camera lens. The lights are then positioned outside the tent to provide an even illumination, minimizing flare and irrelevant reflections. Although this would seem to be an ideal solution, there are drawbacks. Because the object is so reflective, any creases in

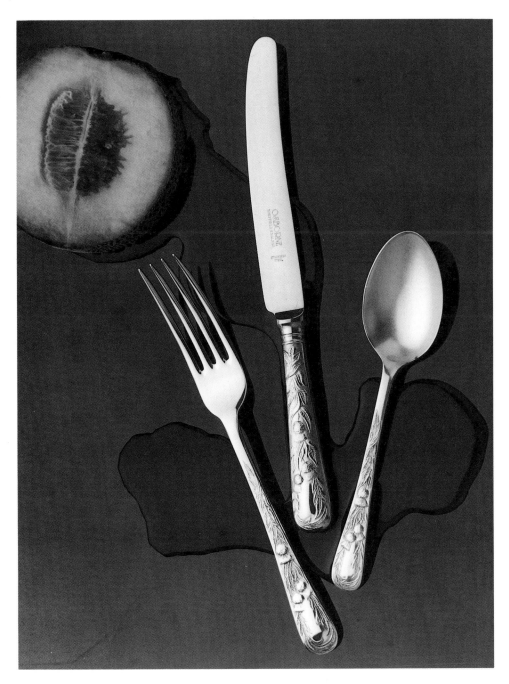

63 Sinar F 5″× 4″, Vericolor II Type S, Bowens Quad 'Big Top'. Photo by Andy Barber

the fabric will show. The quality of the light may be soft and diffuse in the extreme, but it precludes any attempt at drama and may not be the kind of approach you are aiming for. The tent also makes it rather difficult to get at the set for any re-arrangement, and completely surrounding the object gives no scope for alteration of a high camera angle, for the tent will be in the picture. The latter point may be overcome by using a half tent, where the camera and lights are surrounded, but the back of the shot is left open for a background to be introduced.

Another method is to use dulling spray. Used with discretion, this is a convenient way of eliminating unacceptable reflections, but you should be careful that it does not excessively alter the character of the surface on which it is used. For instance, a manufacturer who makes pewter in both bright and dull finish will be looking for a photograph to distinguish between the two, and if spray has been applied, this will be impossible. It also tends to give the surface a speckled appearance, and will smudge easily if touched. Proprietary brands of spray in aerosol cans are available in semi-matt, matt and black versions, and milk sprayed from an airbrush may be used as an alternative.

Fig. 63 shows a dramatic, graphic approach to photographing cutlery, using back-lit black Perspex and an overhead camera angle. Viewed from the front, a spoon bowl shows a complex series of unattractive, distracting reflections which cannot be removed by using a light tent, as the hole for the camera lens will inevitably appear. Under these circumstances, a light coat of dulling spray on the spoon bowl was felt to improve the appearance of the image as a whole, which, although intended primarily as a small shot in a catalogue, was also to be blown up to 60″ high for an exhibition display panel. The feeling of brightness and smoothness of surface in this picture, originally in colour, is retained by the Perspex and the pool of water.

As a contrast, this solid silver cutlery (fig. 64) was required to be in a more traditional setting, and the oblique shooting angle relieved some of the problems of reflection. In this case the major concern was the position of the light in relation to its appearance in the pieces of cutlery, together with the need to show the pattern clearly.

In both photographs a fish frier lamphead with an opal diffuser was used. An alternative is to construct your own diffuser, a frame of translucent material, such as tracing paper or the same opal acetate as in the custom-made lamps, and place this in front of a standard lighting head. This may be a reasonable solution for an occasional shot, but if you are going to need this quality of light on a regular basis, the makeshift diffuser has severe limitations. You are likely to find you have a 'hot-spot' effect corresponding to the position of the light: a manufactured fish frier is an integrated unit of lamp, reflector and diffuser, which a lamp with tracing paper in front of it is not. Also it is not easy to manoeuvre to change the lighting angle, so you may find yourself making do with a lighting arrangement because you have neither time nor, perhaps, the inclination to make a troublesome alteration, and the light will control you rather than you controlling it.

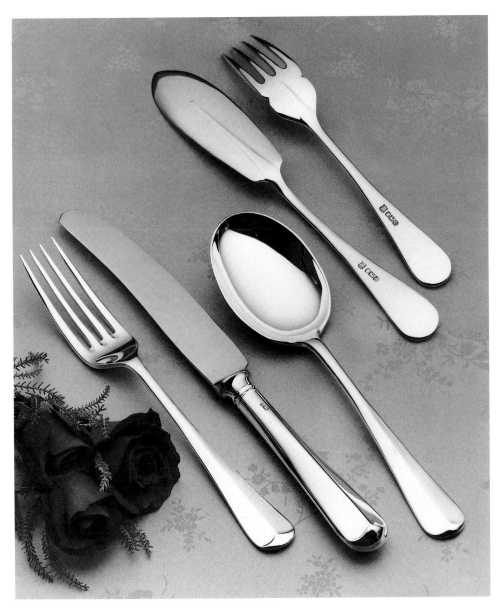

64 Sinar P 5″× 4″, Vericolor II Type S, Broncolor Hazylight

There is little apparent difference between a black-and-white and a colour shot of a polished metal object when it is photographed on a neutral background, as the effect in each is essentially monochromatic. If colour must be introduced, the temptation is to place the object on a colourful background, but my advice here is 'don't' unless little of that colour will appear reflected in the surface. Having once photographed a small silver bowl on a bright red ground, I discovered that there was no means of removing the red reflection from the underside of the bowl.

137

65, 66 Two shots of an antique decanter, to show the effect of different methods of lighting

In reality we can accept strong colours reflected in silver because we know the object is silver, not red, or blue, or any other colour, but in the photograph we cannot readily accept the effect. I had the red retouched out, but this made the image appear extremely false and totally dissociated from its surroundings. A more suitable way of introducing colour is to have a neutral surface, with props and backdrops arranged to add colour without swamping the object.

Glass is transparent, but it is also reflective, is apt to showing highspots and milky flare on its surface, and under certain lighting conditions it will simply disappear. As the purpose of a photograph of a piece of glassware is not to cause it to vanish, there are several rules you should observe to bring out the delicate qualities of the subject.

1 Glassware should not be directly lit. In certain circumstances, where the glass is not the main subject of the photograph, or where it has contents, direct lighting from behind may be acceptable, but this depends on the type and thickness of the individual piece of glassware and the colour or tone of its contents.

2 Ideally, glass should not be placed on a background of a strong colour as this will show through the glass and confuse the image.

3 All marks and dust specks will show, so polish the glass carefully, preferably with an anti-static cloth.

In these two photographs (figs. 65 and 66) of the antique ship's decanter, different methods of lighting have been used.

1 *Underlighting* A sheet of opal Perspex was placed over a sheet of glass for dimensional stability and curved up to form a smooth, continuous background. A single flash head was positioned under the Perspex to shine upwards underneath the decanter, and the light level was allowed to fall off to give a gradation in the shade of the background. Light is transmitted through the glass to highlight the top of the stopper, and the dark areas are created purely by the action of the light on this individual piece of glassware.

2 *Reflected backlighting* The decanter was positioned on a sheet of black Perspex in front of a white paper backdrop. A single flash head directed at the backdrop was the sole source of illumination.

The degree of light and dark in the object achieved by using either of these two systems will depend almost entirely on the shape and character of the piece concerned. A particularly delicate glass will obviously need a more subtle treatment, and care must be taken not to let fine lines burn out.

Where the glass is required to be placed on a dark ground and there is no possibility of using either of the methods shown, a small spotlight may be directed to illuminate it from behind, or a small mirror hidden within the set may be used as a reflector. Alternatively, a hole may be carefully cut in the background beneath the glass, and a light shone upwards through it as a form of underlighting, although this is not always practicable and does not allow for easy adjustments once the holes have been made.

FOOD PHOTOGRAPHY

The wide variety of colours, shapes and textures in food offer the photographer an opportunity to exercise his talents to create atmosphere with lighting and composition, and the exploration of the natural forms can be fascinating.

Food is advertised heavily and continuously in an extremely competitive market, and photography is now commonly used on the packaging of foodstuff to make the product appear attractive on the supermarket shelves. Home and women's interest magazines carry

editorial material of recipes, generally illustrated by photographs, and an increased awareness of health, nutrition, and cookery as a pastime has led to the publication of a considerable number of books, many of which have photography as an integral part. Individual manufacturers require pictures as reference material for their salesmen, for public-relations purposes, or for exhibitions, and so on.

Food also appears as a prop in many situations where the main subject is a home-orientated consumer product, such as all types of tableware and kitchen accessories. Simple arrangements of food, a bowl of fruit, for instance, present no particular difficulties to the photographer in terms of special facilities or treatment, but where the preparation of food is likely to be complex and the requirements specific, the situation is less straightforward.

The mouth-watering dishes we see so frequently in books have not been prepared by the photographer, but by an expert cook, called a home economist, whose responsibility it is to buy, prepare and present the dish for photography. An experienced home economist will know precisely how the food is supposed to look, and how to prepare it for the camera, which is rather different from preparation for the table.

However, a home economist is not always available, so it is useful to know how to present the food yourself, or how to instruct a helper to do it for you, as setting up a shot and working in the kitchen simultaneously may not be practical with tricky items, such as soufflés.

If you intend to become seriously involved with food photography, you will need the same kitchen facilities as a well-appointed domestic equivalent: a refrigerator, preferably a freezer (many foodstuffs are frozen) and a cooker, together with cupboards for storage. A microwave oven is helpful as it will cut down cooking time, and food may be arranged on a plate or serving dish to be re-heated very quickly.

For maximum appetite appeal, hot food must look hot, cold food cold, and all food should appear as we would like to see it, rather than how we usually do see it. A dish which may be delicious to eat will not necessarily photograph well, as we accept imperfections in presentation when the smell and the taste are good.

Food should be under- rather than overcooked. Parboil vegetables to heighten the colour and change their appearance from an obviously raw state, but cooking them fully causes them to lose colour and shape. Meat and poultry are cooked lightly, or sometimes not at all, but rubbed with oil and seasoning, then crisped with a blow-lamp. Meat which will be carved is cooked very slowly, to be done in the centre, and the outside is browned in the same way. For poultry, I have found a rôtisserie particularly effective. Treat fish carefully, as they disintegrate during cooking, and look unappetizing.

Most food will have a richer appearance if the surface is not dry. Paint with glycerine or oil for a gloss on pastry and meat, and spray fruit and vegetables with water from a mist spray.

Fresh ingredients must always be used, as blemishes will show. Where some vegetables are concerned, canned or frozen products are often more

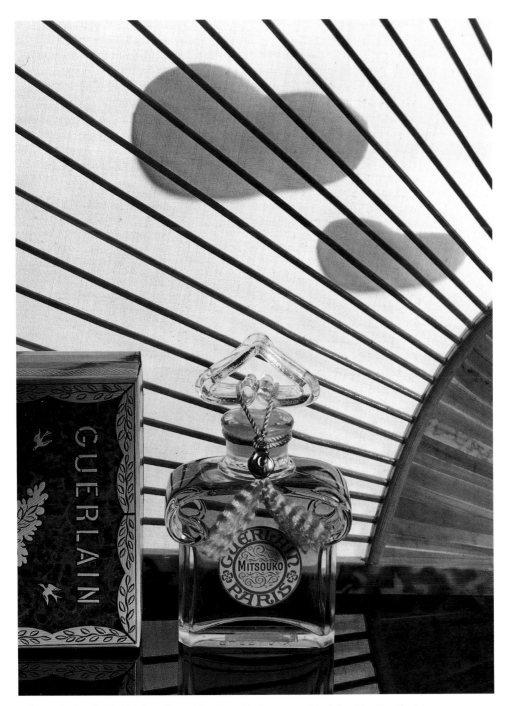

67 Sinar P 5″× 4″, Plus X Pan. Broncolor Spot Projector on the right side. Standard flash head to back-light the cloth fan. The 'clouds' are made of paper behind the fabric

photogenic than fresh ones, as they are of uniform size and shape, and require little preparation.

Make sure you have more than one sample of the food to be photographed. When I have photographed frozen gateaus, my client rarely brings fewer than three of each, which allows us to select the best, and guards against disaster.

Use convenience foods. It is easier and quicker to make sauce from a packet mix, instant mashed potato etc., than to go to the trouble of preparing the real thing.

All accessories to a food shot must be clean and suitable, and conform to health regulations.

DRINKS

Cold drinks such as milk shakes and beer often benefit from condensation on the glass to stress the coolness. This effect can be achieved by keeping the glass in the refrigerator until required, or the glass may be sprayed with water.

Bubbles in fizzy drinks and a head on beer can be created by adding a spoonful of sugar to the liquid.

Wine should be in the correct type of wine glass, and should be compatible with the food illustrated. Red wine will sometimes appear to be black, so a better colour may result from using a rosé instead. A heavy white wine may have an unpleasant green cast, exaggerated by greenish glassware: it may be better to use water as a substitute here.

Substitutes are often suggested for drinks: cold tea for whisky and coloured water for wine, but I have rarely found them successful, particularly in close-up.

A point to bear in mind is that the object of food photography is to produce an image, not to eat the result. Eating the samples may be very enjoyable, but don't be tempted to compromise the shot because the treatment required for it renders it unfit for human consumption.

Every subject is expected to be shown to its best possible advantage. Sometimes this is a forlorn hope and the photographer feels he is having to make a silk purse from a sow's ear. Where possible, the sample should be perfect, for it will receive close scrutiny from the client and, in turn, from the public, who will be able to study it at leisure on the printed page. On occasions, special samples are made, particularly when the object is small and it will be blown up to poster size; on other occasions you will be apologetically given a sample, imperfect, but the only one in existence (I once had a chicken brick to photograph, literally hot out of the kiln), and it is 'desperate' that it be included in the new catalogue, so it must be shot before the printer's deadline. You have no alternative but to use your skill and do your best; in extreme cases ask the retoucher to remove the worst of the imperfections afterwards.

The field of still life is a tremendous discipline for the professional photographer: he is working for an exacting and critical clientele.

CAMERA MOVEMENTS

The purpose of these is twofold: to control perspective, and to control focus distribution.

If the subject plane, the lens panel and the image plane are in parallel, then parallel lines of the subject will remain parallel in the picture.

Example 1 Set the camera as in fig. 68, centred on a picture on the wall. The picture will be square. If the picture is above camera level at zero position, use vertical displacement as in fig. 69 to centre the image. The picture will remain square.

Example 2 If the picture is too high on the wall, angle the whole camera upwards. Now the picture will not be square. On the image plane, the verticals converge because the three planes of subject, lens panel and image plane are no longer in parallel. Tilt the two standards so that they are vertical, and the picture will return to being square. Use vertical displacement to centre the image. This is the procedure for correcting perspective in architectural photography.

Example 3 If the picture is not centred laterally as opposed to vertically, horizontals will converge if your camera is at an oblique angle. Use swing on both front and back panels to keep the three planes in parallel (fig. 74) and lateral displacement (fig. 70) to centre the image. This is used in architecture where you cannot shoot from a squarely frontal position, or if your picture is a mirror, when you and your camera would appear as a reflection were the camera centred.

In these examples, the swing and tilt is used to correct perspective. It can of course be used to *distort* perspective. If we assume a situation as outlined in Example 1, with the three planes in parallel and tilt as in fig. 71, then verticals would converge at the bottom of the image plane, the top of the picture (remembering that the image in a view camera is inverted).

If the planes of subject, lens and image are in parallel, they will be in focus.

In the three examples given, focus is evenly distributed across the image because the subject is flat.

Example 4. Set the camera at a 45° angle over a table top. Without camera movements, depth of field is shallow and can be increased only by stopping down the lens. By tilting either standard or both, you can increase depth of field.

Tilting the lens panel alone will improve sharpness distribution.

Tilting the image plane alone will improve sharpness distribution but affect perspective.

Tilting both will improve sharpness distribution and allow perspective adjustments for the image you require.

The rule known as the Schiempflug rule states that if the three planes are not in parallel, the image is totally sharp only if imaginary extensions of each plane intersect at a single point.

68

69

70

71

72

73

68 The camera with all movements zeroed. Coarse adjustment to tilt, vertical displacement and focusing is by the lower, larger dial. Fine adjustment of the swing and tilt is made by the upper, smaller dials

69 Parallel displacement – vertical on both standards

70 Parallel displacement – horizontal (lateral) on both standards

71 Tilt on the front (lens) panel

72 Tilt on the back (image plane) panel

73 Tilt on both panels, showing calibrations to indicate the angle of tilt

74 Swing on both panels

Example 5. Assume the table and camera as Example 4. Adhering to the rule of intersecting planes may not give the perspective you require, so stop down the lens to increase depth of field.

The most effective method of learning the possibilities of camera movements is to test them in practice as theorizing makes the whole procedure sound infinitely more complex than it actually is. At first, you may feel that the camera has tied itself into a knot, and every movement you use serves only to confuse the issue further, but with practice, the operation will become second nature.

14 Location work

The chances are that the first photograph taken by an absolute beginner in photography will be an outdoor scene using daylight. All that he needs is enough light to give a reasonable exposure reading and the camera can be pointed at the subject, the button pressed and a recording is made as though by magic onto the film loaded in his totally automated piece of modern wizardry. On location the snapshot photographer and the professional are subject to the same conditions of weather and availability of light, but it is up to the latter to maximize his resources of technical ability and possibly greater sophistication of equipment to overcome difficulties which may dissuade the amateur from taking pictures at all.

EQUIPMENT

As with all commissioned assignments, the choice of equipment depends on the purpose of the photograph and its eventual use, but further consideration must be given to the practicalities, as there is an obvious limit to the amount of camera and extra lighting gear it is physically possible to carry. Photographers of the mid-nineteenth century used cameras of a size that we today consider to be large format, but the weight and cumbersome nature of the actual photographic gear and its associated processing equipment did not prevent these men taking pictures in extraordinarily inaccessible places, locations that most of us now would think carefully about approaching at all. Even now, dedicated photographers will carry impossibly heavy plate cameras and tripods to the tops of mountains because they feel it is not possible to achieve the same clarity of result with the use of a smaller format.

The majority of us, however, although dedicated to a greater or lesser extent, are neither physically strong enough to emulate this prowess, nor are we in a position to be able to justify the time spent on such an exercise and charge our clients accordingly. It may well be argued that the quantity and sophistication of the equipment one takes on location is directly related to the quality of the result obtained, and in a sense this is so, but we must strike a balance between quality and practicality.

The most convenient and simplest format for the professional to use on location is a 35mm with two or three lenses, a basic kit for picture taking, to which may be added the refinements of a selection of filters, a small flashgun and a lightweight tripod, none of which will significantly increase the difficulties of transportation. However, excellent as the quality of modern 35mm equipment and materials is, scope is nevertheless limited: transparencies may be too small for first-class reproduction,

and both transparencies and negative material may not enlarge to a high enough standard. Therefore an alternative would be to use a medium format of $2\frac{1}{4}''$ square, or 6cm × 7cm where the larger film area may provide the degree of quality required. For maximum definition and quality, a view camera is the obvious choice, but the drawbacks are that it is essential to use a strong tripod, and the sheer weight of the camera and its accessories means that it is often impractical to use.

Equipment should never become an intolerable burden. Remember that when you leave your studio, your purpose is to take photographs, and your sense of achievement should be with your end results, rather than with the fact that you have merely managed to carry large quantities

75–77 Three photographs of a country house. *Opposite*, Hasselblad, 50mm Distagon, from two different viewpoints. *Right*, Hasselblad, 150mm Sonnar. The house from the hillside opposite, reducing it from the main subject to a small element in the landscape. Note the solar panels in the centre of the frame

of things from A to B. Even when using 35mm, a large bag full of lenses and every conceivable accessory can severely inhibit relaxed working, as everyone who has spent a day on a holiday excursion will know. Instead of being able to concentrate on picture taking, one's mind tends to dwell on the weight of the camera case, and changing a lens can seem to be more trouble than it is worth. Also, when it is essential to work quickly, there is no time to be lost in making decisions as to exactly what should be used. There is a serious problem of security which should not be underestimated in certain areas where bag-snatching has reached epidemic proportions, and you can afford to lose neither your cameras nor your concentration in worrying about the possibility.

Choice of lens
One of the major disappointments with location work is that the features appear so far away, the mountains are reduced to molehills and a great expanse of flat plain seems no larger than an average sized field. You should know the capabilities and characteristics of the lenses you are using, and be able to select automatically the right one for the job.

The differences between the lenses is not simply a matter of how much area each will cover: they exhibit various photographic characteristics. In other words, it is not possible to use a wide-angle and enlarge a small part of the image as though you had used a telephoto, and expect the two results to be the same.

From a slight wide-angle to a fish-eye, wide-angle lenses cover more area from the same viewpoint as compared with longer lenses; have a great depth of field; and distort to a greater or lesser extent depending on the width of the angle.

Although you can use a wide-angle lens simply to cram something into the picture when you cannot move further away – the façade of a

building, say – you can also use it creatively to make the façade appear to be longer. Shoot from close to the building at a low angle: the considerable depth of field will cause it to be in focus along its length and height, and the parallels will converge rapidly, giving the impression of size by manipulating perspective. It will also be useful to convey a sense of space in the wide flat plain which the standard or telephoto lenses cannot capture.

The standard lens is so-called because the results it produces are the closest approximation of all lenses to human vision. It will give an accurate rendition of the landscape, or as accurate a rendition as the camera is capable of giving, with the added advantage that it is likely to be the easiest to use and the most flexible in its range of f stops.

Ranging up to 1000mm in focal length, telephoto lenses enlarge distant features to fill the frame; have a shallow depth of field; compress perspective; and are susceptible to camera shake.

With a telephoto, the distant mountain can be brought forward to fill the picture and give a more impressive aspect, which is important for transparency work where it is less easy to enlarge a portion of the image. The flattening of perspective can be particularly effective to bring out a looming hillside, or to give a graphic look to receding rows of roofs, for instance, or to banks of trees, especially when helped by misty atmospherics. The excessive length of telephotos compared with the size of the camera body make them difficult to control, and fast shutter speeds should be used to minimize the problem when hand-holding the camera, otherwise a tripod should be used. However, this presents further difficulties in low light levels: a fast shutter speed means a wider aperture, which still further reduces the depth of field. Having used a telephoto lens extensively on a sailing yacht, I can recommend using more film than is normal when in such unfavourable circumstances: from a roll of 36 exposures there might be one or two frames which have not suffered from the combination of a heaving deck and an unsteady hand.

PERSPECTIVE

Perspective is the means by which we assess the distance of objects from ourselves and the spatial relationship of the objects themselves, assuming that the objects are in fact what they appear to be. As we have seen, the rapidly converging parallels resulting from the use of a wide-angle lens cause a building to appear longer than it is, because we do not expect the vanishing point to be so close. Accurate portrayal of perspective is a stumbling block to many artists and graphic designers, as every photographer who has struggled to reproduce an impossibly constructed image will know; and graphic artists also, unlike the photographer, can manipulate perspective into total unreality, as seen in the drawings of Escher.

It is generally considered that there are two types of perspective.

78 Horizont, 2475 recording film processed DK50. This panoramic shot is the whole negative area, with the slight implication that the Earth is not flat

1 Linear　Parallel lines will never actually meet but, depicted in two dimensions, will appear to do so, at a point known as the vanishing point. In landscape, we find several features which lend themselves to conveying a sense of increasing or diminishing size, such as roads, railways, rivers and walls. Running straight, twisting or gently curving, these lines or divisions of the picture area not only provide a sense of scale, but create movement and form a scaffolding on which the composition can be built.

2 Atmospheric　Density in the atmosphere causes more distant objects to appear less clear than those close to; thus we expect to see a nearer mountain with more clarity than one further away. In urban areas where there is smoke, or where there is mist, cloud or heat haze, this effect will be more pronounced, and such conditions offer great opportunities for very beautiful effects. Morning and evening mist, coloured by the sun, can produce a delightful merging of land and sky, and there is an ethereal quality as features progressively vanish into the haze.

TIME OF DAY

As a rule, morning or evening light, with its longer shadows, tends to be more effective in defining topography or architectural characteristics than a midday light which will generally flatten features. The quality of light given by the morning or evening sun will also produce richer colours than the bleaching glare of noon. There is a greater contrast between areas of shadow and highlight when the sun is at its strongest. If, for instance, you are photographing a white building against a darker surround of trees, you must be careful to take an overall exposure reading of the scene in front of you. A reading from the white surface alone will give you a smaller lens aperture than a reading from the less bright section of the picture.

Sunrises and sunsets are particularly photogenic, and are more successful in colour than in black-and-white, as this is a subject where the essential appeal is in its colour. Again, the principal point to watch is exposure, as over-exposing will wash out the rich colours and destroy the power of the picture. So after taking an overall meter reading, bracket your exposure to give a range of, say, half a dozen shots, which should cover all possibilities.

When pointing the camera towards the sun, you should be careful of flare in the lens, and bear in mind that reflections on the elements and on any filters you are using are a strong possibility. Extreme caution should be exercised when viewing the sun directly through the camera. At morning and evening, when the rays are filtered through a greater thickness of atmosphere, there is less danger than at noon, when the strength of the light is not particularly good for the camera and, focused through the lens, can be a real danger to the far more valuable lens of the photographer's eye.

THE WEATHER

It is not necessary to restrict your location photography to a perfect sunny day, although extremes of weather tend to result in more interesting pictures than a dull, grey day which often simply produces dull, grey shots. Snow, mist, heavy rain and stormy conditions can often provide dramatic effects, although under most of these adverse circumstances your major difficulty will be a relatively low light level. However, the grainy quality of high-speed film should not detract from the atmospheric nature of the subject, and may in fact add to it.

If you are on a commercial location assignment, you would be well advised, on most occasions, to wait for good weather. It is a rare client who is happy with his publicity pictures shrouded in mist, and to go out in bad weather knowing the results are likely to be unacceptable simply because the job has been booked is a waste of everybody's time.

LANDSCAPE PHOTOGRAPHY

Landscape changes only with light and the seasons: the photographer has no control over it except to alter his viewpoint and his composition. One of the great themes in photography, landscape work is also one of the areas where the beginner may suffer a great deal of disappointment and be discouraged by his lack of ability to reproduce successfully the scene he knows was in front of his camera.

One of the factors contributing to the impact of a landscape is the sense of actually being in it, of being part of it oneself, and of having it completely surrounding one to the extremities of one's vision. Obviously, a photograph cannot do this, selecting as it does a section of the view and taking it out of context.

Landscapes stand or fall by composition, the arrangement of the picture elements and their tonal values. One of the fundamental factors in composition is the relationship between the land and the sky: the positioning of the horizon. This definite division between distinct elements of the picture is generally placed roughly according to the Golden Section, this being most pleasing to the eye.

Exactly how you position the horizon depends on how you 'see' the place you are in. Do you feel enclosed, or is there a tremendous sense of space? Is the land more interesting than the sky, or vice versa? If you feel the former of both alternatives is true, try a high horizon with a mere suggestion of sky, or none at all; if the latter sums up your views, use a low horizon. A central position gives an impression of symmetry, and is emphasized when the symmetrical nature is carried through in other elements of the picture, such as the converging lines of a straight road disappearing into the distance.

Earth, air and water
As a general rule, the sky is lighter than the land, except where there is snow or in certain stormy conditions. The actual brightness is emphasized when black-and-white film is used, because it tends to register the sky tones in a lighter shade than they appear to the eye, and together with the fact that the sky is likely to be slightly overexposed to allow detail to show in the land, we are left with a rather disappointing blank sky. To overcome this, there are alternatives we can use, such as filters (see p. 101). Alternatively, you can expose the picture for the sky, being aware that the darker land is likely to lack detail, but a strong silhouette should produce an interesting effect.

A third possibility is to print-in the sky in the darkroom. Unless the negative is severely over-exposed in the sky area, there should be sufficient detail to appear on the print, although it may need three or four times more enlarger exposure than the correctly exposed land. However, this method should be used with caution: tell-tale haloes of light sky are often seen to appear over horizons and behind trees on prints so treated. Also, I have seen photographs where the photographer maintains he has achieved a dark sky with the use of a red filter on the camera: he may have, but he has helped it along with printing-in at a later stage. A red filter alone will not magically produce pseudo-moonrises, or miraculously fail to react to clouds through branches.

Water offers a wide range of effects, from a mirror-like surface on a still lake to a complete contrast in a fast-flowing river or the spray of breakers crashing on the sea shore. Calm water gives superb reflections of the sky, the reflected image being darker than the real one and there-fore easier to capture in the overall exposure of the shot. Use the reflection of the subject as part of the whole image, or shoot the reflection alone to give a 'through the glass darkly' effect or a mute, ephemeral impression. For rapidly moving water, use a fast shutter speed to freeze the action; alternatively, a slower speed will blur spray into a white foam, so try a series of shots and choose the best result from these.

79 Cheddar Gorge. Nikon, 24mm, Plus X Pan, straight print. The sky was overcast and no filter was used

80 The same negative as Fig. 79, but the sky has been badly printed in to exaggerate the so-called red filter effect

ARCHITECTURE

Photography of the exterior of buildings, whether old or new, is tackled in much the same way as a landscape. The brief may be to show the structure as an integrated component of the overall scene, or to isolate it as a distinct entity. When you are commissioned, it is generally required that the building should be shown in the best possible way, and careful consideration must be given to lighting and composition. As with landscape photography, lighting is uncontrollable, and it is a matter of waiting for the right conditions, time of day, or even season to ensure a successful result. You may find that the main frontage of the building faces the 'wrong' way relative to the light, and will never be directly lit by the sun, leaving you with muddy tones and the problem of flare from the sky. Under these circumstances it is better to choose a hazy day for photography, where contrast is reduced. If the sun strikes the frontage in early morning or late afternoon, the raking light will define textures and shapes, the high contrast is working for you rather than against you, and colour saturation will be good. At midday these effects will be less pronounced, but a polarizing filter can be used to darken the sky and thus emphasize a light façade.

Where the building is isolated in a large site, you have a wide choice for camera position, but in towns and cities, proximity of other property causes many problems.

Frequently, the furthest away you can get is the other side of the street, and the angle of view is often limited to an extreme perspective, with the nearer corner towering above while the further retreats into infinity. This is exaggerated by the often necessary use of wide-angle lenses for the sole purpose of including all the building in one shot.

Other buildings close by can cause lighting problems as they may cast shadows. If no sun position will remove them, choose a hazy day, to minimize contrast as before. Windows will also reflect an image of surroundings, particularly noticeable on glass frontages, and although reflections may be used to dramatic effect on a purely pictorial photograph, a client may be less keen on irrelevant superimpositions, although sky images will usually be acceptable. A polarizing filter is again used to minimize reflections, and should be used when you are interested in photographing the subject behind the glass, such as a shop window display.

Photography of a building at twilight, when the windows are lit from within, can produce dramatic and atmospheric results, where clinical detail is not the prime objective. You must wait for the correct balance between internal lighting and the remnants of daylight, and don't forget that the eye will compensate far more than the film. It is often the case that a satisfactory balance is achieved photographically when the exterior light level appears to be too high.

Another problem with architectural photography in towns is the intrusion of normal town life, acceptable in reality, but less so photographically. You should take careful note of direction signs, lamp

standards, tattered posters and general rubbish interfering with the subject. A picture may easily be spoiled by a failure to shift the camera position a few feet to one side or the other. Heavy traffic is also a nuisance, and often it is preferable to do the job on a Sunday, when the place is less likely to be congested.

Pedestrian traffic is another difficulty on a busy city street. As you and your tripod are technically causing an obstruction in a public place, you are in theory liable to prosecution, or at the least, moved on, so you should make every effort not to make a nuisance of yourself. It is almost inevitable that you will collect a crowd of interested onlookers, who should be dealt with politely as they have as much right to be there as you, but you should be aware of accidental damage or even theft by a passer-by, and you will find the company of an assistant very useful under these circumstances.

Controlling perspective

If a camera is pointed up at a building so that the film plane is not parallel to its sides, the result will show the building apparently falling over backwards. Whereas this approach may be successful for a deliberately dramatic effect, in most architectural photography it can be visually disturbing and unacceptable to the client.

Thus it is necessary to use a technical camera with swing and tilt movements to correct perspective. A monorail camera is preferable to the older baseboard types, as modern buildings are often tall, and the rising front will be needed to eliminate unnecessary foreground and include the top of the building. It is also necessary, bearing in mind the extent of the movements you are likely to need, to use a Super Angulon wide-angle lens with its greater covering power.

If the building is particularly tall, and the distance you can retreat from it is limited, your camera movements may not be enough, so a solution is to ask permission to use a building across the street as a vantage point, and climb to a height approximately halfway up your subject.

Once you have corrected your perspective so that the sides of the building are precisely parallel, you should adjust fractionally so that the verticals converge very slightly. Exact parallels will cause the building to appear wider at the top on the resulting print. When your camera is positioned at the corner of a building, allow the corner vertical to fall back slightly, otherwise you will have a 'ship's prow' effect where the top of the structure will appear to be protruding over you.

Interiors

From a small domestic room to the vast inside of a cathedral, correct lighting of an interior is your major concern. Normal visually acceptable light levels are too low for photographic purposes and there is often a mixture of light sources within the picture area, with the associated variety of colour temperatures, and problems with flare and burning out.

With a relatively small interior it is possible and fairly easy to use flash to raise the light level inside sufficiently to balance the daylight outside,

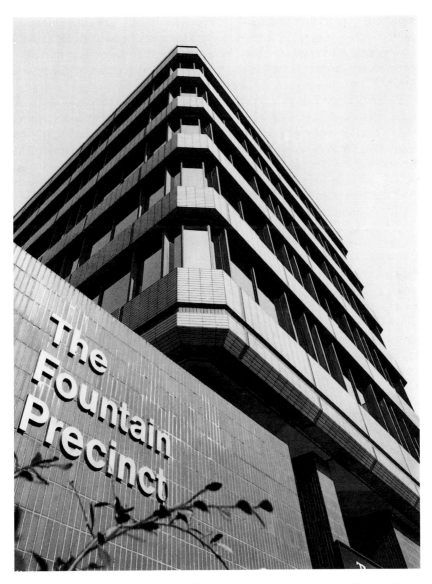

81 The Fountain Precinct. Hasselblad, 40mm Distagon, Vericolor II S printed on Kodabrome II paper. Printing black-and-white from a colour negative will often give a sky tone without further work, whereas filters would have been required with black-and-white negative material

thus retaining both detail within the room and the scene on the other side of the glass. If the interior light level is too low, the window area will over-expose, and there will be loss of definition around the frame. If this over-exposure is not too severe, correction may be made in the darkroom by printing-in, but for transparencies, the balance is critical. If you are working with colour materials, remember that you must use flash to mix with daylight, with a daylight-balanced film.

Not only must you have enough light, you must also ensure that it is even. Our eyes are capable of making adjustments which the film does not: whereas we can see quite well into a rather gloomy corner, the film, abiding by the inverse square law of the fall-off of light, will record it as being pitch-black, with a complete loss of shadow detail.

When you are using flash in an interior, it is most likely that you will be using a mixture of flash and time exposure for correct balance. There are no absolute rules: it a matter of achieving a balance depending on the individual characteristics of the interior in which you are working. If, say, the room is tiny and painted white, and the day outside is dull, you will need a longer exposure to record exterior detail than you would with the same lighting and aperture in a dark room on a bright day, where a single flash exposure may be sufficient. Where there are interior lights which must be shown, you must regulate exposure to allow them to record, but not burn out. For example, a single flash exposure to include a lit table lamp will not record the lamp as being particularly bright, as it will be completely overwhelmed by the flash. Thus you should give a time exposure of a few extra seconds to give the lamp more prominence. This applies especially to candles: a visually impressive candelabra will appear disappointingly feeble on a single flash. As a rule, it is preferable to allow candle flames to flare rather than to make them seem weak. With a long time exposure, if you are using not flash but available light, you may find the reverse situation applies, and the lamps will over-expose, so arrange for the lamps to be switched on for only part of the camera exposure.

Remember that when you mix artificial lights with flash, the lamps will appear more yellow on the photograph than in reality, but this is not usually detrimental to the image as a whole. For correct colour balance, you should of course use film balanced for artificial light, but if windows are included, the colour will then be incorrect in areas lit by daylight. Although it is not possible to use colour-correcting filters on the camera, the windows themselves may be corrected with large sheets of acetate, as used by film companies.

It is rare that the time required to illuminate a large area by the means described above, will be economically acceptable to the average client. There is no reason why huge interiors cannot be lit by arrays of flash-bulbs, flash heads or tungsten lamps, but the amount of light needed for the interior of, say, Westminster Abbey, is, to say the least, considerable, and setting up the lights is incredibly time-consuming. When you have an interior which cannot be lit adequately with the lights you have at your disposal, it is possible to 'paint' the walls with light. For this you use a long exposure, effectively not less than half a minute, and walk around with a floodlight during the exposure so that the area receives an even illumination. While you are in the picture area you must keep moving so that you do not appear on the film and the light must not be pointed directly towards the camera. However, the result of this operation is not easy to predict, as you will be unable to assess accurately how much accumulated light any given area has received during the exposure.

More commonly, the photographer must rely on available light, which is often in the form of fluorescent tubes. These are quite suitable for black-and-white work, as they provide an even light and do not flare badly when in the picture, but their spectral characteristics make them a non-starter for colour work. Normally, they will produce an overall green cast which can be partially corrected on negative material by filtration at the printing stage, although some colour distortion may remain. I quote from the Kodak *Professional Data Guide* a passage which is also relevant for still photographers: 'For television newsreel work where tests cannot be made in advance, use an artificial-light film and a CC40 red filter with any fluorescent tubes. This will not always give perfect results but if the picture content is sufficiently interesting and newsworthy, the colour quality will be adequate.'

Composing a photograph of large areas can often be controlled only by camera position, but with smaller rooms it often helps to effect a slight rearrangement. Photography visually enlarges the space between objects, so that what appears to be a normal gap between sofa and arm-chair appears almost as a three-lane highway in camera. Other elements of the room – ornaments, books, plants etc. – should be treated as though they were objects comprising a still life, grouped together or separated to form an aesthetically pleasing composition. It may also be necessary to move some items further away from camera to prevent size distortion because of their proximity, especially if you are using a wide-angle lens.

Wide-angle is used frequently in photography of small interiors, not simply for the purpose of covering the entire area in one shot, but also to make it appear to be larger. Tiny rooms can be made to seem spacious, boats and caravans more roomy than they actually are: all of which is advantageous to the seller when the photography is being used to attract buyers to the property.

People are unlikely to be included in a wide-angle shot taken for the reason outlined, as they provide a sense of scale to destroy the illusion. If people are to be included in other shots, you will need a short exposure to stop movement. A longer exposure, giving more depth of field with a smaller aperture, is suitable for a statically posed shot, otherwise there will be a suggestion of movement. Some movement in passers-by in a shopping precinct, for instance, may not be unwelcome, as it is indicative of a busy atmosphere. If you use a very long exposure, you may be able to eliminate passers-by altogether, the speed of their progress failing to register on the film.

INDUSTRY

Industrial location photography has many facets: overall views of construction sites, quarries, mines, factory floors, as well as individual items of machinery working in these environments; details of machinery; and human operations of all kinds. You should be prepared for relatively dangerous and dirty conditions, and make sure that you follow the normal safety rules applying to other workers on the site. Suitable

82 Nikon FM, Micro Nikkor, 400ASA colour negative. Using natural light and a tripod, the exposure was 1/15 sec. to give a sense of movement. The inherent grain of the film is in keeping with the craft of the potter

clothing and footwear is essential, and try to keep the equipment you take to a minimum, as you will doubtless be the one carrying it. It is, however, helpful to take more film than anticipated, to allow for bracketing exposures and variations in shots, and to take the inevitable extra pictures which have not been pre-planned.

Whereas with other branches of photography on location you may have the flexibility of waiting for the right time and conditions for best results, industrial photography may require more specific scheduling: a delivery or a craning operation cannot be delayed for you to be able to take better pictures, so you have the responsibility of making the best of the conditions there are at the time, using your ingenuity to overcome rain, snow and low light levels.

When machinery is in use, and when workers are included in the picture, it is important that they are seen to be observing the correct safety procedure. It is useful to have a responsible member of staff with you to ensure that this is being done: operatives are notoriously lax about using the guards or wearing the helmets which are required, and a photograph will be rendered useless in the case of such omissions.

Shop floors and industrial workplaces, by their nature, are not expected

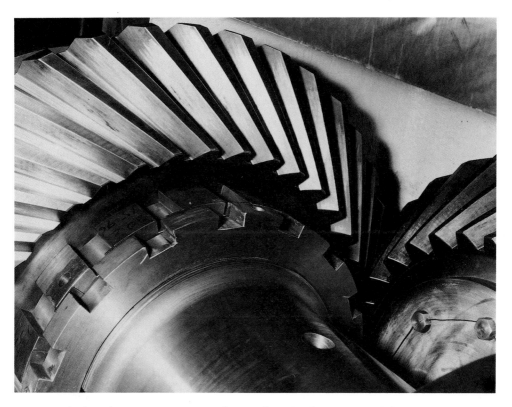

83 Gear wheels, a dramatic composition of strong lines, implying power. Calumet
5″ × 4″, 150mm

to be particularly clean, but they should appear to be tidy for the
photograph. Make sure that clutter is organized, coffee cups and cigarette
packs cleared away, floors swept and trailing cables put in order. Some-
times a re-arrangement of the tools being used by the worker is helpful
for a more visually pleasing image: during a recent commission at a
pottery factory I felt that the large red plastic bucket the lady was using
for dipping clay, although entirely suited to the operation, somewhat
dominated the image, whereas the less strident replacement we found did
not detract.

The majority of industrial equipment, even when new, is not in
pristine condition photographically. A machine, a drill bit or a hammer is
not intended to be a decorative object, but is judged as a functional tool
on the basis of efficiency rather than quality of finish. A photograph will,
however, exaggerate marks and blemishes, so if the brief calls for a look
of perfection, you must make it clear that you will require the item to be
specially prepared for photography or the picture must be retouched
subsequently. Machine tools and industrial items are often retouched at
print or transparency stage to remove blemishes, clarify details and
generally improve appearance. Machinery is often blocked out on the

84 Machinery already showing signs of use, so photographed at work. Black-and-white, from VPS 120

negative or transparency to give a clean, white background from which the object appears with more clarity. All retouching and blocking out, as already stated, is a skilled job. Blocking out looks easy, but this is deceptive: the straight lines of machinery are difficult to achieve, and an unsteady hand can give cables and hoses the appearance of a string of sausages.

On some occasions a lack of pristine quality in the machinery or working situation may be put to good atmospheric effect. Fire, dust, smoke, water etc. can all be used in conjunction with relevant machinery, providing a vitality and immediacy by showing work in progress, and serving to obscure blemishes in appearance as well as giving an 'explanation' of any paint damage or lack of cleanliness.

Space and access are often problems in an industrial situation. A wide-angle lens is a necessity in many cases, or a high viewpoint may be taken. It may even be physically impossible to position the camera for the best angle, so in some circumstances the solution may be to mount a high-quality front-silvered mirror in front of the camera and photograph the

reflection, remembering to reverse the negative when it is printed. Camera mounting where a tripod will not fit may be overcome by using a clamp with a ball-and-socket mounting for the camera, fixed to a convenient stable point. This is particularly useful when working on an overhead gantry or a crane.

Unless the job requires a 'scientific' clarity, I prefer to use a medium-format $2\frac{1}{4}''$ square camera for industrial location work wherever possible. This size gives quality and flexibility, allowing shots to be taken from positions inaccessible to a view camera. Easily portable lighting is preferable, if possible equipped with its own power source, although these units may not be powerful enough for the purpose. Most industrial locations will have a mains electricity supply, but it may be necessary to arrange for cable extensions to feed your lights. However, it is often more convenient to rely on available light and fast films, with some extra lighting to highlight certain areas rather than provide overall illumination.

In conclusion, industrial photography will require a certain amount of tact and diplomacy on your part. People going about their business may not care to be interfered with in a high-handed manner, although most will prove to be friendly and helpful when treated fairly.

15 Processing in the darkroom

CHEMICALS

All commonly used photographic chemicals are available from manu-
facturers in pre-packaged form as liquids or powders, ready to use from
the bottle, or more usually, to be mixed with a specific quantity of
water. Although at first glance it may seem to be a money-saving activity
to mix your own from raw chemicals purchased from a laboratory
suppliers, this argument has serious flaws for the busy professional.
Even pre-packaged materials are tediously time-consuming to make up,
despite the fact that the quantities are measured for you: so, with loose
chemicals bought in bulk, many more valuable hours are spent in
precision weighing.

Developers
During development, the highlight areas of the negative appear as
black silver first, followed by mid-tones, and finally detailing emerges
from the shadow areas. Contrast builds up during development and
grain becomes more pronounced. In simplistic terms, the longer the
development, the more contrasty and grainy the negative will be. Thus,
if you under-expose, intending to compensate by over-development,
remember this will occur, so unless the intention is to produce a negative
with extreme contrast, try to choose a 'soft' subject when you push
film in this way. Conversely, if you under-develop, the negative may
appear flat, as contrast has not been given time to emerge to a satisfactory
level. The terms under- and over-developing are of course related to the
temperature of the developer: a normal time in a cold solution will
effectively result in under-development.

These characteristics apply to all developers, colour and black-and-
white alike.

The increased use of smaller negative sizes led to a need for a developer
which would minimize the grain effect on the negative. Whereas the
grain would not be apparent on a 5″ × 4″ negative enlarged to a 10″ × 8″
print, a 35mm negative with similar grain characteristics enlarged to the
same size may, because of the degree of magnification involved, give a
result too coarse to be acceptable.

The most popular fine-grain developers in use today are D–76 and
ID–11. These are identical, the first being the brand name of Kodak, the
second that of Ilford. This developer is suitable for all normal require-
ments and material formats, and may be used in dishes or deep tanks.

Special films and developers for use in particular circumstances are
widely available, and photographic manufacturers will provide infor-

mation on what products they market and how the materials will react. For instance, Kodak produce a 2475 recording film, which when processed in DK–50 developer will give good results under street lighting conditions, although the effect will be rather grainy. Extremely fast films (rated between 1,000 and 4,000 ASA) are not only useful in low light levels, but with consequent development compensation can be used under normal conditions to produce interesting graphic images for special effect.

BLACK-AND-WHITE PROCESSING

Formerly, the normal method of processing negatives was in flat dishes, as prints are developed today. However, it is less easy to handle loose sheets of film than it is to handle prints, since negatives as a rule must be processed in total darkness, and film emulsion is generally more sensitive and susceptible to damage than that of paper. The time/temperature ratio is more critical in negative processing, and precise timing is required, as in darkness it is not possible to make a visual check on the progress of development. It is therefore sensible to use a more controllable method of processing, where films are placed on hangers or spirals; as they are never touched directly by hand during the time in developer, the risk is removed of uneven development caused by a slight rise in temperature through contact with the fingers.

Deep tanks are the most convenient for the professional photographer. Solutions are stored in them permanently and heated to temperature when required. Separate tanks are needed for developer, stop, fix and wash. Chemical tanks should have covers to prevent evaporation and contamination, but only the developer requires a floating lid to reduce aerial oxidation. In this form of processing, either the chemicals are used to exhaustion, or replenishment procedures are carried out according to the manufacturer's instructions. Darkness is required throughout the process until the films have been in the fix for several minutes, although room lights may be turned on once the light-tight lid on the fix tank has been replaced.

Small daylight tanks must be loaded in darkness, but once the films are in the tanks and the lid fitted, processing can continue under normal room lighting. Solutions are poured into the tank through a light-tight hole and emptied after each stage, to be either discarded or returned to an airtight bottle to be used again. The major disadvantage of these tanks for the professional is their small capacity: only a few films may be processed at one time. Also, because of the reduced size and consequent low volume of solutions used, the chemicals will cool rapidly if the temperature of the room is below normal, a factor very relevant in some of the new high-temperature processes. However, it is useful to have one of these tanks for an occasional special process where it would be wasteful to make up a large quantity of solution to treat one film only.

Deep tanks can be brought up to temperature by several methods.

1 Stand the tanks in a large deep sink which can be filled with hot water and drained when the required temperature is reached. A thermostat may be fitted to control the water temperature, but this is uneconomical and unnecessary when the chemicals are not in continual use.

2 Suspend the tanks in a hot-air cabinet where the air is heated by electric elements similar to those in a low-power radiator.

3 Use an immersion heater suspended temporarily in the solution itself and removed when the chemical is warm enough. The temperature is checked with a thermometer, and unless the room is exceptionally cold, only the developer needs to be heated. The only drawback to this method is that it needs constant attention to ensure that the developer does not overheat; forgetting to switch the immersion heater off can eventually raise it to boiling point.

Solutions for small daylight tanks are most easily heated by standing them in hot water (a fairly rapid process because of the small quantities involved), and again, if the storage conditions are warm, only the developer needs heating.

Processing in a deep tank line
Sheet film is loaded onto clip hangers which hold it securely at all four corners, and the hangers are suspended in a basket of a size to fit the tank being used, while roll films are loaded onto spirals and placed in a cage. Stainless steel spirals are recommended for regular use: they are stronger and can be dried more quickly than the plastic type. Also, choose those which are loaded from the centre outwards as they are generally easier to use and can be loaded when damp in an emergency, unlike the type where the film is fed from the edge of the spiral and pushed along a groove until it reaches the centre.

Black-and-white negative development is a function of exposure, processing time and temperature. Variation in one of these functions will affect the others; for instance, cooler solutions require longer processing, film known to be over-exposed will require shorter development, and so on. Although some compensation can be made at the printing stage for inadequacies in the negative, this should not be used as an excuse for careless processing, and it is wise to follow recommendations on time and temperature given for the particular combination of film and developer used, making adjustments only if essential to take into account known or unavoidable factors such as under-exposure in camera or relative weakness of the solution.

When development is complete according to the clock, the films should be drained and transferred to the stop bath before being placed in the fix. This stage halts further development of the image, but is not essential as the fixative has the same effect. Use of an intermediate stop bath, however, tends to prolong the life of the fix as the fix is not being regularly saturated with developer. The length of time the film needs to spend in the fix depends on the age and strength of the solution, but the general rule is that 'twice clearing time' is required.

At all stages of the process correct agitation procedure should be observed, particularly when the dry film is first immersed in developer. Omitting the initial agitation may leave air bubbles adhering to the emulsion, to cause undeveloped spots on the negative, and incorrect agitation may result in uneven development or a contrast which is too high or too low. Although not so important, agitation in stop and fix ensures a flow of solution around the negative and an even treatment of its total surface.

Finally, the negatives are washed in a flow of clean, running water to remove all traces of chemicals, immersed in a wetting agent to prevent the formation of water marks caused by uneven drying, and dried in a dust-free atmosphere. For fast drying, hot-air cabinets are used, and enclosing the film in a cabinet will help to protect it while it is in a vulnerable damp state.

Dish processing
Where there is no large throughput of black-and-white prints, it is normal to process manually in dishes of developer, stop and fix, followed by a wash in a sink or tank of running water and dried according to the type of paper. Several prints may be processed in the dish at one time by feeding them in and taking them out at regular intervals: fibre-based paper has the advantage here that the prints will slip against each other whereas resin-coated paper (see p. 175) must be arranged face to face and back to back to prevent them sticking together to cause uneven development and fixing. When transferring the paper from one dish to another, take care not to transfer fixer to developer, so use separate tongs for each dish, or rinse your hands thoroughly. Fixer on the hands will also mark unprocessed paper: a point to watch when printing and processing at the same time. Manual processing of prints allows the printer to assess the progress of the image through all stages of development and he may accelerate or retard areas of the picture if he chooses; but there is the temptation to 'pull' prints over-exposed in the enlarger or over-develop those which have been under-exposed, a practice to be discouraged as the result is never satisfactory. Paper should be developed according to the manufacturer's instructions with reference to type of paper, developer and temperature.

Machine processing
If large quantities of prints are being ordered regularly, manual processing becomes difficult and time-consuming. Another variable, too, has to be taken into account: chemical exhaustion, as there is no system of replenishment for dish processing. Also, the logistics of printing, processing and drying hundreds of prints at a time are formidable, and there is a strong possibility of noticeable variation in quality due to uneven development, inadequate fixing and general contamination. The printer, as well as the developer, tends to become exhausted. Some time ago, after having made approximately 1,500 half-plate prints over the space of two days, I felt that some form of automation was essential.

Resin-coated paper is ideal for machine processing because it requires only a minimum of time in chemicals and wash, and remains structurally sound when wet.

When purchasing an automatic machine consideration must be given to several factors.

Size Machines vary in size according to the type and size of paper they will take, and occupy a relatively large area of the darkroom. Not only must the dimensions of the machine itself be taken into account, but some types require more space around them to allow for ventilation and access. My own machine is a Meteor Siegen Metoform, which will accept paper up to 24" wide, requires little space around it, and has a dry-to-dry time of about four minutes. Although the width of the paper is restricted by the size of the rollers, it will take almost any length, and I have watched a print coming out of the drying section while still feeding into the machine unprocessed.

Power and water As the machine uses electricity heavily, the darkroom wiring must be sound, and it will need a power point of the same standard as a domestic electric cooker. A supply of running water is essential as the temperature is controlled thermostatically for washing, and the rapid wash means that water must be fresh and at the correct temperature for it to be effective.

Cost Machines are expensive to buy and expensive to run, so there must be absolute certainty that to have one will be economical. A machine should reasonably be expected to pay for itself in terms of convenience and time saved over a year or two. To reduce initial cost, look for a good second-hand model; to reduce running costs do not leave it switched on all day without using it, and where possible 'batch print' rather than do oddments of printing at intervals throughout the day.

Manual and machine processing have each their advantages and disadvantages. It has been argued that machine prints are of an inferior quality to those processed by hand, because it is not possible to monitor the print as it travels through the machine, whereas in the dish it is. However, if the exposure is correct in the enlarger, and if all dodging and printing-in is done at this stage, it should be unnecessary to interfere with the development of the print in the solution. Also, with a machine-processed print the result may perhaps be assessed better because the print will be dry and in a finished condition, rather than wet with fixer. Where large numbers of prints are being made, the machine will produce prints which will be standard, as the time in the chemicals controlled automatically and replenishment of chemicals ensures that they remain at the correct strength.

Using a machine will help to reduce the time taken in printing, not only because it will process a print to a finished state in under four minutes, but because it does it automatically, thus removing the need for a human operator. Although it is possible to print long runs alone, it

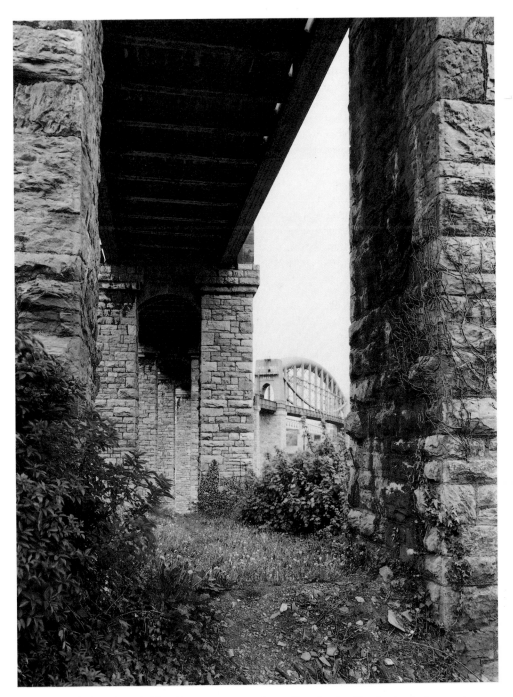

85 Under Saltash railway bridge. Exposure was made to allow for detailing in the shadow, and considerable shading was required on the print

is quicker and more convenient to have two operators working with the manual system, one to expose the paper and the other to process. With a machine doing the processing, it is easy for a single person to print and process simultaneously. A disadvantage of the machine is that it requires time to warm up, four minutes to produce a test, and another four minutes for the finished print, so it is not really possible to provide an instant rush service if the machine is cold. However, if the print were to be made manually, after taking into account the time needed for mixing chemicals and for drying, production time would not be much less.

Cost is closely related to time when the operator's hourly rate is taken into consideration. Reduction in actual printing time in terms of man-hours means that the operator is free to do either more prints or something else – in other words, the capacity of the studio is increased. The purchase price of the machine is obviously greater than the cost of dishes, and it is expensive to run because of the consumption of electricity. Chemical consumption will be similar, except that the chemicals in the machine tend not to deteriorate as quickly as those left in a dish, having a larger volume relative to the surface area. The same quantity of developer left in a large flat dish, particularly if partially used, will not remain workable, whereas the chemicals of the machine, with continued replenishment, will have a longer life.

Chemical dishes are spilt easily, and dripping solutions while trans-ferring prints is inevitable and messy. Having one's hands immersed excessively in chemicals can be harmful to the skin, and although it is sensible to wear rubber gloves or use tongs, this is somewhat incon-venient. With machine processing, the printer's hands are never in the solution, except in an emergency, so contamination is unlikely to occur.

Dishes, unless treated very roughly, will not be damaged or broken, and there is nothing in them which can go wrong. Machines are liable to wear and become faulty, and necessary repairs and replacements involve further expenditure. The pumps which heat and circulate the solutions are particularly vulnerable, and will overheat if the machine is accidentally switched on when there is insufficient chemical to cover the heating element. Chemical deposits dry and crystallize around the cogs driving the rollers, causing them to cease operating, so they must be cleaned at regular intervals. To clean the entire machine can take several hours, but should be done every month, and water baths should be emptied every day to prevent the formation of algae. Machines also have the irritating habit of devouring prints in their works, and to find a missing sheet of paper a certain amount of dismantling must be done. Adjustments may have to be made to the rollers before printing can continue.

Processing large prints

Prints too large for standard dishes or too wide to go through the machine are processed in troughs or sinks. Exposed in the normal way, the paper is rolled emulsion side in, placed in the developer and unrolled. Pull the print through the developer, ensuring that the whole surface is covered, and form a new roll. Repeat this procedure until the image has

fully appeared and finished development. The solution can be reduced to half strength, which will increase the time needed, but helps to ensure that the whole image is treated evenly. The print is then rolled through both fix and wash, similarly ensuring that it has been fully covered for a sufficient time, and finally hung up to dry on a line.

I use a series of three 42″ × 24″ × 6″ sinks for processing large prints, custom-made for the darkroom from PVC. Each is fitted with a waste pipe and hot and cold water taps. Two sinks are for developer and fix respectively, and the third, which is also fitted with an overflow, is for washing. Their width makes handling of large prints easier than in a trough, and the water supply and waste outlet simplify mixing and disposing of chemicals. When not in use and empty of chemicals, they provide a convenient surface to place dishes in for special printing operations or processing lith film.

ENLARGING

The factors affecting choice of enlarger are principally one's personal requirements and the funds available. Good second-hand models are advertised quite cheaply, but choice is restricted by what happens to be for sale at the time.

Before buying a second-hand enlarger, it should be thoroughly checked for damage, particularly to the bellows; where possible, ask to see it in use, and test for faults by exposing a few prints through it.

My own enlarger, a wall-mounted De Vere 54 with a cold-cathode head, was bought second-hand several years ago, and it has proved to be very reliable under heavy use. Fitted with a drop baseboard (see p. 172), in a room with a 9-ft ceiling, it will produce a 60″ × 40″ print from a 5″ × 4″ negative. Although the warm-up time required for the cold-cathode head can be a nuisance, only a little forward planning is needed to switch on the enlarger twenty minutes before starting to print, and experience tells how much exposure adjustment should be given, to allow for the increase of light during a long print run.

The points to consider, when buying new or second-hand, are: size of negative; degree of enlargement; type of head.

The enlarger must obviously be able to handle the largest negative size which will be commonly used. An enlarger which will take negatives up to 5″ × 4″ or 7″ × 5″ is the ideal size where one enlarger only is installed, as it is also conveniently small to use with 35mm negatives. If a 10″ × 8″ enlarger is required, then it is sensible to obtain another one for printing small-format negatives because the sheer size of the 10″ × 8″ makes it relatively difficult to use.

Most enlargers manufactured specially for the amateur market are small-format, 35mm or 120 roll-film size. The professional photographer who expects to be taking a significant number of pictures on a 5″ × 4″ or 7″ × 5″ camera will need an enlarger to accommodate negatives of this size. Although he may possess a 10″ × 8″ camera, the photographer may find he has so little use for 10″ × 8″ negatives that a 10″ × 8″ enlarger is

unnecessary. Negatives of very large format are generally used only for making giant enlargements, something which I feel is best left to a processing laboratory.

Commercial processing laboratories use horizontal enlargers running on floor tracks to project the image onto a wall-mounted easel. These are more powerful than the conventional vertical type, to compensate for the degree of enlargement they produce, and take up a great deal of floor space. Large prints are time-consuming to make, and mistakes lead to an expensive waste of paper, so the photographer must decide exactly how large are the enlargements he is prepared to tackle, before fitting out his darkroom. If the intention is to undertake printing of a less ambitious nature than photo-wall-size blow-ups, the degree of enlargement provided by a vertical enlarger can be extended by projecting the image onto the floor, either by buying a model fitted with a drop baseboard operated by rack-and-pinion gearing, or constructing a drop baseboard under a conventional wall-mounted version. A simple removable baseboard can be made by fixing the board to the wall with hinges and supporting it at the front with a wooden frame, soundly made to ensure that the board is steady and square to the film plane when in the 'up' position. To print on the floor, remove the frame and hinge the board down. This does not give a board with infinitely variable height, as the rack-and-pinion system does, but the relative positions of enlarger and board can be calculated to cover all sizes of enlargement.

Condenser or cold-cathode head

A condenser head gives slightly crisper image definition than a cold cathode, but a dusty lens can negate this advantage, and contrast in the print can be increased by using a different grade of paper. A condenser head will tend to produce prints showing dust spots and negative imperfections, and time must then be spent on finishing the prints to remove unsightly marks. Also, a full set of condensers purchased for every negative format will add significantly to the starting price of the enlarger. The major disadvantage of the cold-cathode head is that it must be allowed time to warm up, and while it is in use, the light level increases as the tube gets hotter. Therefore a test made while the tube is cool will not be relevant when the tube is hot, and when a long run of prints is being made, adjustments to exposure are needed to ensure that the first prints do not vary in density from the last. A condenser head uses a bulb as the light source, and the light rays are focused by condensers, which are convex lenses. The lens must have a focal length matched to the negative format to ensure even illumination, hence the need for separate condensers for each negative size. A cold cathode head is simply a fluorescent tube in a zig-zag form behind an opal plate which diffuses the light. Evenness of illumination depends on the design of the head: a poor design will cause the light to fall off at the edges of the negative.

A third type of enlarger uses the condenser system, with illumination provided by a point source which will give maximum possible image sharpness, but this is only really necessary for specialist scientific work.

A choice in the types of illumination is usually available only in the larger-format enlargers, $5'' \times 4''$ and above. Most small-format models are fitted with condenser heads.

Extras
Some models are fitted with sophisticated devices such as 'autofocusing'. This consists of a cam system which links the lens board to the main column, so that the lens is racked in and out to focus the image automatically as the head moves up or down the column to alter the image size. On a multiformat enlarger there will be several tracks and cams, one for each focal length of lens used. My view on focusing negatives is that the best method is a visual correction with the aid of a magnifier, and I feel the need to make a visual check for focus even when it is supposed to be automatic, which rather defeats the object of the gadget. The autofocus makes no allowance for the possibility of the negative not being exactly in the focal plane. Using it without checking is bad working practice.

Some enlargers are fitted with a tilting baseboard and negative carrier, working on the same optical principle as a monorail camera to correct perspective, so that converging verticals are made parallel. This facility is particularly useful in architectural photography where it is not possible to make corrections when the picture is being taken. It should be added, however, that it is more satisfactory to make the required adjustments in camera by using the swing back and front than relying on a tilting enlarger, which should be looked on as for emergency use only. Interesting creative effects, however, can be produced from normal negatives by means of the tilt device, although this is not likely to be in great demand for professional purposes.

Negative carriers serve one purpose, to hold the negative flat and steady during the time it is being exposed. There are two basic types.

1 Carriers of different sizes for each negative format hold the film on all sides, masking off light at the edges. Roll film should not be cut into individual frames, and the carriers will allow a complete film to be pulled through, some having cups at either side to prevent lengths of film swinging into the light path.

2 A single carrier which can be used for all formats, with adjustable masks to frame the negative. The adjustable type of carrier almost always contains glass to keep the negative flat; the other type tends to contain glass only for large formats, as these bow easily, and may be knocked out of focus by air pressure in the enlarger bellows. Glass carriers are useful to flatten damaged negatives and will hold those which are on a thin base, but the glass must be kept absolutely free from dust and fingerprints, which show clearly on the prints because they are on the same focal plane as the negative itself. Glass for carriers is extremely fragile as it is so thin, and spares should be kept in case of breakages. Window glass is not a satisfactory substitute because it is not optically correct.

Enlarger *lenses* should be chosen according to the same criteria as camera lenses. It is pointless to buy the finest quality camera lenses to produce pin-sharp negatives, and then try to print them through a piece of glass little better than the bottom of a beer bottle. In effect, the enlarger, of whatever kind, can only be as good as its lens.

Guessing exposures or using a clock is inefficient and unprofessional. An *automatic timer* will, or should, ensure that the same exposure is given over a print run of five or five thousand, and accuracy of the timer is especially important in exposures of only a few seconds, where even a slight variation will have a noticeable effect on the density of the print.

The printing *easel*, which holds the paper in position while the exposure is being made, should have a clean, smooth, white surface to enable negatives to be focused accurately. For borderless prints, there are two types of easel.

The simplest and cheapest form is a board with four adjustable corner pieces to mark the position of the paper without covering or holding it in any way. As some types of paper tend to curl slightly, the centre of the sheet may rise during exposure, rendering the print useless.

A vacuum easel which will hold the paper and keep it flat overcomes this problem. It consists of a thick board with holes in the surface on which the paper is laid. A vacuum is created in the board by a pump, thus forcing the paper flat against the surface.

Prints with white borders are produced by a masking frame with two fixed sides fitted with stops to vary the width of the border, and two movable leaves to adjust for print size. All frames are hinged to a board, but a useful addition to this is spring loading, which allows the frame to stay in the 'up' position without having to be held. I have found this extra to be invaluable when making a long print run.

A large number of identical prints may be made on a roll of paper fitted in a *roll box*, which is similar to the film magazine of a camera. The paper is advanced automatically by a fixed amount every time an exposure is made, and the box is designed to adjust for various sizes of paper, producing prints with or without white borders. Processing the exposed roll is possible only with an automatic print processor with the appropriate fitment, and the final stage is to cut the roll into individual prints. It is particularly useful for photographers with clients who need multiples of prints – for example, for mail shots or public relations.

PAPER

Black-and-white photographic paper consists of a slow-speed emulsion coated on a paper base. It has a narrow spectral sensitivity which allows it to be handled in safelight conditions, except where the paper is panchromatic and like all such materials must be used in total darkness. Before the early 1970's, all photographic papers were based on ordinary paper fibre, which, although easy to handle when dry, became more awkward when wet owing to absorption of liquids into the fibre. Prolonged washing after fixing was necessary for fibre-based papers, to

remove all traces of salts which would eventually destroy the image, and mechanical drying on a flat-bed or rotary drier was needed if the finished print was to lie flat. If the print was to be glazed, it was fed into a rotary machine with a highly polished drum, or laid on a polished metal sheet under pressure, both of which had to be kept absolutely free from grit or marks which would damage the surface of the print. Although the long washing period could be shortened by using a chemical such as hypo eliminator to remove traces of fix, this was common only when archival permanence was required, or where water was in short supply. The process of producing a simple print from a negative could take up to an hour, and during most of that time the printer was simply waiting for each stage to be completed. To reduce the time needed, a resin-coated photographic paper was produced which did not need such lengthy treatment. The resin coat protects the paper and prevents it from soaking up chemicals, so it does not become fragile and difficult to handle when wet, and it does not require as long a wash to remove chemicals since it has absorbed none in the base. The image will process rapidly and yet be suitable for archival use, and because of its special surface, no glazing is required to finish the print. Drying is possible under the crudest of conditions without damage: a print would still remain flat if pegged up on a washing line. Although purists complained that resin-coated paper was not capable of giving as good tonal definition as ordinary papers, it became popular because of its convenience and speed, and is now universally accepted, to the extent that Kodak, for instance, is ceasing to supply fibre-based papers to the professional market except on special order.

Paper is available in a range of grades from very soft to very hard, to allow the printer to choose that which best suits the negative he is printing. A low-contrast negative can be given sparkle by printing on a harder grade of paper, and a high-contrast negative can be made less savage by printing on a softer emulsion. Where black-and-white prints are supplied to a block-maker for producing plates, the required degree of contrast should be checked with him first, but in general the choice of paper grade is a matter of personal taste. For really crisp prints, a high-contrast paper is preferred, but be prepared to hold back or burn in areas to give highlight and shadow details which a straight print will not show. Clients have personal preferences too, and it is good practice to supply two or three sample prints for him to see, with varying densities and on different paper grades.

A range of surfaces, such as matt, semi-matt, gloss and stipple is manufactured in all grades, and manufacturers will supply information to the photographer about their products. The grading system is not standardized, so a grade 3 in Kodak paper will not necessarily be the same as a grade 3 in another type such as Ilford or Agfa. Surfaces also vary, and one described as matt by one manufacturer may be different from the matt of another.

To stock a darkroom with a full range of paper sizes in all grades and surfaces is not practical, firstly because to do so requires a considerable

initial capital outlay, secondly because paper has a limited shelf life and will deteriorate, and thirdly because storage space may be a problem. It is therefore sensible to stock only the paper which will be used regularly, and buy specially as and when the occasion arises. The maximum size of paper kept in stock depends on the maximum enlargement capacity of the darkroom equipment, but for general purposes a useful stock to keep in cut sizes is 7″ × 5″ (17.8 × 12.7cm), 10″ × 8″ (25.4 × 20.3cm) and 20″ × 16″ (50.8 × 40.6cm), in matt and glossy surfaces of two mid-range grades. These can be cut down for smaller sizes.

Ilford Multigrade paper provides a viable alternative to stocking different grades of paper separately. The same stock may be used and grades altered by means of filtration in printing. This makes economic sense and is becoming increasingly popular.

Contact printing
Contact printing gives the best definition of all, as the film emulsion is in direct contact with the paper. No matter how good an enlarger lens is used, its intervention between the negative and the print will reduce the sharpness slightly.

In the early days of photography the large-format view camera was used almost exclusively, and contact printing was the normal method of reproducing the negative onto paper. However, with the increase in use of small-format cameras the negative does not provide an image big enough to see comfortably, and in commercial photography contact printing is used only for visual reference. When contact prints are supplied to a client, it must be made clear to him that they are intended only for visual reference, and he is supposed to choose which pictures he wants and the size they are to be by marking the contact sheet. Ludicrous as it may seem, I know of one instance where the client actually used prints from a contact sheet for making up artwork, was understandably disappointed at the finished mechanically printed result, and unfortunately blamed the photographer. Because contact prints are used only as reference, it is unnecessary to produce the quality one would expect to see in a finished print, and although the definition will be good, densities may not be absolutely correct.

EXPOSURE TIMES

Several closely related factors determine exposure times.

1 Power of the light source in the enlarger. The light given out by a condenser head enlarger remains constant from the moment it is switched on, although a new bulb tends to shine with more intensity than an old one. Cold cathode heads, on the other hand, are subject to considerable variation in light level as a result of the tube heating up while the enlarger is in use. Where single or relatively few prints are being made and individually tested, this variation is not critical, but when no tests are being made during a printing session of, say, half an hour, it is advisable to stop from time to time to check densities.

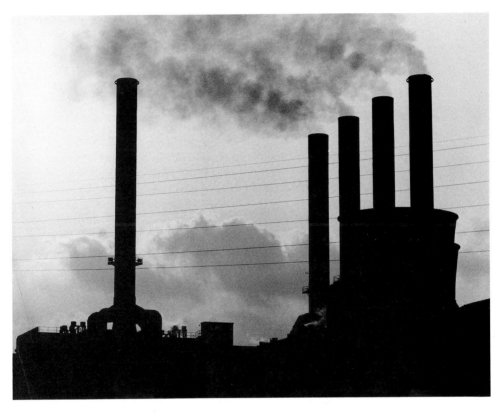

86 A contre-jour industrial skyline. Mamiya C33, 80mm Sekor, HP4

2 Effective speed of paper emulsion. Unlike film, paper speed is not expressed in terms of ASA or DIN, and varies from batch to batch and between different grades of paper.

3 Aperture of enlarging lens. The lens will vary the light according to the f stop, as with a normal camera lens. Ideal apertures for printing standard negatives are f11 or f8: a smaller aperture will necessitate long exposure times, and a fully opened lens will cause loss of definition at the edges of the prints. Where the negative is damaged or if the baseboard is tilted, stopping down will be required to achieve depth of field over the whole print, and a poor-quality lens needs a smaller aperture than a good one to give sharp focus. The advantage of paying extra for a better lens is proved here: the price saved by buying a cheap lens will soon be cancelled out by the extra time taken on exposures, when calculated according to hourly rates multiplied by the number of prints made in a year. Assume an average exposure increase of six seconds over 10,000 prints: 60,000 seconds, or 1,000 minutes, or 17 hours, or two working days in a year are thus wasted.

4 Density of negative. Two factors influence density, silver image deposit (the quantity being determined by the combination of exposure

and development) and the base fog of the film (a residual density over the whole negative and dependent on the types of film and developer used). Base fog on a print would cause degradation of highlights and is caused by excessive development when trying to compensate for under-exposure of the print, so a correct exposure to development ratio is essential to avoid it. Allowance may be made in printing for reasonable over- or under-exposure in camera, or slight imperfections during the processing of the film, but extremely thin or dense negatives will rarely produce satisfactory prints.

5 Degree of enlargement. The theory is the greater the magnification, the longer the exposure, with all other factors being equal. Following the law of physics, the amount of light on a surface falls off as the distance between it and the source increases. Consequently, a 10″ × 8″ print from a 35mm negative with a seven times enlargement will need a longer exposure than a 10″ × 8″ print from a 5″ × 4″ negative with an enlargement of only twice.

Exposure assessment
Various electronic devices are available to assess exposure and take into account all the variable factors involved, but they are accurate only in the sense that they can produce 'average' prints from 'average' negatives. They are invaluable under certain circumstances when it is not economical to make an individual test for every frame printed, such as when making a single print from every shot on one or several rolls of 35mm film. Any high-quality hand-made enlargements should be assessed visually by means of a test strip, arranged so that a representative sample of the density range of the whole negative is covered. For instance, to test for a print of a landscape, make the various exposure bands *across* the density contours in the negative, not with them.

COLOUR PROCESSING

Where the photographer is within easy reach of a colour laboratory which can provide him with a fast turn-round of processing, there is little advantage in his having facilities to do this in house. Exposed film may be taken to the lab and be ready for collection in two hours, a service which is available at all times of day. Laboratories are only able to offer this when they have a large volume of materials submitted for processing, as they obviously have to ensure that each process run they make will be cost-effective. In areas where the quantities they receive are not so great, they must 'batch' orders, and processing will be done twice, or perhaps only once, a day. If, for example, the local laboratory processes transparencies at 12 noon, orders must be received before then to be ready for collection later in the afternoon. Therefore, film shot on a day's assignment can be brought to the laboratory in the morning and will be ready within 24 hours of the completion of the job. Should the noon deadline be missed, a whole day will be lost, and because there is a tendency for clients to want results 'by yesterday', the situation may become desperate.

There are several advantages in processing immediately. If a complex set is occupying the studio, it is useful to know that the pictures are satisfactory before taking the set down as hours would otherwise be wasted building it again. Where models are involved, props hired or product available for only one day, it is critical that the shots be successful because to repeat would be difficult, impossible, or at the very least embarrassing. Although a Polaroid or Copytone test will indicate the result, it cannot predict a disaster such as a blemish on the transparency itself. If the set is still in the studio, it is an easy matter to repeat the shot after making adjustments to correct any inadequacies.

Clients appreciate jobs done quickly, so a fast processing service adds to the general efficiency and reputation of the studio. Sometimes a job will be lost to a competitor if the photographer is unable to meet the deadline.

Colour transparency processing in the photographer's own darkroom is the answer if he is working in an area where laboratories, for whatever reason, cannot offer a fast service, and when he is using a relatively large quantity of colour transparency material. Not only will he be able to produce results quickly, but he may also find it to be cheaper. The major disadvantage is the initial cost of the processing equipment and chemicals, and more time will be spent in the darkroom, although an E–6 transparency run can be completed in three-quarters of an hour. He may also be discouraged by the idea that it is difficult to do because of problems with colour balance and other related factors, but if the instructions on mixing chemicals, temperature and development times are followed *to the letter* the operation is relatively simple.

It is possible to process transparencies with a small daylight film tank, and the same procedure is followed as with black-and-white film, of pouring solutions in and returning them to bottles after use. The bottles are heated to the correct temperature in a tank of water, which may be thermostatically controlled, or filled from the tap and checked with a thermometer. If operated correctly, this method will produce perfect results, and the advantage is that it is very cheap. The disadvantages are that pouring solutions is inefficient and leads to spillages, and only a few films may be processed at any one time.

Transparency processing machines
A wide variety of machinery is available to suit most requirements, and the same criteria of cost and usefulness apply here as with machines for processing black-and-white prints.

Slightly more sophisticated than the method already mentioned, but similar in principle, is the variation on the daylight tank, where the tanks and all the chemicals are built into a thermostatically controlled water bath. There are also rotary machines in various sizes, in which the chemicals are added and discarded after use; some of these machines can be used to process not only transparencies, but negatives and prints. Where there is a minimum of space for machinery in the darkroom this may be ideal, but it should be remembered that the machine must be

thoroughly cleaned between processing different materials, or contamination will ensue.

Replenishment

If replenishment procedures are followed the solutions should, theoretically, remain at a constant working strength, as every time film is processed fresh chemicals are added to replace those lost in processing. Practical tests are needed to ensure that the acid/alkali balance has not tipped with replenishment. Manufacturers supply special test strips of exposed unprocessed film to check that colour balance and density have not been affected. When processed, this strip is compared with a pre-processed, correctly balanced example (also supplied).

Correctness can satisfactorily be assessed only with the aid of a densitometer, as a visual comparison is inadequate. A densitometer will measure the density of sections of the test strip through a set of tricolour filters and give a numerical reading of the result. The figures are then compared with those on the standard strip, and further adjustments may have to be made to account for variations from the standard.

Colour negative processing

The processing procedure is subject to the same requirements of time, temperature and solution quality as those which govern transparency processing, but the process is relatively short, principally because there are fewer baths. Also, a slight degree of latitude is permissible with negative material as small corrections of density and colour balance may be made at the printing stage.

Colour film consists of three layers of emulsion, each sensitive to a different primary colour in the light spectrum. Each layer is balanced against the others with regard to light sensitivity and subsequent development, and where the balance is upset, a phenomenon known as crossed curves occurs. This means that one layer is affected more than it should be in comparison with the other two, and it is impossible to correct this by filtration at the printing stage because if one colour is corrected, such a degree of bias is required that the other colours are adversely affected, and a true rendering of tones can never be achieved. Printing cannot compensate for significant inaccuracies in camera exposure, nor where development specifications for the negative material have not been observed. Film balanced for use in daylight conditions should not be used in tungsten lighting, and vice versa, except where a particular special effect is required.

Printing from colour negatives

For simple colour printing an ordinary black-and-white enlarger may be fitted with red, green and blue gelatin filters in front of the lens on a rotating holder. Three estimated exposures are made, for example 10 seconds on red, 10 seconds on blue and 15 seconds on green, to build up a colour image, and on the basis of a series of tests the printer may finally arrive at a satisfactory result. This is known as the additive process.

Rather more sophisticated is the enlarger fitted with a drawer between the light source and the negative, to hold the three colours of filter required for the subtractive process, the method used normally in commercial colour printing. The enlarger lens should be colour-corrected to refract each ray of the spectrum at precisely the same angle, and preferably there should be a voltage stabilizer as variations in voltage will affect not only the level of light but the colour balance of the lamp. There are three filters used, yellow, magenta and cyan, but whereas in the additive process three filter colours are used, the subtractive method uses only two at any one time, as use of three would result in a neutral density. For example, a filtration of $30Y + 75M + 10C$ simply equals a filtration of $20Y + 65M$, so the cyan is unnecessary.

Test strip: simple subtractive method
A test strip is made without filters to assess the density of the negative. Then a second test is made for colour correction using one of the filters – for example, yellow – by adding increasing values ($10Y$, $20Y$, $30Y$ etc.), meanwhile making an adjustment in the overall exposure (determined by the result of the first test strip) to allow for the reduction in the effective light level from the lamp caused by the thickness of the filter pack. From the result of the second test, correct yellow filtration is established, and the exposure time reset accordingly. The procedure is repeated to test for, say, magenta, and on the basis of this result a full-size print is made. Further adjustments may be necessary after examining the effect of filtration and exposure on the whole image.

It is possible to produce excellent colour prints with simple equipment and a trial-and-error method of working, but in commercial terms this does not make economic sense, and from the point of view of professional quality a print may leave much to be desired. It must therefore be stressed that colour printing of a standard expected by clients will necessitate a large capital outlay on special equipment and rigorous quality control throughout. However, once a colour printing service is established it may prove useful where quantities of colour prints are required as quickly as possible, as in public-relations work or social photography, or in an area where there is no colour laboratory at all, and the studio may undertake work for other photographers, either professional or amateur.

Colour negative analysers
These analyse the negative electronically to give readings for density and filtration, thus reducing the tedious business of making a series of test strips. Their accuracy depends on the degree of sophistication of the individual machine, and that, of course, determines the price one may expect to pay.

AUTOMATIC PROCESSING

As time and temperature of processing will radically affect density and colour balance of colour prints, it is essential that these be standardized. The only means of eliminating variables for commercial purposes is to

use an automatic processor, and a range of types are available, from small daylight spiral tanks to roller transport machines in varying sizes. One-shot rotary machines can provide processing facilities for transparency, negative and print materials, and are probably the most suitable for the small studio with limited space, although it should be repeated that thorough cleaning must be carried out between the different processes to prevent contamination.

COLOUR ENLARGERS

For serious colour printing on a commercial basis a modern enlarger with a special colour head is essential, and here it is not always possible to buy second-hand, as the older models have often been fitted with non-dichroic filters which may have faded. 'Dial-in' heads on colour enlargers allow adjustments in filtration to be made by turning a calibrated dial to lower the filters into the light to the degree required.

Colour prints from transparencies
Prints are made either with an internegative which is then printed in the normal way, or directly onto reversal paper, of which two types are currently available: Kodak R–14 and Cibachrome.

R–14 paper is constructed on the same principle as normal colour printing paper, in that the colour is introduced to the emulsion by the action of the chemicals, and the resulting image is not stable in high levels of ultra-violet light. The 'greenish' appearance of colour prints in shop windows is the result of the prolonged action of fluorescent tubes or daylight on the dyes, causing them to fade. Cibachrome, on the other hand, has had the dyes pre-coated into the emulsion at the manufacture stage, and processing *removes* those which are not required to form the image. The dyes remaining give a print of great depth and intensity of colour, and the print also has the advantage of being stable and capable of being displayed for long periods in bright light without risk of deterioration. Backlit Cibachrome transparencies, some of gigantic dimensions, are also used for display purposes, in hotel foyers, airport terminals etc., where lighting is on continuously and a stable image is required.

SILVER RECOVERY

The photographic industry is the world's largest user of silver, the resources of which are not unlimited. Recovering the particles of silver dissolved in the fix, and recycling, therefore not only makes economic sense for you, but also helps to conserve the precious supplies. To recover the silver you will need a special cartridge, available from manufacturers such as Kodak. You feed the fix into it, and it will gradually collect the silver from the solution. After a specified quantity of liquid has passed through it, you return the unit intact, and claim the value of the silver collected. Do not empty the unit: we are told that it is liable to catch fire in contact with the air.

16 Copywork

Copywork is the name given to the photographic reproduction of an existing and (usually) essentially flat original. This original may take many forms, from a single word of type to an oil painting, from a black-and-white photograph to a colour transparency, and there are many methods of coping with the wide variety of copywork encountered by the average photographer. Some are relatively simple and easily mastered, while others require a little more skill and experience. As its name suggests, copywork is principally a matter of producing as exact a replica of the original as possible in terms of colour and tonal values.

You should always assume that your client owns copyright in any piece of work he requests you to reproduce: it is wise to include a clause to this effect in your terms of business, as a disclaimer for yourself, should it be discovered subsequently that he does not own reproduction rights and action is taken against him by the copyright holder.

When you are given an original to copy, you should ensure that it is 'camera ready'. We have found that it is not good practice to undertake repairs, alterations or additions to someone else's artwork, and although it is equally a mistake to be completely inflexible over the removal of a stray speck of adhesive, it is not reasonable that the photographer should be expected to effect major changes – a situation which does occasionally arise. If you feel that, for whatever reason, the original has defects that make successful copying difficult, point them out to the client so that he may make the choice of reworking or going ahead prepared for the worst.

All surfaces, lenses, glass etc. should always be kept clean and free from dust or fingerprints, but in copywork this is particularly important. Given that there will, of necessity, be a loss of quality between the original and the copy, no matter how slight this loss may be, lack of cleanliness will compound the effect.

The basic principle of flat copying is that the camera is square to the original, which should be lit evenly: besides this, all other rules of photography apply. There is one very definite point in your favour: you should have no depth of field problems.

You can copy in the studio, using your normal camera and lights, proceeding as though you were working with a 3–D subject with limitations. The original may be fixed to a vertical board with pins or tape, or laid on the floor, and the camera squared to it with the help of its own viewfinder or a spirit level. Two lights, one placed on either side of the original and each equidistant from it, may be adequate to illuminate a relatively small subject evenly: otherwise, for a larger subject, four lights may be needed. Check that the lighting is even by taking an

exposure reading at several points over the surface of the original. This is a temporary set-up which may be removed at any time.

To be cost-effective, however, you will need a more permanent arrangement which will allow you to put your original under camera and lights, and make your copy with the minimum of time spent on it. The fees you may reasonably expect to charge for copywork do not allow for more than a few minutes' preparation, nor should copywork, which is often of an urgent nature, disrupt the more long-term and profitable activities of normal studio photography.

If you have room in the studio, construct a horizontal copyboard with fixed lights attached, and a pole with a camera bush to take all formats, so that when the camera is in position, it is centred over the board. Either the camera or the board, or both, should be made movable for size adjustment, but at whatever position, the lights will always remain constant relatively to the flat artwork.

A third method is to do copywork in the darkroom, using the enlarger. For this you will need a special attachment for the enlarger, known as a copy head. The enlarger lamphousing is removed and replaced by the copy head, which effectively turns a $5'' \times 4''$ enlarger into a plate camera, able to take dark slides. There is a ground-glass viewing screen, fitted with a mirror, placed at right angles above it, corrected to allow you to see the image clearly (it is obviously impractical to see down into an enlarger, because of its position). The lights are fixed permanently onto the walls or ceiling of the room, directed onto the material placed on the enlarger baseboard, and if you ensure that the baseboard is in the same position every time you copy, the illumination will be constant.

If you have a permanent copying method, then you will be able to make a copy almost instantly, knowing through past experience what the exposure is likely to be within a reasonable degree of accuracy acceptable within the tolerances of the film you are using. Thus, you will be able to maintain a rapid service while keeping your prices down and your profit margin high with minimum wastage of material. Remember that you cannot realistically use the same volume of materials on copywork that you can on original photography: profit margins are generally low, and the prices you may charge are normally fixed by those charged by others in your area offering the same service.

Here we will deal with copying originals using any of the systems outlined above, whereby a re-usable negative is produced, and printed as usual.

BLACK-AND-WHITE LINE

'Line work' is usually either line drawings in various media on various surfaces, or type. The first step is to ensure that white is white and black is black. An overall greyish original will not copy successfully as the image will break up.

In theory, the edges of the paper where additions or deletions have been made, the 'patch-marks', should not show on line work given even

lighting and correct exposure. To minimize casting of shadows, arrange the artwork so that the light runs along the line of the cut rather than across it, and over-expose the negative slightly if you are in doubt. However, if the cuts are deep, the paper is thick, or the adhesive used is grubby with handling, the shadows will reproduce, so give extra exposure to burn the marks out. This, as we shall see, is particularly awkward, if not impossible, when the artwork also has fine lines to copy.

For fine lines, do not stop the lens down too far, and tend to under- rather than over-expose. On the principle that patch-marks are effectively fine lines, this is effectively a reversal of the above procedure for eliminating them. Aim for a slow development, which can be more easily controlled, and do not use developer which is too strong or too hot. Also, you should use as large a negative as possible. 5″ × 4″ sheet film is used professionally as a matter of course for this type of work, but it is particularly important where it is essential to hold fine detail. For very large originals, such as architectural plans, even 5″ × 4″ may be too small to hold detail, as the degree of reduction from original to negative is so great.

Thus there is particular difficulty when dealing with an original with both imperfections to be eliminated and detail to be held. Assuming the compromise reached produces a reasonably acceptable negative, then blemishes in the black of the negative may be removed by spotting, either with ink, or preferably with a red paint known as Photopaque. Large areas may be masked with black or ruby lith tape. Spots on the clear film are less easy to eliminate, but they may be scratched from the negative with a sharp knife, or the final print may be spotted with black ink.

Materials and processing

For line work, special lith film is recommended, developed in lith developer. These graphic-arts films are not considered to have the same characteristics as normal camera films, and are not given ASA ratings as such, so check the instructions supplied with the material for an exposure assessment. They are mostly not panchromatic, so they can be used in safe-lighting as specified by the manufacturer, and they are remarkably tolerant. After exposure, the film is then processed in the lith developer for up to five minutes for full development, although, if your exposure is correct, you should expect to see an image appear in less than one minute. Make up the developer and use it according to the instructions given for temperature and time. Process the film until the black is dense: on the backing it will appear slightly more grey than on the emulsion. Insufficient exposure or processing will result in a black specked with pinholes and soft edges on the image: over-exposure or over-development will destroy fine lines.

If some parts of a line negative need more development than others (although if correct lighting procedure has been observed on a piece of camera-ready artwork this should not be common), then careful application of neat developer over that area may help, or use the simple

expedient of breathing on it to raise the temperature, and thus increase development. Such means, however, are not particularly controllable to a specific area.

Throughout processing, you should agitate to ensure even development and monitor the progress of the emerging image. You can 'pull' the negative from the developer to halt development if you feel the image is beginning to disintegrate, but this is not to be recommended before a reasonable time has elapsed, about two minutes or so. Pulling too soon may result in uneven development and many blemishes.

Reversals

This generally means a reversal 'black to white'. However, the term has a certain ambiguity, and is sometimes used to mean a reversal 'left to right', also called 'flipped' or 'flopped', where the negative is simply turned over to give a mirror image of the original on the print. If the instructions from the client are unclear, ascertain from him exactly which kind of reversal he requires.

To make a black-to-white reversal of a line negative, contact-print or expose through the enlarger onto a second sheet of lith film, processing it in the same way. Some subjects are unsuitable for black-to-white reversal, such as fine type with serifs and other material containing delicate lines. On the print, the thin white lines of the subject will not hold when enough exposure is given to achieve a solid black background.

Bleach-outs

Also called lith reductions, bleach-outs are line copies of continuous-tone originals, and form the basis of such darkroom techniques as posterization. The original is copied onto line film, but here a variation in the exposure/development time will cause a variation in the amount of black recorded. A slow development is again an advantage, to allow you to see how the image is appearing, and once again, you can pull the negative to halt development after the first stage. However, it is likely that a second or third attempt may need to be made to record exactly the correct amount of black to retain the character of the original.

Reversals may be made from continuous-tone negatives by printing onto a sheet of lith film to make a positive. This is then converted into a negative by printing onto a second sheet of lith film.

Printing

Line negatives may be printed on any photographic paper, although it is preferable to choose a hard grade. Some special papers are manufactured specifically for line work and are thinner than normal papers to be more suited to use for preparation of art work.

A film positive is a print made on line film instead of paper, and is used for overhead projection purposes or for overlays on art work.

BLACK-AND-WHITE CONTINUOUS TONE

When an ordinary black-and-white photograph is copied, the contrast is increased, so the major factor here is to keep contrast under control.

Thus, you should work with the low-contrast films and developers, observing the same rules as apply to normal three-dimensional photography. We have found that Plus X Pan sheet film processed in D–76 is very suitable, although we have used Kodak Gravure Positive, a slow, blue-sensitive film which can be used under safelighting, with excellent results. This film is made specifically for copying, and is developed in D–76 or something similar.

Ideally, the original to be copied should be of low contrast. On some occasions, a copy made of a particularly soft print will sharpen it quite significantly if the contrast is allowed to increase. Old photographs often copy very successfully for this reason, and if the resulting print is also sepia-toned for the characteristic antique appearance, the copy may be more pleasing than the original.

Continuous-tone copying is not suitable for holding a crisp white background. If the surround to the main subject has been whited out with paint on the print to be copied, you will find that the background will tend towards grey, showing brushstrokes and changes of tone, and you must give enough exposure to reproduce that correctly when printing the negative. Continuous tone does not have the bleaching property of lith, so to achieve a white background, it is far better to suggest that either the original negative or the copy negative be blocked out. Blocking out is done with Photopaque, but unless you are an expert, subcontract this job to an artist, as the slightest defect will show alarmingly on the final print.

Any original should have as good a quality as possible, but you may be able to remove some stains or marks with filters. Choose a filter of the same colour as the blemish and look for any neutralizing effect. Marks which cannot be filtered out will have to be retouched, which is best carried out on the copy print rather than on the original, in case of mistakes which may be damaging.

Copying colour onto black-and-white is subject to the same difficulties as apply in original photography when rendering an essentially colourful subject onto black-and-white material. It is not always easy to assess what the result will be, but generally, a stronger image will reproduce more successfully than one made of more subtle shades. Filters can be used to reduce the impact of colours by choosing one in the same area of the spectrum as the colour to be lightened. Panchromatic black-and-white film should be used when copying any colour material.

Colour transparencies may be copied by either of two methods:

1 Place the transparency in front of a light source and mask it with black paper or card to prevent flare. Square the camera, check exposure, shoot and process as normal.

2 Perhaps a better method, particularly if the transparency is small and the copy is being made on a larger format, is to expose the transparency onto the film through the enlarger. Fit the transparency into the negative carrier. Using a dark slide loaded with a sheet of white paper where the film normally fits, focus the image to the correct size onto the paper.

Because panchromatic film is to be used, you will not have safelighting, so you must ensure that the position of the dark slide is fixed, perhaps by fitting it into the corner of the masking frame. Place the dark slide, loaded with film, exactly, stop down the lens, and make the exposure in total darkness, using the enlarger timer.

To avoid confusion, and inadvertent 'flopping' or left-to-right reversal of the image in printing, it is important to have the emulsion of the original and that of the copy negative facing the same way. As the emulsion of the copy negative will be facing the subject, the transparency must be turned over so that the emulsion faces away from the copy. Thus, when you come to print, the emulsion is down, as usual.

COLOUR

Colour materials may be used for copying with the same systems as outlined above, although if you are working in the darkroom, remember to turn the safelights off, as these will give a colour cast.

When copying on colour negative, it is useful if not necessary to include a colour scale to enable the laboratory printing the negative to match the original as nearly as possible. If a colour scale is not included, or as an extra help with colour matching, it is an advantage to supply the artwork to the laboratory with the negative so that a direct comparison can be made. As the purpose of copywork is to reproduce the original faithfully, colour variations are unacceptable.

All artwork whether colour or black-and-white, may be copied onto colour transparency material. If, for example, you are asked for a slide of a black-and-white photograph, you can use a direct-reversal black-and-white method, but this means you must carry more stock for a relatively uncommon occurrence, and requires a different processing procedure from normal black-and-white materials. It may therefore be more convenient to copy onto a colour slide, using more commonly stocked material which is easier to process.

Slides may be duplicated with an ordinary 35mm camera, which will need either a macro lens or extension tubes or bellows to allow for same-size reproduction. The slide will need to be illuminated from the rear with light of the correct colour temperature for the film used, and it must be masked to avoid flare.

However, given that a correct colour balance has been achieved by careful processing, and any necessary compensatory filtration for the batch of film being used, contrast remains the principal problem. If you use the above method of copying, you can overcome the increase in contrast by over-exposing by one stop in the camera and lengthening the development time accordingly.

For serious slide copying, you should invest in the convenience of a relatively inexpensive transparency copier, such as the Illumitran, which consists of a small light box lit with electronic flash. The slide is placed on the light box and the camera is fixed on a mounting to look directly

down upon it. The advantages of the Illumitran are that the guesswork is taken out of slide copying since it has its own exposure meter and accurate positioning, and it also has the facility of giving a flash exposure to control contrast.

Flash exposure

This is the technique of slightly fogging film or paper by exposing it to white light as well as the image, and it has the effect of reducing the high contrast resulting from copying. It is used extensively in copywork, and it is again a matter of trial and error, and knowledge through experience. On a transparency copier, the flash exposure is made by means of an actual flash, a secondary tube aimed indirectly at the camera lens. On other occasions, the 'flash' is made by placing a piece of white paper over the original to fog the film for – as a rough approximation which depends on subject material – about five to ten per cent of the total exposure time. This technique can also be used in printing to reduce high contrast.

PAINTINGS

Although some pictures may be brought to the studio and copied as usual, many, for reasons of size and value, will have to be photographed *in situ*. Art galleries, used to having their collections photographed, will normally be able to provide the space and electrical supply needed, together with responsible people to take care of works which may be priceless. In private houses, on the other hand, the task may not be as simple. For example, we were commissioned by Mr Reresby Sitwell to photograph a painting in the collection at Renishaw Hall, a painting which was extremely large and very dark, hanging in a ballroom where there was no electricity. Fortunately, the picture was lit fairly evenly by daylight, and as the copy was to be made in black-and-white, it was possible to give a long exposure.

If possible, paintings should be photographed without glass, for obvious reasons, and without frames, as they are liable to cast heavy shadows. If neither is practical, then the positioning of the light is critical, to minimize the problems. Impasto and varnish cause specular highlights on the picture, which are unacceptable as not being part of the artist's intended image; these may be reduced by light position and with the help of polarizing filters on the camera and on the lamps themselves. Antique oil paintings, because of an accumulation of dirt and the changing character of the varnish, are often dark, and to avoid total loss of detail in the heavier areas, the lighting arrangement may be adjusted to give more illumination there, or extra exposure may be given accordingly.

You should take extreme care when photographing original works of art, as any damage done, even if not completely disastrous, will still be embarrassing both emotionally and financially. You must be careful not only of the subject you are shooting, but also of your surroundings, and for your own benefit it is worth while having a member of the gallery

staff or household in attendance at all times to tell you where it is safe to leave equipment, or even what chair you are allowed to sit on.

COPYWORK WITH A PROCESS CAMERA

A process camera will allow you to make instant copies in line, continuous tone, halftone (i.e. screened) and simple colour. The leading manufacturer in this field is undoubtedly Agfa–Gevaert, whose series of Repromaster process cameras and Copyproof materials system have revolutionized the field of copywork during the 1970's.

'Compared with traditional methods which involve the following separate activities of exposing the negative, developing, fixing, washing, drying, followed by the exposure of the positive, developing, fixing, washing, drying, it's not surprising that the Copyproof system has become so popular with design studios, advertising agencies, in-plant and commercial printers, publishers etc.' (*Instant Graphic Techniques*, produced jointly by *Graphics World* magazine and Agfa–Gevaert.) You will note that the professional photographer is not mentioned.

Because the system is quick, easy to use and takes up comparatively little space, it is indeed not surprising that it is so popular with those mentioned above, who also constitute the vast majority of regular users of copywork. It would therefore be unrealistic to assume that you, as a professional photographer, will now be able to earn a particularly lucrative or regular income from simple copywork alone.

Thus the purchase of a process camera is an investment you should consider carefully. Apart from the initial capital outlay, the materials are expensive in comparison with other photographic materials, so the materials cost/profit ratio is high, and you need a large volume of turnover to make any economic sense at all.

Most process cameras are automated to a greater or lesser degree, with guides for reduction and enlargement percentages, and for exposure times. The artwork to be copied is placed on the copyboard, illuminated by four tungsten halogen lamps for even lighting. Sizing and focusing are adjusted by two handles, although in some models this is automated, and the image appears on a large glass screen for easy viewing. Negative materials are paper, not re-usable, and must be used in red safelighting, while the positives are paper or film and may be used in normal room lighting. Exposures are calibrated, the negative placed on the viewing screen and kept in position by a vacuum head during exposure. After this, the negative and the positive are fed together through a one-bath processor with roller transport: 30 seconds or so later, the two are peeled apart, the negative thrown away and the positive ready for use, although it is recommended that it be rinsed and dried to remove residual chemical deposits, which may crystallize. The positive is ideally suited for pen-and-ink or coloured marker work, and is thin yet stable for use in preparation of artwork.

AUDIO-VISUAL SLIDES

There is a vast difference between a simple slide show where single images appear at one time on a screen, and an audio-visual programme, where the conventional photography involved is only one part of a complex whole. For AVs using more than one slide projector, where images will be superimposed and faded, the most important consideration is registration, otherwise pictures will not so much fade as jump disturbingly. Because of the degree of accuracy required it is not possible to produce registered AV slides on any 35mm camera: the film must travel through the camera in such a way that the sprocket holes are always in exactly the same position relative to the individual frames. Look at the next roll of 35mm you shoot to see how accurately your camera is in register. You may be lucky: of the three Nikon bodies in our studio, two, by pure chance, happen to be in register.

However, an audio-visual programme is something a photographer is not usually able to produce on his own, as production of the sound track and programming sophisticated electronic equipment to control the array of slide projectors involved are specialized fields, and planning the programme as a whole is more akin to producing a movie film than a set of still photographs. If you are going to compete in the increasing AV market, you must understand this.

ROSTRUM PHOTOGRAPHY

The two illustrations shown here are examples of photography which may be used either in an AV programme or in other ways: in a slide show to illustrate a lecture (known as speaker-support slides), or even for title pages in brochures, books etc. I asked an expert in rostrum photography, Dave Jessop of R.S. Colour Laboratories, Manchester, to explain its principles and possibilities.

'Ask any child over the age of two about his favourite cartoon. He will happily describe a fantasy world where animals and everyday objects dance and have truly impossible adventures: he is describing one form of rostrum photography.

'We simply read the titles and credits at the beginnings and ends of films, TV programmes and commercials: many of the special effects we have come to expect in science-fiction films would not have been possible in the past. This is rostrum photography, and without realizing it, we are aware of its potential because we see it every day.

'What is a rostrum camera?

'A rostrum camera is a high-precision instrument, which allows the operator to photograph and reprograph (multi-expose) a single frame or a length of film, to within an accuracy of two ten-thousandths of an inch (.0002″). This is made possible by, firstly, using films with perforations (16mm, 35mm, 46mm etc.) and secondly, having a special film transport system.

'There are two methods of "pin registration", dependent on the camera's manufacture. One version uses fixed registration pins, while others are

movable. In practice, the registration pins are inserted into the film sprocket holes prior to exposure, accurately locating each frame.

'Rostrum cameras are in many shapes and sizes, from customized Nikons to a free-standing vertical copy camera with a variety of features and movements. The illustrations here were made on such a camera, a Forox. Cameras may be used for stills, or computer-controlled for cine.

'Artwork for copying may be supplied in either of two ways:

1 Full-colour flat-copy artwork with overlays, punched and registered, prepared in the same way as an animator would originate his artwork.

2 Punched and registered black-and-white lith films and colour transparencies.

'The advantages of making colour slides from black-and-white lith are: savings in the cost of artwork preparation; colours on the final slide are more intense; many effects would be either impossible or expensive for an artist to create.

'Many people talk of rostrum cameras as if they are a source of magic – at the touch of a button. If there is any magic at all, it is the imagination and the hard work of the artists, designers, animators and photographers: the camera is simply the tool.'

Glossary

Cameras

BASEBOARD Large-format camera with standards mounted on a flat board.

DIRECT-VISION CAMERA One in which the viewfinder is separate from the lens.

FRESNEL SCREEN A light-concentrating 'flat' lens, distributing image brightness evenly, particularly useful for viewing screens on large-format cameras.

INSTANT-PRINT CAMERAS Cameras in which the positive print emerges without the need for conventional negative/positive darkroom work.

MINIATURE CAMERAS Those with a format of 35mm or less.

MONORAIL Large-format camera with standards mounted on a rail to allow for maximum flexibility of movement.

PINHOLE A primitive 'camera' with no lens, but a small hole through which light passes to the sensitive material. The smaller the hole, the better the definition, but the longer the exposure required to record the image.

PLATE CAMERA Large-format camera designed to take the glass plates on which the sensitive emulsion was formerly applied.

ROLL-FILM CAMERA Medium-format camera, commonly 6cm × 6cm ($2\frac{1}{4}''$ square) or 6cm × 7cm size. 'Roll film' is the term used for film suitable for this format. 35mm film, although supplied in rolls, is not called roll film.

SLR Single-lens reflex.

SUBMINIATURE Cameras such as the tiny Minox, high-quality precision instruments, with a negative size of 8mm × 11mm.

TLR Twin-lens reflex.

VIEW CAMERAS Large-format cameras, usually of $5'' \times 4''$ or larger, sometimes colloquially called 'plate' cameras.

Lenses

ABERRATION A distortion of shape or alteration in colour when inherent lens inadequacy gives an imperfect image of the subject.

ANAMORPHIC LENS One which compresses a wide angle into a standard frame.

ANGLE OF VIEW The angle of coverage of a lens which produces a usable image.

APERTURE Indicated by *f* numbers, the aperture controls the light falling on the film and alters the depth of field. A wide aperture (known as 'opened up') results in a shallow depth of field; a small aperture ('stopped down') gives greater depth.

DIAPHRAGM The adjustable aperture mechanism.

EXTENSION TUBES/BELLOWS Fitted between the lens and the camera body to allow for close-up work.

FISH-EYE LENS One in which the angle of view is extremely wide (180° or more), giving a distorted result.

FOCAL LENGTH The distance between the rear of the lens and the focal plane when focus is set at infinity.

FOCAL PLANE The plane of sharp focus when the lens is set at infinity. This is normally coincident with the film plane.

LENS Ranging from simple to extremely complicated, a lens is an optical device to bend rays of light, which normally travel in straight lines.

LENS HOOD/SHADE An attachment fitted in front of the lens to prevent light from falling unnecessarily on the lens surface and causing flare.

LONG-FOCUS A lens with a long focal length, but no special optics to reduce its necessary physical size.

MACRO A lens designed for close-up work, in which the size of the image is only half the size of the subject, or even the same size.

MIRROR LENS A system of mirrors used in lenses with extremely long focal length, to reduce otherwise excessive physical length.

PARALLAX The variation of viewpoint between what can be seen through the viewfinder and what is seen by the lens.

STANDARD LENS The standard lens for a given camera format is one in which the focal length is approximately equal to the diagonal of the film area, e.g. for 6cm × 6cm the standard lens has a focal length of 80mm.

TELEPHOTO A lens with a long focal length, and special optics to allow it to be mounted close to the focal plane. Thus it is less long physically than a true long-focus lens of the same focal length.

TTL Through-the-lens metering.

WIDE-ANGLE A lens whose focal length is shorter than that of the standard lens, and the angle of view is wider.

ZOOM A lens with variable focal length.

Lights

BARN DOORS Attachment for lamp, comprising hinged doors (hence the name) which are moved to control the direction of the light.

FLASH Very short, very bright illumination of either expendable bulb or electronic type.

JOULE Unit of measurement of the light output of electronic flash.

KELVIN Degrees Kelvin (°K, same as degrees centigrade but starting at absolute zero) measure the colour temperature of light.

MODELLING LIGHT The continuous light of studio electronic flash, not normally used to expose film but to assess subject lighting.

REFLECTOR Generally, any device used to reflect light onto the subject. Specifically, the term refers to (*1*) the white or grey card surrounding the subject to add light, or (*2*) an attachment to the light to maximize the use of the light emitted.

RING FLASH A ring-shaped flash attachment fitted round the lens of a camera giving a shadowless effect.

SLAVE UNIT Mechanism whereby a photo-electric cell instantaneously triggers a flash from the light emitted by another flash. It is used instead of synchronization cables.

SNOOT Conical attachment to a lamp, giving an intense spotlight effect.

SPOT PROJECTOR An electronic studio flash spotlight which can project images, being focused and flash-synchronized.

TUNGSTEN LAMP Lamp producing bright light when electricity is passed through a tungsten filament encased in a glass envelope.

TUNGSTEN-HALOGEN LAMP A smaller, improved version of the tungsten lamp, formerly called a quartz-halogen lamp.

UMBRELLA An umbrella-shaped reflector attached to a lamp to reflect light on the subject, most usually of white, silver or gold cloth.

Physical laws

CHARACTERISTIC CURVE A graph representing (principally) the build-up of contrast during development of a given type of exposed emulsion.

CIRCLE OF CONFUSION High spots of light in the image will appear as small points when the total image is sharp, or as larger circles when it is not. The 'circle' is formed because of the circular shape of the lens: a heart-shaped mask over the lens will produce heart-shaped circles.

COLOURS, COMPLEMENTARY In colour-subtractive printing the complementary colours of blue, green and red are, respectively, yellow, magenta and cyan. Thus, cyan is considered to be the 'opposite' of red,

being a greenish blue. A primary and its complementary, travelling together, produce white light.

COLOURS, PRIMARY In light, these are blue, green and red, which produce white light when the rays travel together in parallel. In pigment, the primaries are blue, yellow and red.

INVERSE SQUARE Light from a point source falls off at a rate inversely proportional to the square of the distance. Thus, if the distance between the light and the subject is doubled, there will not be half the light level, but a quarter.

MAGNIFICATION The size of the image on film relative to the size of the subject, and the ratio of subject-to-lens and lens-to-image distance. If the two distances are equal, magnification is × 1.

NEWTON'S RINGS Rainbow-coloured lines caused by contact between two transparent surfaces.

PERSPECTIVE, AERIAL Atmospheric haze causes a gradual diminution of clarity towards the distant horizon, thus giving an immediate impression of depth.

PERSPECTIVE, LINEAR Parallel lines never meet, but appear to do so as they approach vanishing-point. The observer judges distance by angles of convergence and size of objects.

POLARIZATION Light, travelling in straight lines, also travels in waves, vibrating in all directions. Light rays passing through a polarizing filter are 'polarized' to vibrate in one direction only.

RECIPROCITY Exposure is equal to the intensity of the light multiplied by the time that light is allowed to act on the emulsion. If the reciprocal arrangement of light level, emulsion speed and exposure is unbalanced, then the emulsion will not react as expected and the result is called reciprocity failure.

REFLECTED IMAGE The image is effectively as far behind the reflective surface as the object is in front.

SCHEIMPFLUG RULE Also known as the intersecting plane rule (related to view cameras), this states that the image will be uniformly sharp only when the subject plane, the lens plane and the image plane are in parallel. If the three planes are not in parallel, there will be uniform sharpness only when the extensions of each plane meet in a common point.

Film, paper and printing

BATCH NUMBERS Paper or film with the same batch number has been produced at the same time, and therefore has the same characteristics of speed, colour and contrast. Different batches may vary slightly.

BLEACH-OUT Removal of all mid-tones to leave only black and white. Also called a lith reduction or line reduction.

BROMIDE PAPER Photographic printing paper coated with light-sensitive silver bromide emulsion. Hence the term 'bromide' meaning a photographic print, to distinguish between this and other forms of print.

CONTINUOUS TONE A continuous variation from white through grey to black.

DICHROIC FOG A bloom on negatives caused by contaminated fix.

DODGING (also called shading) In printing, this is a means of reducing exposure over part of the image area to 'hold back' from its becoming too dark – usually by using opaque card, hands or other means.

EXPIRY DATE The end of the useful life of the material.

HALFTONE A continuous-tone print which has been screened to a dot pattern for the purpose of mechanical reproduction. Although all mid-tones are removed, a continuous-tone appearance is retained. Occasionally this term is applied, incorrectly, to a continuous-tone photograph, on the principle that continuous-tone monochrome cannot be truly continuous because it is not in colour.

ORTHOCHROMATIC Emulsion sensitive to blue and green, but insensitive to red.

PANCHROMATIC Emulsion sensitive to all colours.

PRINTING-IN Giving extra exposure to certain areas of the print. If the whole of the negative is not given equal exposure, it could be said that some areas are dodged, while the remainder is printed-in.

PULL Removal of material from the developer before development is complete.

PUSH Increasing the speed rating of film, as specified by the manufacturer, to cope with poor lighting conditions and compensating with development. Also called 'up-rating'.

RC Resin-coated (of paper).

REDUCTION *1* Chemical reduction of contrast and density in materials. *2* Decrease in size. *3* Reduction to line, i.e. a bleach-out.

REVERSAL *1* In black-and-white line artwork, a reversal from black to white, e.g. black type of white paper becomes white type on a black ground. *2* A reversal from left to right. The image is turned over and viewed from the other side. This is also called 'flipped' or 'flopped'.

REVERSAL MATERIALS Materials such as transparencies, in which the positive image is produced after exposure in camera.

SCREENED PRINT A halftone, after the image has been exposed through a screen of dots, as distinct from the result produced by the mechanical process of screen printing.

TRANSPARENCY A positive on film, generally in colour, of any size, 35mm transparencies for projection are commonly referred to as 'slides'. 'Trannies', 'Ektachromes' and 'chromes' are other colloquial names.

General terms

AIRBRUSHING Method of retouching by spraying colour or dye onto the print with an airbrush.

ARTWORK A camera-ready piece of finished artwork (abbrev. a/w) has all type etc. in place and is ready for the printer.

BLEED A print is 'bled' when it has no borders. 'Allowing for bleed' means to print oversize so that the image may be trimmed down to size.

BLOCKING OUT Retouching on negative or print to remove background and isolate the main subject.

BRIEF Instructions given by client.

KEY, HIGH Photograph comprising light tones and the minimum of dark areas and shadows.

KEY, LOW Photograph comprising dark tones and the minimum of highlights.

LAYOUT OR ROUGH A representation of the proposal for finished artwork, showing positioning for type, proportions and possible arrangements for photographs.

MONTAGE Properly, a composite image made from several different photographs, but sometimes a group of objects in a single photograph is referred to, incorrectly, as a montage.

PROOF A mechanical printing term used in photography to mean prints not intended as final, but for reference, generally contact prints. Alternatively, prints may be marked 'Proof', in inks which can subsequently be removed with solvents, to prevent unauthorized use.

RETOUCHING Generic term for non-photographic treatment on a negative or print.

SPOTTING A form of retouching to remove small blemishes on negatives and prints by means of a pencil or brush. In 'knifing', the surface of the print is carefully removed with a knife, to dispose of the black 'pin-holes' caused by tiny gaps in the emulsion of the negative.

VIGNETTE Fading out of the image towards the border of the print into either dark or light, in camera or in the darkroom. The term is taken from the oval frame or mask used to mount the picture.

Chemicals

ACETIC ACID Used in stop baths and fixing solutions.

BLEACH Used to re-halogenize black silver.

BLEACHING The process of removing black silver, usually prior to colour toning.

DEVELOPER All types are designed to cause the latent image to appear on the exposed material. The actual chemicals used, and their proportions, are formulated for specific materials and results.

FIX Dissolves unused silver halides and makes the image stable in light.

HARDENER A potassium or chrome alum additive to the fixing bath to harden the emulsion.

HYPO A familiar name for fix, from hyposulphite of soda, a former (and inaccurate) name for sodium thiosulphate.

HYPO ELIMINATOR A clearing agent to remove all traces of fix.

INTENSIFIERS These increase density in negatives with a two-bath process in which the image is bleached and then redeveloped.

pH A scale, from 0 to 14, to express the acidity/alkalinity of a solution, in which 7 is neutral, less is acid and more is alkaline.

REDUCERS These remove silver from negatives and prints to reduce density and contrast.

REPLENISHMENT Adding chemicals to stock solutions to maintain their original characteristics and thereby prevent exhaustion.

STOP BATH Used to halt development and preserve the life of the fix.

TONERS These change the colour of the black silver on a print (e.g. to sepia).

WETTING AGENTS These reduce the surface tension of water on the film and should be used after washing to give even drying.

Further Reading

LANGFORD, M. J.: *Basic Photography*. Focal Press, 1977.
—: *Advanced Photography*. Focal Press, 1979.
—: *Professional Photography*. Focal Press, 1974.
—: *The Darkroom Handbook*. Ebury Press, 1981.
SPENCER, D. A.: *Colour Photography in Practice*. Focal Press, 1975.
HEDGECOE, John: *The Photographer's Handbook*. Ebury Press, 1977.

These are excellent general handbooks, covering all aspects of photography. For information in more specialized fields, you will find a wide range of publications covering in greater or less detail the most diverse topics, and your further reading will depend on your personal interest. We would recommend you to read as widely as possible, and we would also recommend that you not only read, but just 'look'. Picture books, collections of photographs, are a great source of ideas and inspiration. One with particular relevance to professional photographers is *The Art Directors' Index to Photographers*, published annually, a comprehensive, glossy advertising medium for photographers world-wide. This is not only a source of ideas, but an indication of the standards you should aim to achieve.

Acknowledgments

We would like to thank the following for their kind permission to use for illustrations the material we have shot on their assignments:
Brian Asquith Associates; Aveling Barford Ltd; Crucible Theatre; Stanley D. Dickson Ltd; John Lovell & Co. Ltd; Moss Advertising Ltd; W.E. Norton Machine Tools Ltd; Parkin Silversmiths Ltd; Pearsons of Chesterfield; Stanley Tools Ltd; and Viners Sheffield Ltd.

We would also like to thank Kodak and Agfa Gevaert for technical information, Laptech Photographic Distributors Ltd for advice on equipment, David Jessop of R.S. Colour Laboratories Ltd, our colleagues Andy Barber and Mike English, Sheila Brabin-Smith for listening patiently and her excellent printing, and our editor W.S. Taylor for his invaluable help.

Although they are not named here, there are many other of our clients whom we would like to thank for their help, direct and indirect, in furthering our knowledge and making this project possible.

Index

Page numbers in italic refer to illustrations

THE THAMES AND HUDSON MANUALS
GENERAL EDITOR: W.S. TAYLOR

Professional Photography